OFFSHORE

AN ARTIST'S VIEW OF BRITAIN'S ISLANDS

Peter Collyer

ADLARD COLES NAUTICAL

London

Published by Adlard Coles Nautical
an imprint of A & C Black Publishers Ltd
37 Soho Square, London W1D 3QZ
www.adlardcoles.com

First edition published 2005

ISBN 0-7136-7176-9

A CIP catalogue record for this book is available from the British Library.

A & C Black uses paper produced with elemental chlorine-free pulp, harvested from managed
sustainable forests.

Edited by John Lloyd
Designed by Eric Drewery
Printed in Singapore by Tien Wah Press (Pte.) Ltd

Peter Collyer is represented by
Chris Beetles Ltd, St James's, London
Telephone 020 7839 7551
Specialists in English Watercolours
www.chrisbeetles.com
www.petercollyer.co.uk

OFFSHORE

Contents

To the memory of my artist friends who are no longer with us and
are much missed
David Evans, Robin Tanner, Seán Crampton and Cilla Lloyd

Acknowledgements

I don't want to sound like an actor at the Oscars, but I couldn't have done this without the help and support of my family, my friends, indeed 'my brilliant team': John Lloyd – my editor, confidence booster and mentor; Eric (Mr Organised) Drewery – graphic designer par excellence who, somehow, through his gentle authority, managed to keep us all running to time; and our new recruit Janet Murphy – our kindly taskmistress in the hot seat at Adlard Coles who, amazingly, still believes artistic temperament is good for business. I would also like to thank all at Chris Beetles' gallery for their hospitality and support, especially Chris himself and Phil Tite who always have encouraging and perceptive things to say.

I am greatly indebted to the following for supplying me with vital information, pulling strings and generally going above and beyond the call of duty, and on top of that, making this book a pleasure to work on by being all-round great folk.

Denise at Anderson MacArthur & Co, Tim Bentinck, Dr Richard Bevan, Katie Campbell, John Cattini, Deborah Clark and Tony Orchard, Peter and Winifred Colven, Fr Daniel, Bobby Elphinstone, Tony and Helen Erwood, Ian Gilmore, Mark Godden, the Griffin family, John Hammond, Martin Lane, Patrick Lyons, Mary Macdonald, Torquil and Janice MacInnes, Margaret Mackay, Lindy MacLellan, Jeff Macleod Ramsden, Mary Ann and Donald John MacSween, Margaret Anne Mactaggart, all at NorthLink Ferries especially Inga Wallace, Richard Offen, Ian Parkinson, Julia Peters, Steve Pike, Ailsa, George and Jack Sheil, Ray Shields, Jim Smith, Heather Squires, John Stanford, Bill Stanton, David Steel, Malcom and Avril Turner, John Walton, Mike White, Gary Whittaker, Brian Wilson, Dominic Woollatt and Geoff Wyatt.

The Enigma of Islands

The word island evokes a sense of mystery and fascination. In Britain we all live on an island, but those of us on the mainland are unconscious of the fact most of the time, possibly because it is the eighth largest island in the world. Our shared island experience is something taken for granted and goes largely unexpressed, but, strangely, when an advertising agency conducted a survey to gauge people's reactions to headlines, the one word that grabbed people's attention the most, enticing them to read on, was 'island'. Whether we realise it or not we are all, it would seem, spellbound by the sea-bound.

Why this subliminal pull towards islands? Why are they so deeply ingrained in our psyche? Is it because we are, uniquely, a large island surrounded by so many smaller ones? Is it that that we are more able to understand these islands because of their size, each an identifiable whole, more human in scale than the mainland, where we can be the metaphorical single cartoon figure sharing a mound of sand with just a palm tree and surrounded by water?

How interesting that the word preceding subliminal in the dictionary is one I found myself wanting to use so many times in the course of these travels – sublime.

Today we think of islands as being isolated, remote, out there somewhere, on the fringe... In Celtic culture the sea was the highway and islands were the crossroads. Movement and trade were almost exclusively by sea, being safer and easier than by land, where there was little rule of law and few roads. Island inhabitants were not on the fringe, they were at the heart of things. These coastal settlements were the equivalent of our modern-day cities.

We have now made moving rapidly and safely by road, rail or air across land a speciality, whereas crossing water to islands is still so strangely old fashioned, elemental even. No matter how space-age modern boats look they remain totally

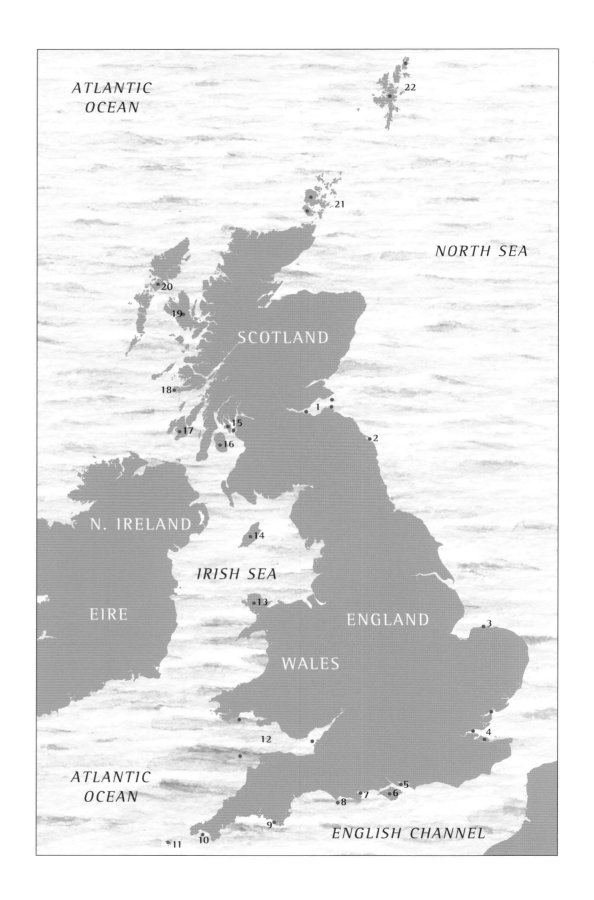

at the mercy of the weather and still plough through water in the slow and often ponderous way they always have done.

Scattered around the island of mainland England, Scotland and Wales are no fewer than 6,288 islands. Most of these are little more than pieces of rock permanently protruding from the sea that have, over time, acquired the status bestowed by the granting of a name. Only 803, a little more than 12.5 per cent of the total, are grand enough to be bounded by anything that could reasonably be described as a coastline, and only half of these have a land area worth mapping. They make up 43 per cent of Britain's coastline, but are home to only one per cent of its population, despite the fact that one of them is the most densely populated urban area in England outside of London.

So which islands to choose, and where to begin?

I began with a list, placing Lindisfarne at the top and keeping the English, Welsh and Scottish islands together in a geographical sequence. I don't know why, but there seemed to be a certain logic to the order. You can walk to Lindisfarne, and as you go down to the lower half of the list the islands become further away and the journeys to them more of an adventure. As a list, it worked fine.

There was something natural, too, about going round them clockwise. The Shipping Forecast is read in a clockwise direction and I didn't question the logic of that when I illustrated it for my first book *Rain Later, Good*.

But where should I start? Being a circular journey there was no natural starting point. Then inspiration struck. Perhaps I shouldn't be thinking about where to begin, I should be deciding where to finish. Where should I go that would bring this journey, and this book, to some logical conclusion?

Wherever it was to be, I would begin by getting in my car and driving away from home, so maybe the place at which I should end these travels should be as far away from the mainland as I could possibly go with my car; the end of the road. And where do I think is the end of the road in the British Isles? Read on to find out!

This, then, is my personal selection. I have chosen these places to illustrate the varied nature of island life in Britain today, and for the diversity of their landscape, history and location. These islands are all accessible (in theory at least). You don't need to have your own boat to get to them. To visit some you do not even need a boat at all; you can drive or even walk there. This account of my travels to offshore Britain tells of the journeying as well as of the islands themselves. I would like to think that it will whet your appetite and entice you to visit some or all of them for yourself.

So that is how I eventually found myself beginning these travels by driving to Anstruther to catch a boat out to the Isle of May.

Islands in the
Firth of Forth

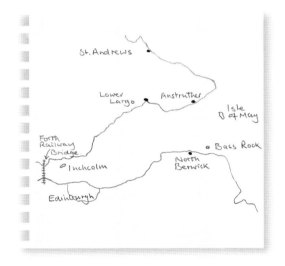

Twelve miles short of Anstruther, where I was due to join the boat for the Isle of May, I caught sight of something out of the corner of my eye that had my finger momentarily hovering over the panic button.

I'm not one to believe in superstitions or omens – there are perfectly sensible reasons for not walking under ladders and I stop counting magpies when I get to four – but as I passed through the village of Lower Largo I noticed a sign luring me in the direction of the harbour and indicating that this was the birthplace of Robinson Crusoe. There's even a statue of him and a Crusoe Hotel. Perhaps that explains why the *May Princess* doesn't sail on a Friday. I must remember to pack my goatskin jacket next trip just in case.

Sailing times vary from day to day according to the tide. This is more for getting in and out of Anstruther harbour than landing at the May (as it is locally and more correctly known). Schedules are well advertised by way of a 24 hour recorded information line, a website, and, more traditionally, chalked on a blackboard at the quayside booking kiosk.

However, the phrase to remember when planning a visit is 'weather permitting'. The previous evening's forecast for an onshore 'breeze' and a continuation of the late June heat-wave was answered with a reassuringly clear blue sky, but the breeze had unexpectedly blown up into a force three gusting to five, with waves breaking into white horses. The lack of a swell was in our favour, but whether we could land safely or not was the decision of the skipper once we arrived.

May lies five miles off the East Neuk of Fife, a ridge of basalt sitting on the horizon where the sheltered Firth of Forth merges with the North Sea. On a northwest – southeast axis, 1,900 metres long and 450 metres across at its widest and covering 57 hectares, it is the largest island on the east coast of Britain without

The Angel, Isle of May

a physical link to the mainland. The shore is generally steep and rocky and on the west coast its impressive cliffs rise to more than 45 metres.

May has three lighthouses, one church-like and visible from the mainland, and another that was Scotland's first (1636), and the remains of a twelfth century priory. But it is not these that seem to attract most visitors. My impression was that people were here because it is a National Nature Reserve and a Site of Special Scientific Interest famous for its seabirds, ones you rarely get close to or see in any quantity if you confine your watching to the mainland.

Some of the waves we met head-on almost brought us to a shuddering standstill, but after a long meandering hour we arrived at May, where waves crashed over the rocks at the narrow entrance to Kirkhaven anchorage. The engine was cut back and for an achingly long moment we bobbed about uncontrolled while the crew contemplated the situation and the rest of us stared longingly at the seemingly unobtainable, hoping for a positive outcome.

Cheers greeted the recorded message asking us to remain seated while we tied up at the landing stage.

Our collective feeling of good fortune was bolstered when the resident Scottish Natural Heritage warden, who sees the island and surrounding waters in all weathers, expressed his amazement that the journey had been attempted at all.

Under a blazing sun and a temperature of about 22 degrees a lightweight fleece was still necessary garb to feel comfortable in the conditions.

With instructions to keep to the paths – mown strips marked with short, blue painted wooden posts – we all wandered off to explore and enjoy our two and a half hours ashore.

May is an undulating grassy plateau and at this time of year, in the summer, is a carpet of white sea campion. The native rabbit population and the visiting puffins burrow into the thin soil layer. Wandering from the footpaths can not only be dangerous for the human visitors, who could easily turn an ankle in a campion camouflaged burrow, but could also prove fatal for any feathered occupants.

On my wanderings I met the warden, who told me he thought this year's bird population was close to a quarter of a million. I asked how much food it took to maintain such a number and his reply was that a study to look into just this was currently being undertaken. Sand eels are the main source of food for many of the birds, so the health of the local sand eel population is crucial. He has estimated 5–10,000 tonnes per nesting season, but will know more when the study is complete.

It turned out to be my lucky day. In a cove along the west coast cliffs I came

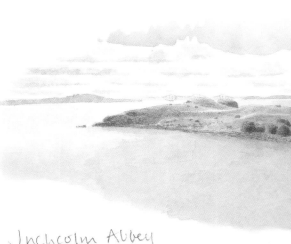

Inchcolm Abbey

- Forth Bridge in the distance

> Alexander Selkirk came from Lower Largo and spent four years and four months marooned on a desert island. The account of his experiences inspired Daniel Defoe to write *The Life and Strange Surprising Adventures of Robinson Crusoe, of York, Mariner.*

across the Angel, one of the most spectacular freestanding cliff high pinnacles of rock I have ever seen; a perfect painting subject.

At the same time, the peace I had just become attuned to was broken by a cacophony of kittiwakes that were nesting on the tiny cliff-face ledges around the cove, along with several hundred guillemots and razorbills.

The smell and noise apart, how fortunate I had been. To think that we might have turned back without landing and by now I could be standing on the quayside back in Anstruther disappointed. Instead I felt that I had already had a satisfyingly productive day. I was sharing a cliff top with a dozen puffins enjoying a stunning view and still had enough time left just to sit back and enjoy being here.

Over the horizon and 25 miles back up the Forth lies Inchcolm. By comparison the ferry ride and the one and a half hours ashore are (in good weather at least) a jolly three hours away from the traffic you have to endure to get to Hawes Pier where the journey begins.

Arrive early, make your way down the pier and just gaze in awe for a while at the magnificent and unique structure that towers over everything thereabouts; the Forth Railway Bridge.

The ferry journey is accompanied by an informative recorded commentary on the many interesting sights you pass on the way, and is in the style of someone reading *Kidnapped* to a class of primary school children. This, amusingly, even includes the safety announcement, most of which was drowned out (no pun intended) by a train rattling over the bridge.

Inchcolm is small, being less than half a mile long and looks like it is two unequal wild and rocky islands joined by a low and narrow neck of land. This lower area is an immaculate lawn on which stands just about the best preserved mediaeval abbey you are likely to see anywhere in Britain.

As we drew near to the island only the abbey's tower was at first visible beyond a low headland, but as this was rounded and we turned to approach the landing stage the whole complex of buildings was revealed, making for a magnificent and picturesque prospect.

You do not need to be an expert on such sites to realise how well preserved these buildings are; for instance, the cloisters and chapter house are still roofed. Their remarkable survival is put down to the island's sea-bound location, although at only a mile and a half off the Fife coast near Aberdour and within sight of Edinburgh it's hardly isolation of Crusoeian proportions. Presumably though, such isolation is enough to have made stone robbing a difficult operation in the days of oar and sail.

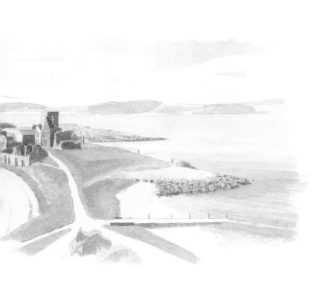

In the last century the island was heavily fortified to provide protection for Edinburgh and the naval base at Rosyth, but even these buildings are in ruins after a half-hearted attempt to demolish them in the 1950s and 60s. Had they been left intact they would no doubt be another popular attraction; those that survive are not considered safe for viewing and by their nature are visually unobtrusive, preserving the abbey's sense of isolation.

Inchcolm's first permanent inhabitant is thought to have been a hermit associated with St Colm (or Columba) from where the island derives its name (Inch being a Celtic word for island) and the reason for it sometimes being called the Iona of the east. Today the only inhabitants, apart from the seabirds, are the couple employed as the island's stewards by its owners, Historic Scotland.

They live a very different life, although if the excellent guidebook and my fellow travellers were anything to go by, their life still includes being invaded by the English. Unlike the hermit they have one day a week away, when they return home to Fife to perform the routines imposed by modern living: supermarket, dentist, optician...

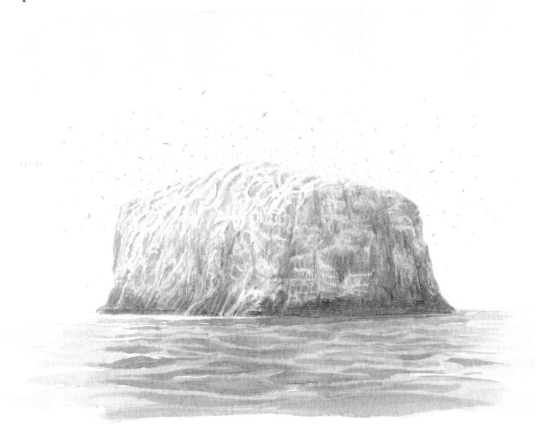

Bass Rock from the south east

> In the days before sprung mattresses, it took the feathers from 300 gannets to stuff one feather bed.

Bass Rock has its faults (almost slicing the island in two forming a cave that can be canoed through from the north side to the south), but being dull isn't one of them.

Looking out from the beach at North Berwick on a sunny summer's day it shimmers off-white on the horizon like a misplaced iceberg, but that is only its ethereal summer plumage. Naturally it is an almost black basalt.

Unlike its several nearby cousins, Berwick Law and Edinburgh's Arthur's Seat to name just two, this volcanic plug (what's left after the cone of ash has eroded away) is in the sea, making it about as 'des res' as anywhere could possibly be; if you are a gannet that is. Bass Rock is so closely associated with the largest of European seabirds that it forms part of its latin name *morus bassanus*, being the site of the first known gannet colony in the world.

A breeding pair produce one chick a year, and in the spring every gannet that has made it through the winter returns to the exact location of its birth to repeat the cycle, so as you can imagine over time (the Bass colony has been known about for a thousand years) the numbers have increased a little. At present this piece of rock measuring a mile in circumference and a hundred metres in height is home to about one hundred thousand breeding pairs.

From North Berwick harbour an open boat takes you on a one and a quarter hour trip around the rock to view this spectacular sight at close quarters. If you prefer the dry land approach there is the excellent Scottish Seabird Centre at the harbour, where you can control powerful zoom cameras sending back live pictures from Bass, and also from the Isle of May.

The scale of Bass is not easy to take in from the shore (it is two miles out), but it certainly became evident as the boat drew nearer to the rock, the air thick with the huge birds wheeling overhead in increasing numbers.

As the west side of the rock was reached we were taken close in to see the birds at close quarters. I gasped in amazement at the precarious nesting sites, crammed onto to every vaguely horizontal surface; no wonder the island takes on the gannet's hue for the summer.

Slowly we encircled the rock clockwise, passing the fault lines where erosion has created a massive vertical cleft (which appeared to be supported by great natural buttresses of columnar rock that have become avian tower block tenements) and craning our necks to look up at the places where the cliff face projects beyond the vertical.

This is Mother Nature at her most impressive and elemental, a truly unforgettable experience.

Lindisfarne and the Farne Islands

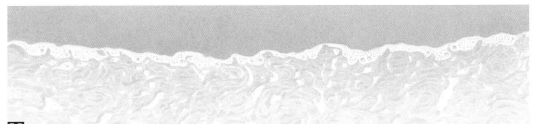

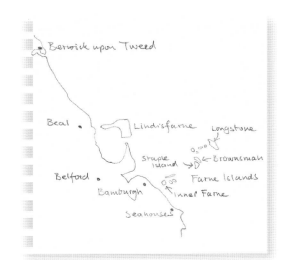

The erosion-resistant Great Whin Sill sweeps in an arc across northern England, a line of crags and cliffs utilised by the Romans as the natural fortification on which they built their own wall and which forms a spectacular setting for Bamburgh Castle. Its offshore outcrops, where even the grim North Sea has been unable to batter down its ramparts, are Beblowe Crag on which the homely Lindisfarne Castle stands, and, most easterly, the Farne Islands.

Lindisfarne is very definitely an island, at least some of the time, but you could almost see it as a long, low, sock-shaped headland that has had its toe of dunes washed away and is waiting to have it blown back by the wind to be darned with marram grass.

The road to Lindisfarne leaves the A1 on a hill, descends to cross the main east coast railway line, on between the stone buildings of Beal Farm, skirting fields of barley before reaching the causeway, where a straight tarmac strip stretches out for a mile across tidal sands that become the seabed for about two hours before and three hours after high tide.

Before reaching solid ground the road runs in a two mile curve around the southern fringe of dunes that form the island's western extremity, then a short rise brings visitors to the car park north of the village. The road sign reads Holy Island, a name not unique in Britain to this one.

The approach of cut-off time used to signal a mass exodus of visitors, but that's not so marked today as more people stay to enjoy the relative peace brought by isolation and true island status.

Lindisfarne attracts a wide variety of visitors beyond the merely curious. It is a National Nature Reserve, has something of an industrial past and, most significantly, was for centuries a cradle of civilisation.

The latter is well documented and too extensive to do justice to here, but briefly, here goes anyway. An Anglo-Saxon monastery was established in 635 by St Aidan when, in the days before a united England, Northumbria was its most powerful kingdom. St Cuthbert became Bishop in 685 and after his death his life was commemorated by the creation of that masterpiece of mediaeval art, the Lindisfarne Gospels, now gone the way of all good things that belong elsewhere, to London.

Slaughter and plunder interrupted the monastic life in 793 when the first recorded Viking raid on the British Isles took place. After further raids the site was abandoned in 875 and St Cuthbert's body, apparently still free from decay after 200 years of burial, was removed to the site on which Durham Cathedral was later built.

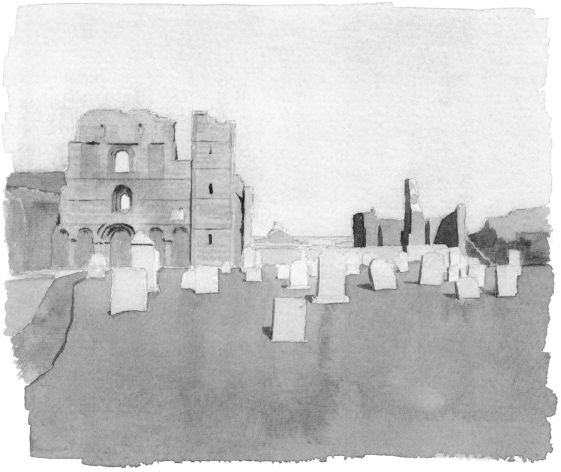

Lindisfarne Abbey

In 1082, a decade before the foundation of Durham, a new Benedictine priory was begun in memory of St Cuthbert and it is the ruins of this and later monastic buildings that we see to the south of the village today, suffering the fate of all at the Dissolution of the Monasteries, but still attracting pilgrims and the greater number of the island's present day visitors.

The local red sandstone of the 1082 building has not weathered well. The rich Romanesque detail has lost much of its crispness. Yet those familiar with Durham might be able to evoke its former glory by imagining the magnificent cathedral standing in the place of today's ruins.

Across the harbour, sitting sturdily astride its crag is Lindisfarne Castle, built originally with stone taken from the abandoned priory. The castle dates from late Tudor times and was a border fort, made redundant when James VI became James I. It then went on to serve three centuries as an outpost of Berwick Barracks before being abandoned after a short time as a coastguard lookout.

Abandonment and dereliction are, apparently, what many visitors expect to see, and they are somewhat surprised when they arrive in the entrance hall. Here I have to admit to a degree of smugness, as I knew what this building had become and had looked forward to this moment with a great deal of anticipation.

Lindisfarne Castle is now an Edwardian country house, converted as a holiday home for Edward Hudson, founder of *Country Life*, in his 'spartan romantic' style by Sir Edwin Lutyens. He was an architect of genius so highly thought of that when he died in 1944 the architectural press bore black borders as if mourning the loss of the King.

Although quite plain inside with whitewashed walls, exposed stonework and patterned brick floors, the castle, helped by its small-scale rooms, feels warm and welcoming with some great views and clever touches of detail to keep you absorbed. The sturdy Durham Cathedral-like columns in the entrance hall are a neat historical allusion.

A confession: I try to experience all of my professional journeys as anyone else would, hoping to demonstrate how easy it is to enjoy these amazing islands around our coast. However, I have two very good friends in Berwick who work here and they fixed it for me to meet Bill, the man who had been looking after it for the National Trust for more than a decade. So, four days after I visited incognito, I went back on the day they are closed to the public, saw the rooms you don't get to see, and we sat at the kitchen table for a couple of hours drinking coffee and chatting about life on Lindisfarne.

This was the first island on my current travels to be a normal working

Lindisfarne Castle

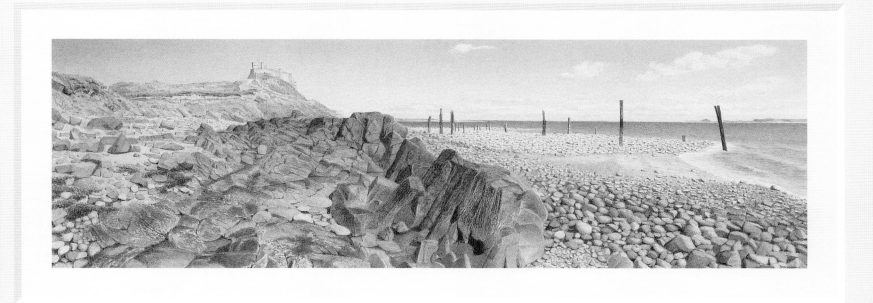

community with a village not unlike many on the mainland, easy to relate to and not difficult to imagine living in.

It soon became clear to both of us that my main concern would be the isolation brought by high water. You get used to fitting the supermarket trip around the tides, but what about emergencies? He was from the mainland and acknowledged that his wife had that problem. What if there was an accident and she was needed to look after a grandchild? I put the what if someone needed to be rushed to hospital at high tide? question. That's easy, the air ambulance comes up from Blyth.

What if there is a fire? There's a fire station with a tender but no crew. There was a retained crew, but when the service needed to 'rationalise' it came down to losing one at Belford, Berwick or Lindisfarne. If there's a fire a tender from Belford or Berwick goes to the causeway and an RAF rescue helicopter flies up from Boulmer, collects the crew and flies them to Lindisfarne. The island's tender is not allowed off in case its return is prevented by the tide, and if there is a fire . . .

To finish, a question you're all probably wondering about; is the castle haunted?

A decorator touching up the whitewash one closed season heard the sound of marching feet, at first thinking it something on a radio until the sound grew louder. The shadowy shape of a figure passed down the passageway where he was working. He drew it and it was identified as a seventeenth century soldier from Berwick Barracks.

The Farne Islands vary from 15 to 28 according to the tide, and are an inner and an outer group between one and a half and five miles offshore. No one lives here permanently anymore. There have been monastic communities (St Cuthbert lived on Inner Farne) and several lighthouses, two of which still operate, but since 1925 the islands have been owned by the National Trust which manages them to protect the precious seabird communities.

One thing I had already learned is that people go mad for puffins. I prefer mine braised Faroese style, but most people seem content just to see one waddling about a cliff top.

Studying my fellow passengers as we boarded the *M.V. Golden Gate*'s trip at Seahouses I had the impression that most were here mainly for that purpose. I am sure that for some there was a 'because it's there' motivation and there were a few who looked as if they were dressed more for an afternoon swanning around Marks and Spencer, but I think that if I'd shouted out 'What do we want?' their instant response would have been 'Puffins!' 'When do we want them?' 'Now!'

Well we didn't have to wait too long. Nothing needed to be said, just one agitated person pointing was enough to bring everyone to hysterical detonation point.

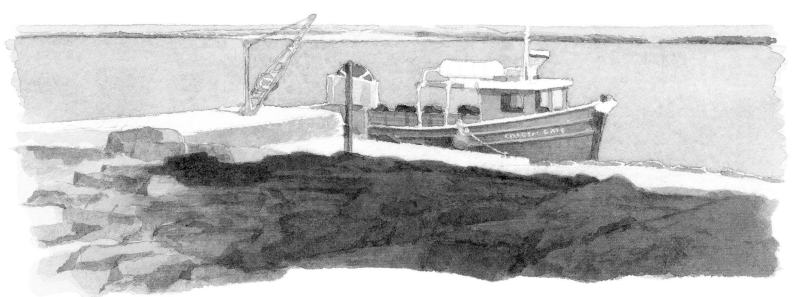

Golden Gate at Longstone
with lighthouse shadow

Sure enough, in a blur of wings a plump black and white body (you stuff them with a seasoned cake of breadcrumbs and dried fruit) cruised past at low level, arrow-straight and with a purpose, a catch of sand eels gripped in its jazzy beak. Soon another, then another, and before long the air was full of the chubby chappies, occasionally swerving to avoid a collision (just serve with new potatoes). We hadn't yet made land, but these shooting stars had already made our day.

After a pause alongside The Pinnacles off Staple Island, a line of magnificent stacks with flat tops packed with guillemots, we landed on Longstone, once the home of Farne's most famous inhabitant, of whom *The Times* wrote: 'Is there in the whole field of human history, or of fiction even, one instance of female heroism to compare for one moment with this?'

Grace Darling was ten when her parents moved to the newly built Longstone Lighthouse where her father was its first keeper. Although modified since, that original 1826 tower is much as they would have known it, with their circular quarters one above the other, as you always envisage them to be but rarely are.

The isolation of their family life on this low, bare, sea-washed rock is unimaginable today, but this was their world, and the intrusion of being thrust into the limelight after her heroic rescue must have been as shocking and profound as it was unwanted.

The only way to see inside the building and to look out of the same window Grace did when she saw the *Forfarshire* wrecked on nearby rocks is to travel on the *Golden Gate*, as the Shiel family who operate it also maintain the lighthouse for Trinity House.

Another confession: Somehow they had discovered the purpose of my trip and wanted to help make it as memorable and useful a day as possible, and they did. Instead of returning to Seahouses I stayed on Longstone with Jack until the second trip came out, giving me the privilege and time to talk with someone who has an intimate understanding of these islands. Not only that, my Berwick friends had arranged with the National Trust's Farne Islands Manager for me to visit the warden on Brownsman, an island not open to the public, and I was taken there in the *Golden Gate* while the second party of the day toured the lighthouse.

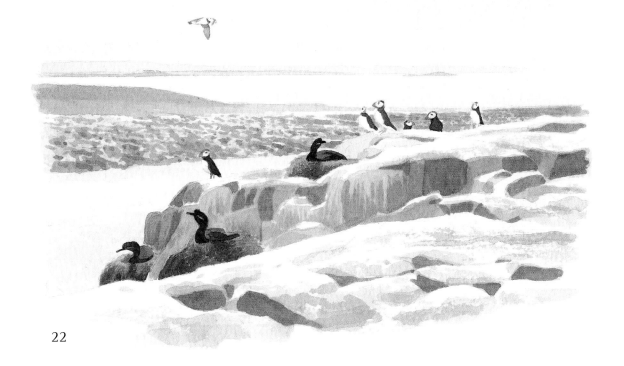

puffins and nesting shags,
Brownsman

Little did I realise as I stood with Jack on the gallery outside Longstone's lantern room gazing out across the islands that I was about to have the most extraordinary experience of my life.

Brownsman is a flat island of coarse grass and bare rock, with a ten metre cliff as its southern coast. Close to the landing stage the cliff face was packed with guillemot, razorbill, shag and cormorant; the stench was overwhelming. The warden's cottage, built alongside the remains of the Darlings' previous lighthouse, is reached via a duckboard path that enables the island to be crossed without crushing any puffin burrows (each one is an arm's length into the ground and divides into two, providing a nursing/feeding room and a lounge/bedroom).

Around the cottage a colony of Arctic terns nested on the ground. They lay their eggs anywhere, even on the path and you have to watch every step to avoid treading on eggs or chicks. These are beautiful birds that become understandably aggressive when defending their young. Their bills are described as blood red in colour and I now appreciate why.

I was warned to wear a hat and survived the walk to the cottage reasonably well. Once inside I had an interesting hour or so with the warden and his temporary helpers who were there principally to count the birds (34,500 pairs of puffins alone). Life here is somewhat rustic, but I could appreciate its charm and it was heartening to meet a group of young lads who wanted to do this with their lives, a real 'restoring faith in human nature' experience.

After a while I felt I should be outside. Have you seen the Hitchcock film *The Birds*?

Looking out from the doorway, all was terns; they sat, fluttered and stared. Stepping outside roused them into taking to the air and shrieking. Unlike gulls they can hover, enabling them to defecate with great accuracy and to give you a nasty jab on the head with their long, scalpel like bill, injecting into the bloodstream a mixture of sprat remains and whatever lines their and their chicks' mouths. Each attack is announced with a vigorous and disturbing clicking sound.

The bombardment probably lasted only two minutes, but at the time felt much longer. It wasn't until I later mopped the sweat from my brow that I discovered it was in fact blood. My hat, once dark blue, was now white outside and reddish brown inside. What a trophy. Later reports suggested that no one on the islands can recall anyone else experiencing such a vicious and sustained attack. Now what should that tell me?

Later, back in Berwick, a first; never before had I sat down to a meal with friends having first been hosed down with TCP.

Scolt Head

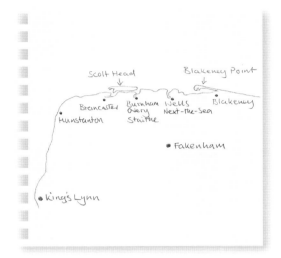

Believe it or not there's a footpath from my house in Wiltshire to Scolt Head. Well, almost.

Out of my studio window I can see the wooded combe on the north side of Morgan's Hill, a rounded chalk prominence that is the high point marking the western edge of the Marlborough Downs. There is a trig point indicating its height as 260 metres, hardly alpine, but not bad for southern England.

Along the northern escarpment of the Downs, roughly on a southwest – northeast axis runs the Ridgeway, a long distance path that dates back to about 2000 BC and is thought to be Europe's oldest road still in continuous use. The Ridgeway crosses southern England following the chalk through the Chilterns as the Iknield Way to their last major outcrop at Ivinghoe Beacon (249 metres). Beyond Ivinghoe the chalk looses its stature, no longer a noble bare plateau but a wooded lowland, distinguished from neighbouring lowlands by the wild plants that can tolerate its lime-rich soil.

Eventually the band of chalk reaches the North Sea where it is the bedrock of the Norfolk coast between Hunstanton and Blakeney, barely noticed as it slips gently beneath the waves under the ridges of dunes that mark the ever shifting boundary between land and sea along this stretch of coastline. One such dune system is detached from the rest and we call this the island of Scolt Head.

Scolt Head is just about the last bit of wilderness left in England, so as you can imagine it is treated as something special. The National Trust and Norfolk Wildlife Trust are the joint owners, but it is managed by English Nature, who lease it from them. None of these bodies promote it in any way; they would rather we didn't go there and, I have to say, I feel guilty even mentioning its existence. Go to nearby Blakeney Point instead; it's very similar, you don't need a boat to get out to it and in addition there are seals, a tearoom and toilets.

Incoming tide, Scolt Head, Norfolk

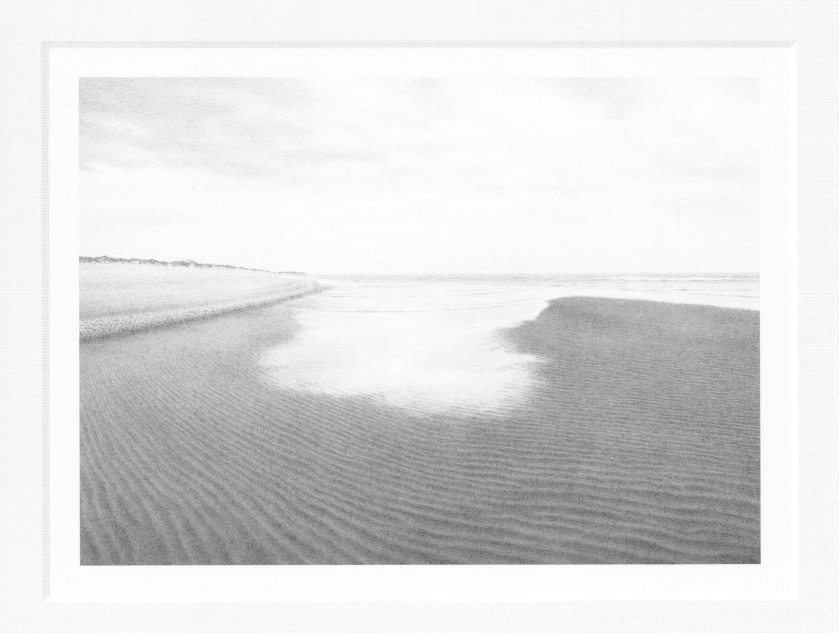

Scolt Head is reached by boat from the village of Burnham Overy Staithe, or if the tide is particularly low you can take your shoes and socks off, roll up your trousers and wade out to it. You'd save yourself the £4 ferry charge, but then you'd miss talking to Gary who operates the boat. Standing at the water's edge and hearing his views on shellfishing, access to the island, incomers and life in general, as he stares out to sea squinting in the bright sunlight, was like being in the presence of a nautical North Norfolk Clint Eastwood (minus the poncho and with a boat instead of a horse) and worth every penny.

Unfortunately we had time to kill. It was going to be one of the lowest high tides of the year and as it began to rise it struggled to make headway against the flow of the River Burn, arriving more than an hour later than predicted.

A small expectant party had gathered on a warm Sunday afternoon in late September for what was possibly the year's last trip out there. Eventually there was just enough water to float the boat, we all clambered aboard and set off on our twenty-minute meander downstream through the saltings. The occasional grazing of the riverbed brought nothing more than a languidly raised eyebrow and a faint smile to the face of our laid-back ferryman. No problem, everything was just cool.

Nelson was born not far inland from here at Burnham Thorpe, and it was an intriguing thought that we might have been recreating one of his earliest waterborne journeys.

Like Gary, Scolt Head's calm appearance is just a ruse to mask the dynamic activity that's going on in the background. This whole North Norfolk coast is about as dynamic as a coastline gets. English Nature describes this as a non-intervention reserve, where the natural processes are allowed to occur unhindered by man's usual meddling with the coast. Its low lying vulnerable appearance and exposed position might lead you to think that it is eroding, but it is actually being added to, slowly growing in a westward direction across the entrance to Brancaster harbour.

It is Britain's best example of an offshore barrier island, formed by sand and silt being deposited over glacial shingle; a four and a half mile long strip of dunes with

Gary manoeuvring in Burnham harbour

a wide sandy beach along their seaward side and saltmarsh along their landward. The island is used as an ecological study and teaching resource for schools and universities. In particular, the saltmarsh is considered to be the finest in Britain and is the best documented and researched in the world. The latest thinking is that the island is only about a thousand years old.

Gary deposited us on the beach at the eastern end and left us to explore for a couple of hours. No map, no signs, just miles of empty beach, high dunes and colourful marsh.

If I'd been here between mid-April and mid-August the opposite end of the island would have been closed off as it is a noted nesting ground for colonies of common, sandwich and little terns. To be honest, I've encountered enough for this year and seeing any more would definitely have been a tern for the worse, so I was rather glad to be here in that quiet period before the autumn invasion arrived. Dark-bellied brent geese were about to fly in from Siberia and as many as 75,000 pink-footed geese from Iceland and Greenland could be roosting here by mid-winter; that's more than a quarter of the world population.

It took a while for me to get much further than our landing spot as my attention was grabbed by the shells scattered on the sand, not so much by their quantity but the variety. In no more than a square metre I gathered the common versions of oyster, mussel, razor fish and whelk, and two I could not identify, one something like a slightly flattened cockle but mainly purple in colour, and a small blue and cream rectangular oyster-like shell with a surface of semi-circular terraces.

There was not sufficient time to walk the island's length and even if I had attempted it, either along the shore or the footpath that threads its way along the sometimes indistinct boundary between dunes and marsh, the scenery would not have altered much. Instead I tried to take in something of everything by walking westward along the beach for a while, where the rising sea had covered all but the last visible vestige of the island's fourth precious habitat, intertidal mud flats, then clambered over the dunes returning along their landward side via the path.

It is the breathtaking panoramic view from the top of the dunes in both directions along their ridge, out to sea and back across the marsh to Burnham Overy Staithe that enables the island's true nature and scale to be appreciated and understood, to see, in fact, that this is an island. Gary and I agreed that this is somewhere everyone ought to experience at least once, preferably while they are young enough for it to have some impact on their lives, but there's the paradox, would it then still remain a little bit of paradise?

> Scolt Head is separated from the rest of Norfolk by North Creek, through which the tide floods eastwards and ebbs westwards. The reserve can hold up to 25% of the UK's population of nesting sandwich terns.

Islands in the
Thames Estuary

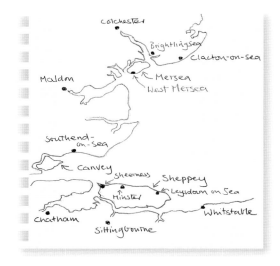

Superficially Mersea, Canvey and Sheppey are very much alike; low lying continuations of the mainland from which they are barely separated, each having its island status granted by a tidal creek that detaches it at high water.

Mersea (pronounced Mersey) Island is not even offshore, but sits back from the coastline between two tidal estuaries. The Colne is to the east and the Blackwater to the southwest and they meet south of the island before entering the sea united. Both have a tributary-like arm that join hands to encircle Mersea every flood tide.

The Strood, a raised causeway across saltmarsh, is Mersea's physical link to Essex. This was a route used by Romans and Saxons and now it carries the B1025 from Colchester. For about five consecutive days a month the road floods for two hours in the early afternoon. I have been told that it doesn't stop some motorists from making the crossing, including even the occasional local bus, the floor of which becomes a temporary paddling pool.

Beyond the Strood the island rises gently to nothing you could call a hill, with only the 10 and 20 metre contour lines to trouble the cartographers at the Ordnance Survey.

This is quiet arable country, with winding lanes between fields of cereals and oilseed rape. After touring the island twice to help me decide where I should start looking for a paintable subject, I settled on its less populous eastern side. I parked where the road fizzles out and wandered down a track and over a flood protection embankment that separates low lying meadows from marshy shore.

Having found just the spot I returned several times during my stay to view the differences brought by the changing light and tide, before settling on the golden glow of a late evening sun at low water. After spending so long in the company of seabirds it made a pleasant change to work to the accompaniment of something

Colne Estuary, Mersea Island

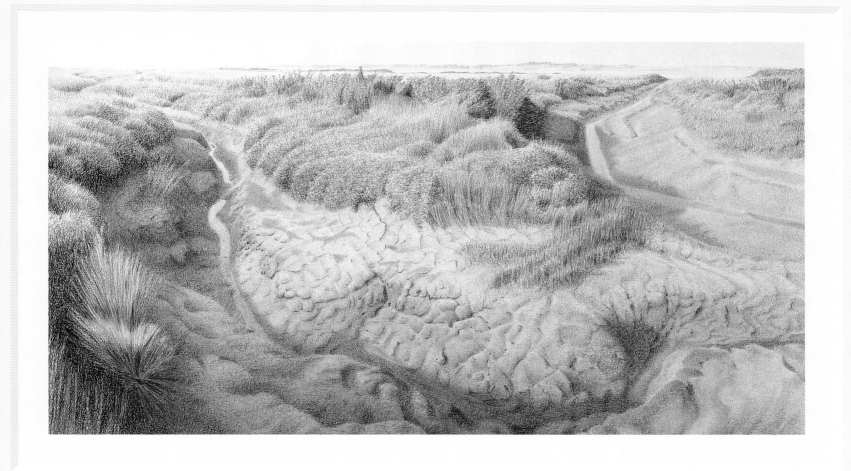

less insistent; the gentle sounds of reed warbler, skylark and lapwing, with the occasional cuckoo unusually as visible as it was audible. The peace was broken only by an emergency vehicle siren drifting across the Colne from Brightlingsea.

On my travels round the island I noticed the occasional roadside sign advertising a 'holiday park'. However, these have been so well hidden that, although I believe there are five such parks, I didn't see any.

Mersea seems to attract holidaymakers without going for them in an undignified manner. Presumably its peace and quiet and lack of the vulgar side of seaside England is its charm. One resident told me that most holidaymakers come from north and east London, recognisable by their accents. She called them Innits, from when she has overheard them in a shop queue saying to one another 'nice here innit!'

Tucked away on the western side of the island West Mersea is the small town where the majority of islanders live. A collection of quiet tree-lined suburban streets centre on an attractive old village green with a pleasant 'not up to the speed of the mainland' air about it. But it is west from here along the shore, Coast Road, where the island suddenly blossoms into something different.

The first sight of The Saltings, an area of saltmarsh that characterises the fringe of all these Thames islands, is enough to stop you in your tracks. It would be an otherwise unremarkable view if it wasn't for the picturesque collection of old residential houseboats that have been parked here (to say they have been moored would suggest they are in the water, which I doubt is the case).

Such boats have been here for more than a hundred years and some of the few mellow old ladies that are left bear the not yet unpleasant signs of decay. One of them, *L'Esperance*, which lists to port in a fashion that must make meal times entertaining, bears the date 1891 and once belonged to Semprini, the pianist who will be remembered by those of a certain age who can recall when Radio 2 was the Light Programme and Reginald Dixon played the Blackpool Tower Ballroom organ. It is a time that Mersea still manages to reflect well.

Mersea is famous for its oysters, and the remains of old oyster pits can be seen at the shoreline further along Coast Road. EU hygiene regulations have changed the nature of the process, but the unique combination of farming and hunting that prepares oysters for the table is still a significant part of the island's economy.

The Company Shed, once the headquarters of the Tollesbury and Mersea Oyster Company that first organised the local oystermen into a corporate body, is now a fishmonger and seafood café and, as I discovered, is itself enough for some to make that one hour trek along the A12 for a dining experience not to be missed.

> The Lobster Smack Inn was formerly known as Sluice House and World's End, and was referred to by Charles Dickens in *Great Expectations*.

Canvey sea wall at Haven R...

Diners provide their own accompaniments and drinks, the Company Shed supplies the seafood along with implements for breaking into it and Tabasco to spice it up.

On arrival a visit to the wet fish counter is necessary for reserving a seat. Being on my own, I was immediately invited to take a vacant place at an already occupied table, a good if guilty start enabling me to jump a queue of four.

One of those occasional strange coincidences then emerged. On my way to Mersea I had made a sentimental journey to the place at the other end of Essex, in east London, where I lived for eighteen months in the 1970s. Lo and behold, the couple I shared the table with had travelled from . . .

They had queued for three quarters of an hour, which made me feel even more guilty.

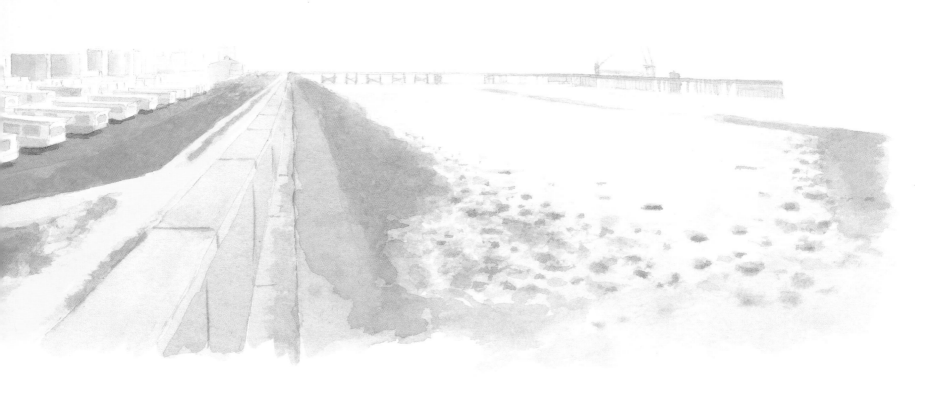

31

We chatted all through our groaning platters of mackerel, herring, oysters, crab, shrimps, lobster, mussels and more before they eventually asked if I was back to work tomorrow. Feeling yet more guilt I exclaimed 'this *is* work'. At this they almost choked on their cockles.

However, in life things tend to balance out, and so after leaving Mersea I made a detour to take another look at Canvey Island.

I first experienced Canvey on a dull wet winter's afternoon in 1976 and all I could recollect were some old makeshift-looking bungalows, veering towards the shabby and looking like relics from a frontier settlement. They were probably temporary holiday homes that had evolved into something more permanent, residentially if not structurally.

I had to see if they were still here and as I remembered them, but sadly, searched in vain. They would have made a wonderful subject for a painting. Presumably they had been demolished to make way for the new houses that are springing up. These are in the mock dolls-house style you can see anywhere in England from Carlisle to Carshalton which have no sense of place. At least the old bungalows showed a spark of originality.

I had wondered if my memory of the island had been influenced by the awful weather and that things might look better under the bright clear blue sky of early summer. Just as the weak glow of a low wattage bulb disguises the odd blemish, seeing it now was like turning on high powered floodlighting that accentuated every imperfection. I'm sure I must have been up and down every road on the island in an attempt to discover Canvey's elusive charms, but without success. As far as attracting holidaymakers goes Canvey is everything Mersea isn't.

Finally I tried the promising sounding Haven Road. This took me past 35 hectares of methane gas terminal and its attendant collection of storage tanks to the southwest corner of the massive concrete sea wall that keeps the sea at bay. Here there is, without doubt (or indeed much competition), the most attractive building on the island, the seventeenth century timber clad Lobster Smack Inn. At last I had found some original Essex vernacular. However, something about one swallow not making a summer came to mind.

Elsewhere, not so much a mediaeval gateway more a pair of gigantic concrete doorframes, was the Kingsferry Bridge, carrying across The Swale channel both the road from mainland Kent and the railway from London Victoria, which makes a passable attempt at providing a grand entry onto the Isle of Sheppey.

If you follow the flow of traffic from the bridge you will end up in the northwest corner of the island in one of its three towns, Queenborough, Sheerness or

> 66 Mersea is the most easterly inhabited island in Britain and has the largest inshore fishing fleet between Lowestoft and Brixham. 99

Minster Marshes, Isle of Sheppey

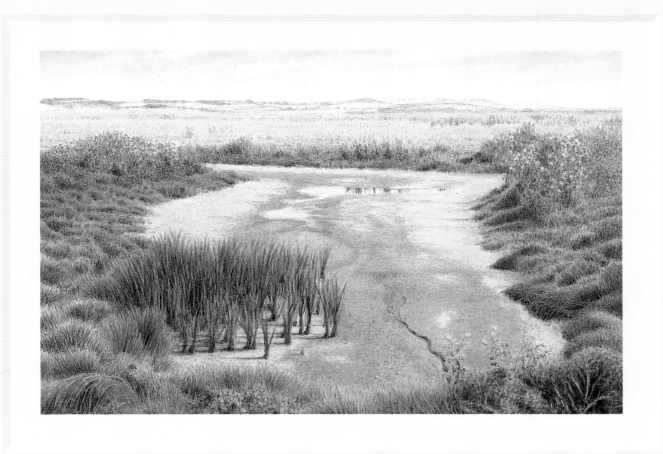

Minster. The old centres of all of these towns are fascinating places if, like me, you enjoy just mooching about, soaking up the atmosphere and finding some interesting buildings and attractive vistas that capture their essence or throw light on their past.

Queenborough and Minster are the more historic, but Sheerness has a particularly significant building, a scheduled ancient monument which is now hidden away in a corner of the commercial port that was part of the former Royal Navy Dockyard. It is a 150 year old iron framed boat store, the only surviving forerunner of the modern skyscraper.

Another surprising and unlikely historic association is celebrated further east along Sheppey's Thames shore at Leysdown on Sea.

Leysdown gives a good impression of being nothing more interesting than a small seaside resort, but among the sea of chalets and caravans is Leysdown Manor, the former HQ of the Aero Club of the United Kingdom. Here the bar which now caters for the holidaymakers is something of a shrine to the history-makers who once frequented the building, with photographs recording the events that took place, including the visit in 1909 of the famous Wright brothers.

From the Manor's grounds on May 2nd 1909 Aero Club member John Brabazon took to the air in the *Bird of Passage* for what is recognised today as the first ever powered flight in the United Kingdom by a British aviator. Consequently the world's first aircraft factory and the firm of aircraft makers, Short Brothers, were established at this unlikely location.

These man-made aspects to Sheppey are concentrated into the northern third of the island, but for me the most enjoyable and surprising find of this visit was the solitude and tranquillity to be found on the rest.

Off the road to Leysdown there is a lane, uneven, narrow and greatly patched, with the occasional passing place, which meanders out across low lying fields and marshland for four miles. There are no fences or hedgerows so the views are unrestricted. Sheep and cattle graze the marsh (brackish ditches and channels act as wet fences for stock control). Sometimes there is a view across arable fields to a distant barn, an isolated house, or a picturesque clump of trees, but above all there is no traffic noise, no whine of aircraft from Heathrow or Gatwick, just the call of the wild.

There is so little vehicular traffic the local wildlife seems unskilled at dealing with it. Small gangs of partridge charge excitedly along the road in front of you unable to decide whether to turn off this way or that and, not surprisingly, I'd never seen so many late pheasants at the roadside or so many flattened rabbits on it.

The lane ends at the hamlet of Harty, a few metres after taking you through a farmyard. There are a couple of cottages, an abandoned former school house falling into ruin, views out across the Swale and along the Kent coast to Whitstable, the most perfect little early Norman church... and silence. This was like discovering somewhere forgotten. Remote and isolated it was most unexpected so close to London. What a delight! Has anyone here thought of twinning with Hayle in Cornwall I wonder?

Part of the marsh not far from the Kingsferry Bridge is the RSPB's Elmley reserve. Their visitor centre at Kingshill Farm is a good place from which to begin a day's walking if you want to experience the solitude of the marsh but are not sure what you should be looking out for.

There are also two National Nature Reserves within the marsh, but on the day of my departure I was privileged to spend the morning looking round a reserve you won't find any reference to... yet.

My fortunate choice of accommodation on Sheppey brought me in contact with a most remarkable man. I'm sure we all have one of those occasional 'wouldn't it be nice to...' thoughts. Well John, along with his late wife Wendy, a mammal ecologist with a strong interest in environmental education, turned his into reality.

Starting with a derelict cottage in a hectare of smallholding, they slowly acquired surrounding fields and three hectares of neglected coppice and have, over a period of nearly thirty years, planted four and a half thousand oak and ash saplings and developed their dream into an impressive area of woodland, hay meadow, hedgerow, scrub and ponds. This, however, is not a mere extension of their private domain. Local people are invited to their creation, to enjoy and learn, and school parties arrive by the coach load.

At the time of my visit work was underway to convert a barn into a wildlife and countryside study centre with accommodation, where people can get an ecological perspective on the countryside, staying for a short course in wildlife studies, organic growing, animal husbandry or to learn some rural skills.

When it has become so common to see Private Property Keep Out signs littering the countryside, it's heartening to find someone determined to take us in the opposite direction in a totally altruitstic way, to share their passion and show that life can be so different – if we want it to be so.

Yet again my faith in human nature had received a restorative boost. Maybe I should consider moving offshore.

Harty Church

Portsea

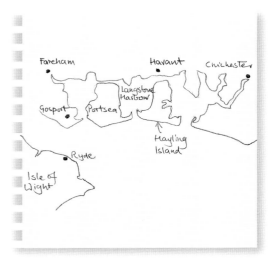

Two low lying islands, Portsea and its easterly neighbour Hayling Island, sit in the marshy basin between Fareham, Chichester and the English Channel. Their southern shores continue the line of shingle beaches that are characteristic of this part of the south coast of England.

The channels and creeks to the west, east and between the islands form three large natural harbours and their narrow entrances effectively make them sheltered tidal lagoons. Until the nineteenth century these were all working harbours with small fishing fleets stationed at the villages around the marshes. Today they are popular leisure boating centres, particularly the two easterly harbours, Langstone and Chichester, with their many marinas and small boatyards.

The harbour to the west of Portsea, however, has remained predominantly a working one. The settlement that has grown over the centuries to service it, although in many ways unremarkable among its peers, has an historic waterfront and a unique place in British history. This settlement has so overwhelmed Portsea that it has effectively taken over the island's identity and today most of us refer to this place only as Portsmouth.

The presence of its extensive Royal Navy dockyard made the city a prime bombing target during World War II and as a result Portsmouth has more mediocre modern buildings than the residents of such an historic city should have to put up with. To make up for it the area around the waterfront, Old Portsmouth as it appears on the brown road signs, is a beautifully restored and preserved area reminding us how attractive parts of this city once were. It is an example from which modern developers can take inspiration.

Not knowing quite where to start as this was my first visit (something of a major lapse on my part, I am ashamed to admit) I joined the early morning rush

Portsmouth's Kingston Prison is Britain's first to have a wing with dedicated facilities for elderly lifers and as such is the only prison in the country to be equiped with electric stair lifts.

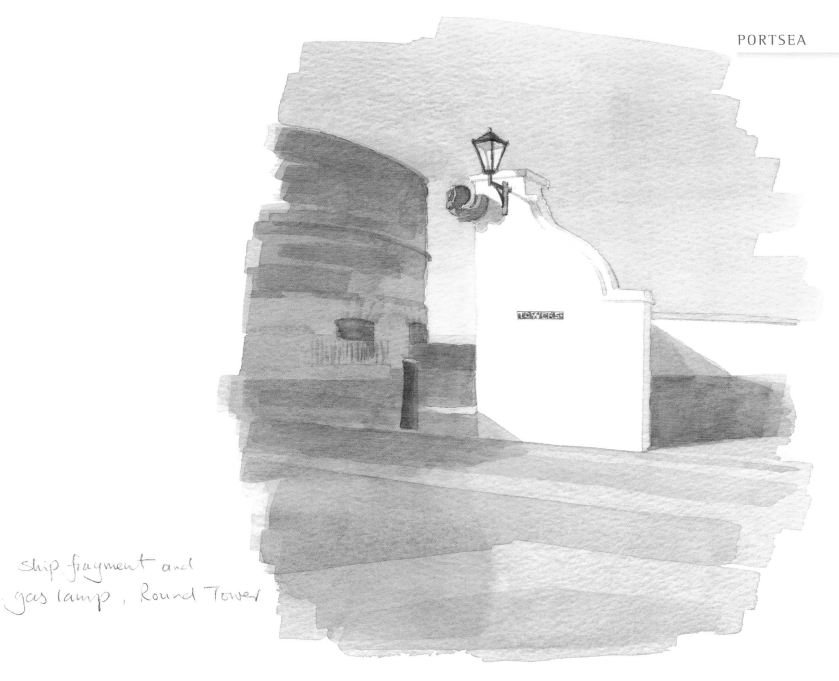

ship fragment and
gas lamp, Round Tower

hour (not my usual island experience). I followed the brown signs and eventually parked next to the sea-front battlements that link Square Tower (mid-fourteenth century) with Round Tower (early fifteenth).

After the frenzy of the city centre traffic I found myself almost alone, save for two beachcombers armed with metal detectors and a binoculared warship-spotter on lookout duty at Round Tower.

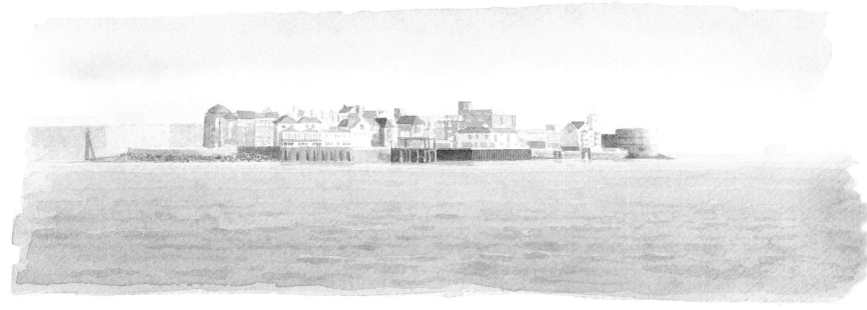

Spice Island - from the harbour tour boat

This is the beginning of a small peninsula of land guarding the old harbour entrance and is known as Portsmouth Point (or sometimes Spice Island). This once notorious area used to be where the press gangs operated, 'enlisting' their drunken victims into the navy. One moment they'd be enjoying a tankard of ale in a tavern, the next they would wake up not only aboard ship but already at sea. Now it is a pleasant area where the streets are cobbled (one of which is still set with tram lines), many of the buildings are timber frame and many plaques point out the historical associations.

The first I encountered was at an opening in the battlements that stated 'The Old Sally Port. From this place naval heroes innumerable have embarked to fight their country's battles. Near this spot Catharine of Braganza landed in state on May 14 1662 previous to her marriage with Charles II... It was also here in 1787 that the first convicts to be transported to Australia embarked'.

Nearby another plaque tells that 'From Portsmouth on 26th April 1587 sailed 91 men, 17 women and 9 children as the second colony sent by Sir Walter Raleigh to the area then called Virginia, now North Carolina. There on Roanoke Island they built the 'Cittie of Raleigh', the first English village in America. On 13 August 1587 they baptised the Indian Manteo. On 18 August 1587 was born Virginia Dare, the first child of English parents born in The New World...'

Naval heroes still pass this spot aboard their warships and their families come here to wave them good-bye, but most of the civilian passengers embarking from the nearby quays are bound for the somewhat nearer Isle of Wight or France.

On the other side of The Point close to where the Isle of Wight car ferries tie up is Camber Dock, Portsmouth's first harbour. Fish are landed here now, but in 1585 Sir Walter Raleigh landed Britain's first consignment of tobacco and potatoes.

It is difficult to think of Portsmouth as anything other than the organisation that has effectively taken over the city's identity, the Royal Navy. Or, indeed, to disassociate it from one ship that can only be thought of in terms of one man, and both only in relation to one momentous event; *Victory*, Nelson, Trafalgar.

In the part of the naval dockyard to which the public are allowed in order to view *HMS Victory* there is a reverence and a profound sense of awe among the visitors that is usually confined to a war grave or a great cathedral. This is an indication that this is not just an old warship, but also a powerful monument to a great moment in history.

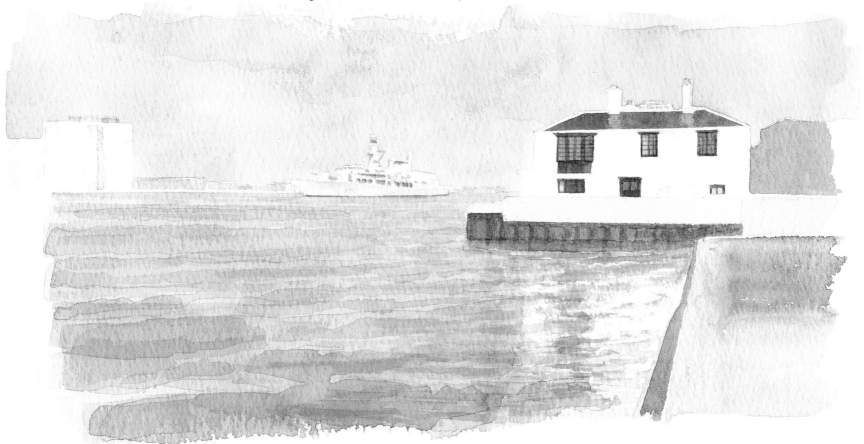

Quebec House & HMS Kent, Portsmouth Point 39

Victory is also Portsmouth's icon, and it seemed somehow disloyal to the city, as well as to my sense of history and of what it is to live on these islands, to come here for the first time and not take the official guided tour of the vessel. So there I was on an unusually warm late March day squinting in the bright sunshine as I gazed up into the rigging of this extraordinary ship with, on this occasion, the recently re-fitted aircraft carrier *HMS Invincible* berthed close by as if there to make a 'this is how we do it now' comparison.

Victory lies in a dry dock (the first one in the world was constructed nearby in 1496) and is therefore viewed as if afloat. If she were a building, an estate agent might describe her as 'deceptively spacious'. However, buildings from *Victory*'s time – work commenced in 1759 – continue to look modern and elegant and be spacious and serviceable (there are some good examples in the surrounding naval dockyard). The eighteenth century is a golden age for modern house builders to aspire to, but you don't need to glance across at *Invincible* for comparison to see that warship design has moved on somewhat since then, functionality taking over from elegance.

Below deck is not the most ideal place for claustrophobia sufferers, or for anyone taller than the average twelve year old. Conditions are cramped, and the lower decks are dark and filled with cannon and the paraphernalia for keeping them firing. Between the guns are the trestles where the sailors ate and the hammocks where they slept. You see the round mahogany table where Nelson sat on the morning of Trafalgar, where he fell when shot and the spot on the lower hospital deck where he died. You are filled with facts; 6,000 oak trees felled to build her, Nelson's Column in Trafalgar Square the same height as her main mast, here a cat of nine tails with no room to swing it, there a rectangular wooden plate off which the men ate their 'square' meals, daily alcohol ration 8 pints of beer, 2 pints of wine or half a pint of rum.

It's all brilliantly done, vivid and at times a little frightening even, but what would it be like rolling in a force 7 with the guns blasting away and the sweet aroma of 820 sailors I wondered? Perhaps one day that is an experience for a simulator (tour optional, I hope).

Apart from the historic waterfront and the presence of the Royal Navy, Portsmouth on the whole is much like any other city of its size, with hectare after hectare of traffic-laden suburbs and the clamour of ugly road signs. To the north only the narrow channel of Port Creek separates the island from mainland Hampshire, bridged by just three roads and a railway, but it is nevertheless enough to give Portsmouth the distinction of being Britain's only offshore city, confined

Victory is still a commissioned vessel as the flagship of the Commander-in-Chief, Portsmouth – making it the longest serving ship in the world.

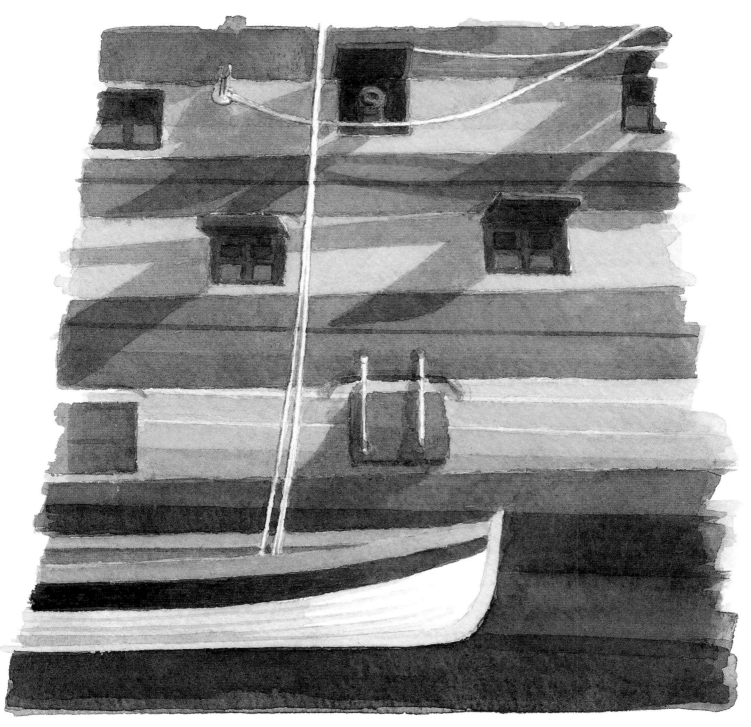

HMS Victory – starboard side

within its watery boundary to make it the most densely populated borough in England outside of London.

Nevertheless, the island is not packed solid to the water's edge with unrelenting urban sprawl. Immediately to the east of Old Portsmouth a wide, mile-long grassy common separates the suburb and resort of Southsea from the shingle beach along Portsea's southern shore. It gives it an air of genteel dignity you don't find everywhere on the south coast and provides the city with a long and largely unspoilt and uncluttered promenade away from the drone and fumes of the city traffic.

I decided to follow the shingle eastwards from here to Langstone Harbour where I discovered a semi-rural world of grassland and marshy foreshore that continues north along much of Portsea's east coast, albeit overlooked by houses and blocks of flats. You never quite manage to get away from the city altogether.

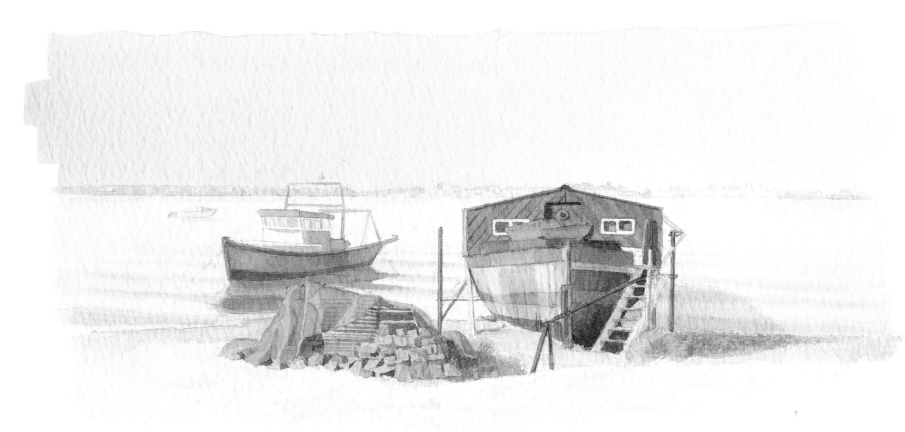

Houseboat, Langstone Harbour.

At Portsea's southeast corner the shingle beach ends as a narrow spit projecting into the harbour, where there is the boathouse of Portsmouth's RNLI lifeboats and the pontoon where you can catch the ferry for the short ride across to Hayling Island. It runs once an hour, but every 20 minutes between 7 and 9 am. There's just no getting away from the rush hour, even here.

The harbour is the domain of the black headed gull and expensive yachts, and home to a small but curious collection of bohemian houseboats that look barely capable of functioning as either houses or boats; they are about as far removed from the sophistication of the vessels on the other side of the island as you could imagine and provided a welcome lack of conventionality.

Apart from being numbed by the traffic I had been pleasantly surprised by Portsea, had seen a few things not the average everyday sight (a nineteenth century battleship moored next to a bus station for instance) and had left a few lines of enquiry open for another visit. This time, as these travels are about islands, it seemed sensible to concentrate on Portsea's unique maritime history (did I mention that Isambard Kingdom Brunel was born here?), but I could easily have filled my time looking at it from a literary viewpoint.

For instance, did you know that Charles Dickens was born here? His father was a clerk in the Navy Pay Office and their house at 393 Commercial Road (then 1 Mile End Terrace) is now a Charles Dickens Museum. They moved to London in 1814 when Charles was only two, but he returned in 1838 to gather some local colour for *Nicholas Nickleby*.

H. G. Wells served two apparently miserable years (1881–3) in Southsea as a draper's apprentice, which is reflected in the early part of his novel *Kipps*.

Sir Arthur Conan Doyle set up practice as a family doctor here in September 1882 and it was here that he conceived the character of Sherlock Holmes (for *A Study in Scarlet*), although he was based on Dr Joseph Bell under whom Doyle had studied at Edinburgh University; Dr Watson was inspired by the President of the Portsmouth Literary and Scientific Society, a real life Dr Watson. You may have been aware of that already, but did you know that he was also one of the founder members of Portsmouth Football Club and was their first goalkeeper? I could go on to say that they are the only league club to play off the mainland, but I think that's going a little overboard with the 'only…on an offshore island' theme.

Portsmouth was the home of Jonas Hanway, the eighteenth century inventor of the umbrella.

One good thing about the ugly road signs I complained of; when the time comes to leave, every major junction has a small sign indicating the direction 'out of city'. What they really mean to inform us is 'off the island', but that may confuse those visitors who were not already aware they were on one. Most of the time you just cannot tell.

43

Isle of Wight

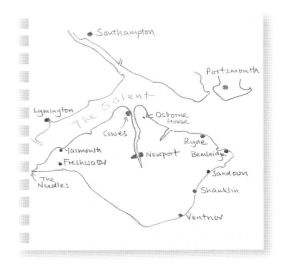

Some of my neighbours, like me, are fortunate enough to live in houses built almost entirely with what is generically known as Bath stone. It is a good quality limestone, not as good as Portland stone (of which more later), but warmer in colour. My less fortunate neighbours have houses built mostly with a local limestone which was once quarried within a stone's throw of my studio. Not that I'm in the habit of throwing stones from my studio. I only do so when jackdaws attempt to nest in one of the chimney pots.

This local stone is a bit on the crumbly side and was best burned in a limekiln to make lime for mortar. As a consequence most of these houses have over time been rendered and/or painted for their protection. The paint colours chosen are usually variations of beige or grey to approximate the colour of the stone, maintaining a degree of harmony amid their variety.

One house, however, apparently inspired by the owner's visit to the Isle of Wight, does not conform to this sensitive individuality.

On my visit to the island I looked out for the houses that might have stimulated this aberration, but came to the conclusion that pink is not a popular colour here either.

Working on the coast has many pleasures and the occasional drawback. The latter is usually crowds of other people so, if I cannot avoid them completely, I try to avoid visiting holiday destinations at peak season. However, the Isle of Wight is such a good example of a holiday destination (it seems to me almost impossible to find anyone in England who has not been there), it made sense within the context of these travels to break my unwritten rule and visit it in season to get the proper Wight experience.

When precisely this was to be was entirely down to Rick Stein.

Hanover Point, Isle of Wight

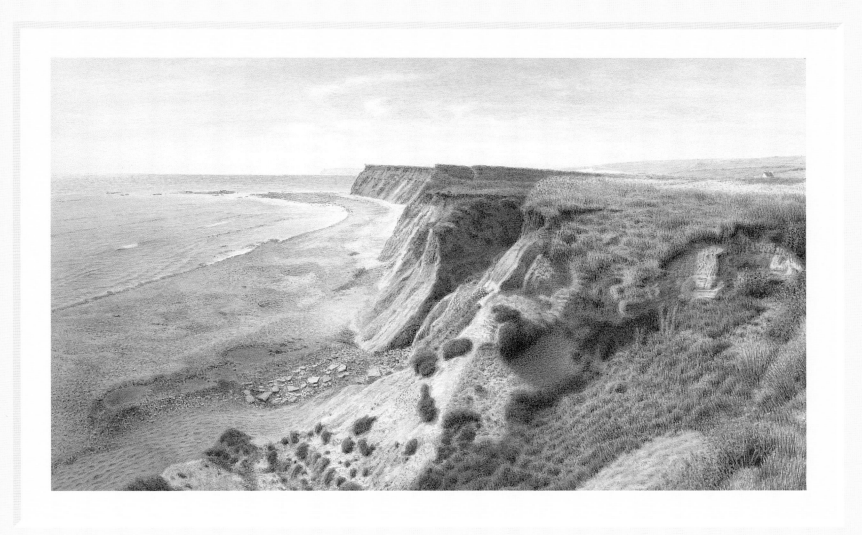

In my household the almighty Rick is greatly revered. He can do wondrous things with fishes... and loaves too no doubt. Whenever I'm about to embark on my travels his *Seafood Lovers' Guide* is always consulted for guidance on where to eat in the locality. On one of his Food Heroes television programmes he visited the Isle of Wight Garlic Festival, so from that moment the die was cast; I just had to go there and experience it for myself.

The Festival – a cross between an oversized village fête and an agricultural show, with lots of garlic instead of the livestock – is only on for one weekend in late August. So, as befits Rick's venerated position, I thought it appropriate that if I was to walk in his footsteps I should go unto the Garlic Festival on the Sunday.

Incidentally, whenever his dog Chalkie appears on screen the name Snowy always springs to mind, but I am thinking of Tintin's dog, and of course Rick Stein could not be Tintin... he's Captain Haddock.

After a 30 minute crossing of the Solent from Lymington to Yarmouth I made my way across the island to a field near Newchurch in the rural heart of east Wight and became one of the 25,000 people who were at the Garlic Festival that weekend.

I have become so used to visiting the coast out of season and regarding it solely as my place of work, that it felt strange at first to be amongst hoards of people who were here just for the fun of it. Being the observer, constantly on the lookout for the next painting or something to write about, I have, I think, lost the art of relaxing and joining in, but here it was thankfully unavoidable.

Thus, and not just in the interests of research, I sampled some of the garlicky delights on offer in the garlic marquee. Here you can get carried away on a tide of all things garlic.

There was some of extraordinarily unusual garlic-laced fare: moules and crusty buttery chunks of baguette of course, but there was also garlic ice cream. This also contained apricot, orange and ginger – very nice, not too sweet. Garlic beer was something I was particularly keen to try. It was a slight disappointment. I suspect garlic was not used in the brewing process, but had merely been pre-crushed into the glass so that when the beer (a cold draught larger) was poured it became infused with the taste. If that is really all there is to it and it tickles your fancy, you can try this at home. I would recommend using the cloudy Belgian wheat beer Hoegaarden as the garlic complements well its hint of coriander.

When it comes to food I'm usually game for anything, but I did draw the line at garlic fudge.

Wight is by a long way England's largest island. Administratively once part of Hampshire, it is now a county in its own right. Roughly diamond shaped, it is 23

miles from east to west and 13 miles north to south, with a chalk ridge as its east-west backbone and the River Medina flowing north into the Solent at Cowes, almost cutting the island in half. Much of it is still farmland dotted with attractive small villages, but the coast, naturally, has become the main focus for its summer visitors.

This is particularly true of the east and south coasts, where the towns of Ryde, Bembridge, Sandown, Shanklin and Ventnor, all distinctly different, have spread along the coast. They almost merge into one continuous development, interrupted only at Culver Down, where the eastern end of the chalk meets the sea as high white cliffs, separating and hiding Bembridge from Sandown. Here from the summit are magnificent views of the east Wight coast.

These towns may no longer be genteel, but in comparison with much of mainland England's south coast resorts, they do remain gentle.

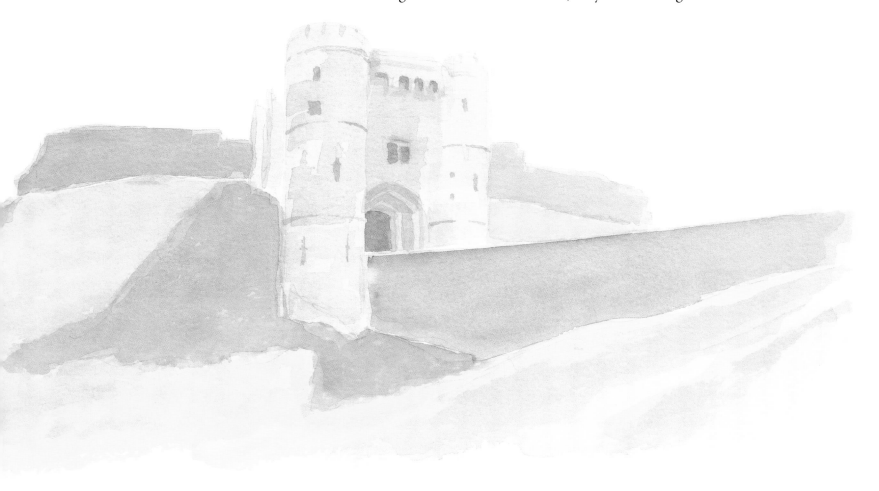

Carisbrooke Castle

Although there are some Regency terraces in Ryde, it is difficult to find much on the coast that was built before Queen Victoria and Prince Albert began the fashion for visiting Wight. They bought the Osborne House estate at East Cowes in 1845 as a retreat from the affairs of state, demolishing the original Georgian house and replacing it with a grand Italianate house designed by the prince and Thomas Cubitt. Victoria spent most of her 40 years of widowhood here. Osborne House is now itself a popular visitor attraction, and is not to be missed. I saved it for a rainy day.

To say that the house is bright, colourful and richly gilded is something of an understatement. The extravagant use of colour and pattern is enough to make even the most broad-minded visitor shudder. I can quite honestly say I have never seen anything like it. The ceilings are, appropriately, particularly over-the-top. It is difficult to equate what you see with Victoria's description of it as 'cosy'.

The year after Victoria died at Osborne, Edward VII, not caring to keep it himself, gave the estate to the nation. It was Edward, as Prince of Wales in the 1890s, who made Cowes a fashionable place to race yachts. Cowes is sailing. For many, mention Wight and the first and perhaps only thought is of Cowes and Cowes Week.

Wandering along the narrow, meandering paved High Street you get the impression that anywhere that is not a café, pub or restaurant is a chandler or a specialist in sailing clothing.

Sailing clothing is a fashion all of its own and when you are around boats you see people wearing clothes you rarely see inland. I once remarked to someone at the Southampton Boat Show that I thought sailing 'a different world', to which the reply came, 'it's not a different world, it's a parallel universe'. How true, and here it is in all its bewildering glory.

I have known a number of people who hail from Wight, and the one thing that united them was their unerring knack of never missing an opportunity to tell you how wonderful their island is. 'Like England was thirty years ago' is a familiar phrase, as if they'd all been taught it at primary school. It is peaceful, and often reminds me of parts of Dorset and Devon (the drive along the chalk ridge from Culver Down to Newport is particularly wonderful), but as I have become more familiar with the island over the years, I reckon that only west Wight qualifies for the thirty years accolade.

West Wight for me begins with a dramatic moment in history. It starts at Carisbrooke Castle just west of Newport, where Charles I was imprisoned before his execution, and ends in the dramatic natural staccato of the chalk stacks of The Needles. In between are quiet lanes, pretty cottages, open country and great views.

For that reason, I have always stayed on this side of the island at Latton House – lovely building, lovely people, and fried bread to die for (if that's not too inappropriate a phrase to use).

Not far from there at Freshwater Bay there is a real step-back-in-time moment where, within a few metres of each other, there is a wonderfully old fashioned village shop (that has been in the same family for 140 years and comes complete with HOVIS in big gold letters down the front), a cast iron fronted post office/newsagent and a church with a thatched roof. It is a real gem of a spot.

Freshwater

After I had been totally garlicked at the Festival and with the weather forecast for the following days not promising much sunshine, I spent the rest of my Sunday afternoon under a mostly blue sky making my way onto the high chalk ridge of Tennyson Down and cut to the National Trust's Needles Old Battery.

This doesn't sound the most promising location on the island. It is a fort built in 1861 when there was a threat of invasion from France and was used during the two World Wars to protect the approaches to Portsmouth. It does, however, give the best view on the island of The Needles, which is worth the long walk up there and the entrance fee alone.

I had wanted to paint The Needles before, but whenever I'd had the time to find a good view the weather had been against me. I had made this walk onto the Down before when the Battery was closed and been dissatisfied with the view. I'd even braved a tour boat from Alum Bay that was full of primary school children, but that was on a gloomy day and not the best situation for sketching. I wanted to see the chalk sparkle in the sunlight, and this turned out to be the perfect afternoon for it. At last!

I had not been aware of it before, but was not surprised to learn on this visit that two large areas of west Wight are designated as Areas of Outstanding Natural Beauty; east of Yarmouth including the marshes of Newtown Nature Reserve and the chalk downland west from Carisbrooke. I was horrified to discover, therefore, that the land between them could, one day, be the site of a wind farm with half a dozen 105 metre high turbines.

I am all in favour of renewable energy. It seems to be the sensible way forward. I have seen wind farms hidden in a valley on Anglesey and on the industrialised coasts of South Wales and Northumberland and have not been too disturbed by their presence. If Mother Nature is big enough where they are sited she will overpower them, but here she is not big enough, she is delicate and needs protecting.

When painting I can choose to leave out or move anything that I feel is out of place or inappropriate. I try to be as honest as I can about the views I choose. I think that as I paint in a realistic manner and try to convince you that this is how it looks, I have a duty to show you how it really is. Consequently anything that is changed is something minor, like omitting a fence or a telegraph pole. When I am actually there, however, looking at the view there is not that choice. The offending object cannot be omitted, it is there and it does, indeed, offend.

> Three freestanding and one attached to the base of the cliff; individually they are Old Pepper, Wedge, Roe Hall and Frenchman's Cellar; collectively they are The Needles. Lot's Wife collapsed in a storm in 1764.

Surely placing a wind farm between two Areas of Outstanding Natural Beauty destroys them as much as placing it within one of them? If Wight has a responsibility to provide natural power, why not harness the energy of the tides that surge up and down the Solent twice a day?

I will be terribly sad if I will no longer be able to enjoy this most special corner of England: no longer England of thirty years ago, but England of thirty years hence.

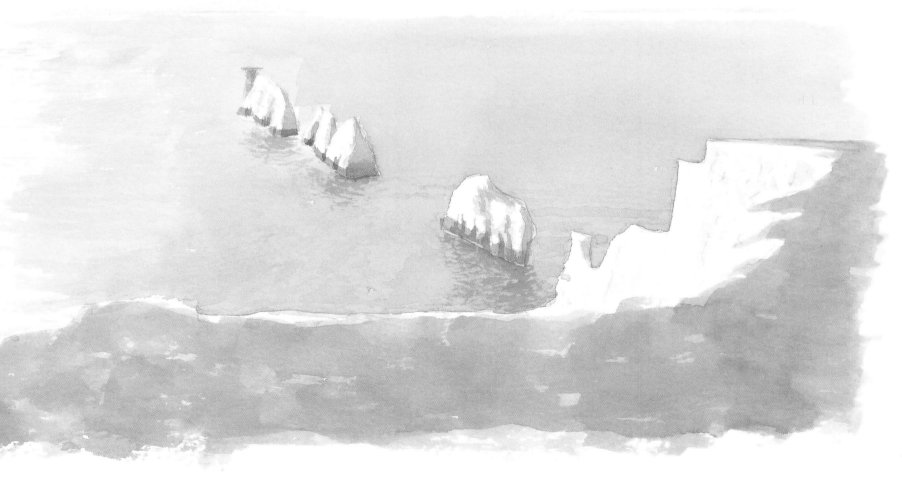

The Needles from the Old Battery

Brownsea Island

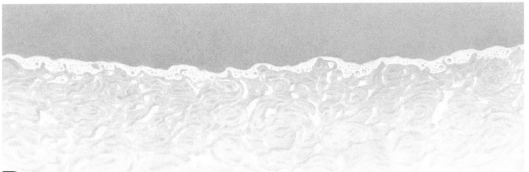

Brownsea is unusual amongst Britain's islands, being enclosed within a natural harbour. That's not all that makes it unusual. Over the years it has been many things to the people who have owned it. Here's a potted history to put what you see today in perspective.

Pottery fragments suggest occupation c500 BC. Monks from Cerne Abbey near Dorchester build a chapel (destroyed by Vikings under Canute). At the Norman Conquest Brunei Insula belongs to Bruno, Lord of the Manor of Studland. William the Conqueror gives the Manor to his half-brother Robert, which reverts to the Crown when he's banished for treason. Monks retain hunting rights.

At the Dissolution, Henry VIII takes control and a small fort is built at the southeast corner protecting Poole (Elizabeth I gives the fort to Sir Christopher Hatton). During The Commonwealth the island is sold to Sir Robert Clayton MP (a member of the delegation inviting William of Orange to the throne), whose heirs sell it (1726) to William Benson (who succeeded Wren as Surveyor-General of the King's Works).

Until then Brownsea was a low, one and a half by three quarters of a mile mound of clay and shingle covered in open heathland. Benson begins its transformation into today's island, converts the Tudor fort into a residence, introduces rare plants and trees, and plants 10,000 saplings.

1765 Sir Humphrey Sturt MP takes over; he greatly enlarges the castle and creates ornamental gardens. It passes through the Sturt family and is then sold to Sir Charles Chad in 1817, who sells to Sir Augustus Foster in 1845, who likes it so much that he slits his throat in the castle.

It is purchased in 1852 by Colonel William and Mrs Mary Waugh who believe Brownsea to be a valuable bed of china clay; they build a church, gatehouse, clocktower, castle pier, and make Tudor-style additions to the castle. At the western

Brownsea Island from Pottery Pier

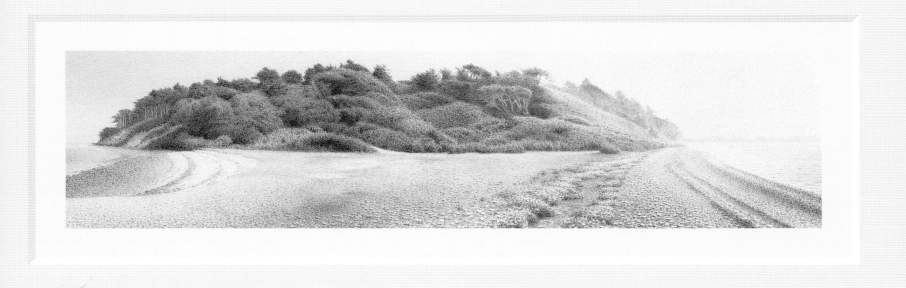

end of the island they build a pottery works and small village (Maryland, named for Mary). They discover the clay is only suitable for making salt glazed drainage pipes. The bank is unhappy, and they flee to Spain.

After legal wrangling among the creditors the island is sold to The Honourable George Cavendish Bentinck MP, whose prime interests are agriculture and art; he plants cereal crops, introduces Jersey and Guernsey cattle, and fills the castle with Renaissance sculpture. On his death, it is sold to Major Kenneth Balfour MP.

In a disastrous fire in 1896 the castle is gutted; Balfour also. After rebuilding, it is sold to wealthy Dutchman Charles Van Raalte. The castle is brought up to the appropriate standard of luxury and the island becomes a hunting/playground where many guests are entertained, including European Royalty.

Charles dies in 1908. In 1925 his widow Florence sells to Mrs Mary Bonham-Christie, who gives everyone notice to quit, effectively sealing it off from the outside world. After the last islanders leave, 90% of the vegetation is destroyed by fire – sheer coincidence? The castle is left to decay, farm animals allowed to roam, nothing is cultivated, and the land goes back to nature. On her death (1961) her grandson gives Brownsea to the Treasury in lieu of death duties; they hand it over to The National Trust.

Which is where we come in, or more accurately, sail over. The ferry from Poole Quay takes about 20 minutes and the commentary informs us that the 104 miles round the perimeter of Poole Harbour makes it the second largest natural harbour in the world. I have, however, read that same claim for the harbour at Maó, Minorca. I have also read that both Poole and Maó are the *largest*, along with Pearl Harbour (Hawaii), Sydney (Australia), Trincomalee (Sri Lanka), Kingston (Jamaica), San Diego (California) and Vancouver (British Columbia).

The frequent ferries (also from Sandbanks) land at the quay at the eastern end of Brownsea close to the castle, where a picturesque collection of buildings continue the castle theme with castellated parapets and crow-step gables, creating harmony from an otherwise mixed collection of styles, colours and materials. Visitors with their own boats must land at the old pottery pier at the opposite end of the island to ease congestion, as the main thoroughfare through Poole harbour passes close to the quay.

The National Trust facilities are excellent, but once you move beyond the quay area the rest of the island is pretty much au naturel. Maps are provided showing the various tracks across the island. The northern half (about 40% in fact) is leased to the Dorset Wildlife Trust who maintain it as a nature reserve. You can join one of their guided walks, or view the lagoon from their hide near the quay. The castle

The Scout and Guide movement started on Brownsea. Robert Baden-Powell set up a camp for 22 boys in August 1907. From this small beginning the international movements developed and the site is still used by Scouts and Guides from around the world.

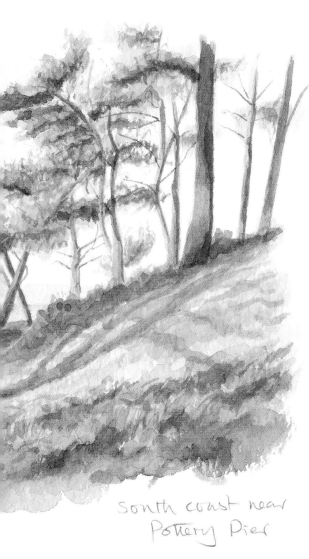

south coast near
Pottery Pier

is leased to the John Lewis Partnership and is a hotel for their employees, so if you fancy staying there you'll need to get a job stacking shelves at Waitrose.

Although there are areas of grassland, open heath, brackish lagoon and freshwater lake, it's the pinewoods and broadleaf woodland that dominate. Walking in the shade of trees with patches of dappled light and stumbling across the occasional sunlit glade is one of the island's delights.

When walking along a woodland track you might think there's nothing much here in the way of wildlife – the subtle natural sounds are masked by those of your crunching footsteps – but just stand still for a moment and you can hear rustling in the undergrowth and a variety of birdsong. Find a bench to sit on and before long a peacock (a Van Raalte legacy) will appear, expecting a snack.

Brownsea has a rare colony of red squirrels and, although I've been here several times before, I still await my first sighting. That's not so surprising as they're most active around sunrise and sunset and National Trust opening hours are 10am – 4, 5 or 6 pm, depending on the length of daylight. If it's wet or hot during the day they are likely to be sheltering. You would need to stay on the island or have your own boat to stand a good chance of seeing one.

Their diet is 70% scots pine cones, but rhododendrons are squeezing out the pines. At Parkyn Copse an area of rhododendrons has been cleared to allow the pines to regenerate in their place. The area has been fenced off to protect the saplings from rabbits and sika deer – I haven't seen any of these either.

At this point we are a short stroll from Maryland and further across the island than I'd ever been before, but if you're expecting to see anything resembling a village you will be disappointed. There is a sign to indicate you are there, but it's now a moss-covered jungle of rhododendrons. There are small sections of low wall, scattered bricks and shattered roof slates, slabs of limestone, broken pieces of fireplace and a fragment of a cast iron cooking range. That's not much to record the lives of the inhabitants of twenty houses over an eighty-year period.

I had crossed on the first ferry of the day and made a bee-line for here to have it to myself for a while. I wandered down to the old pottery pier to get a view of Brownsea I'd not seen before. The beach material at this end of the island is composed almost entirely of broken pieces of salt glazed pottery, an enigmatic sight if you don't know the island's history.

With my back to the pier I painted the view of the island. The tree-covered cliffs and my woodland walk to get here made it all seem so natural. Who, in this quiet moment, would have guessed what had passed at this most unlikeliest site of industrial dereliction.

55

Portland

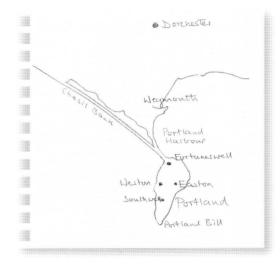

I know there are going to be some of you out there in the real world already considering writing to tell me that Portland is not an island. It is not surrounded by the sea and is joined naturally to the rest of Dorset by Chesil Bank, which at no time is covered by the sea whatever the state of the tide. You can drive there anytime you like along a conventional A road without fear of being cut-off, so it cannot possibly be an island.

In my defence I would like to draw your attention to the aforementioned Chesil Bank (about which there is a whole chapter in my book *Encompassing Britain*). It is a tombolo, which my Collins English Dictionary defines as 'a narrow sand or shingle bar linking a small island with another island or the mainland'. Case dismissed.

When approaching from Weymouth the sight of Portland's steep north face rising up 120 metres above the cluster of houses in Chiswell never fails to fill me with awe. However, I think one of the best views of Portland is from London's Hungerford Bridge, the footbridge across the Thames between Charing Cross Station and the South Bank Centre. I'll admit that on the face of it it's a pretty strange thing to say, so here is some clarification.

Thomas Hardy described Portland as being 'carved by time out of a single stone' and it is indeed a gigantic tilted slab of the finest quality limestone, the champagne of building stone.

When you go to Portland you cannot help but notice that there are a number of vast holes extending for hundreds of hectares across the island, where quarrying has been carried out for centuries. Much of that stone has been shipped to London and used to construct some of the city's finest buildings. Why leave it lying in the ground on Portland where no-one's going to see it when you can assemble the blocks into something as fantastic as St Paul's Cathedral?

Portland Bill at a low spring tide

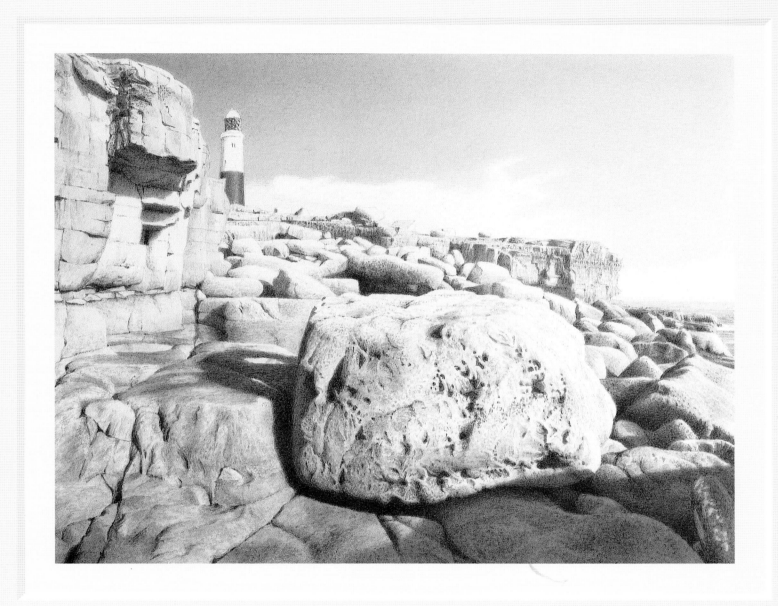

Personally, I prefer my buildings a little more restrained and my favourite outcrop of Portland Stone is the Royal Festival Hall, which looks fabulous from Hungerford Bridge day or night. When you look around at the view of the city from there and see just how much Portland stone is visible (60,000 tonnes or nearly one million cubic feet in St Paul's alone) it's a wonder there is anything of Portland left to quarry.

Signs of quarrying are inescapable. Even those quarries that appear to be no longer worked and gradually going back to nature are likely to be merely lying dormant, waiting to be resuscitated when restoration work on an old Portland stone building requires a new batch of identical stone.

Although quarrying still dominates visually it is no longer the island's major employer. One quarryman informed me that there are only about 25 men physically extracting the stone today (there would have been about a thousand in the nineteenth century), although he thought that another 130 or so are employed in the masonry business generally and there are other trades, transport and engineering for example, that rely on the Portland Stone business for their survival.

It seems odd to be drawn to something that is no longer here, but there is something intriguing about the thought that out of these chasms in this unassuming location came such grand London buildings as Somerset House and the National Gallery, Birmingham's Civic Centre and City Hall in Belfast, even some of the UN building in New York.

Paradoxically, Portland's most monumental structure is so well disguised it would be easy to miss if you were not aware of its existence. The Verne Citadel was built in the mid-nineteenth century to house the 3,000 troops who manned the shore defences of the new Portland Naval Base, in its day the largest man-made harbour in the world.

Inspired by the bank and ditch construction of ancient hill forts, the Verne was built into the remodelled hillside overlooking the harbour and is surrounded by a great dry moat 22 metres deep and 37 metres across, the excavation of which yielded one million tonnes of stone for the construction of the harbour breakwater. Even at close quarters the Verne can easily be missed, a line of chimney pots incongruously protruding from a grassy hilltop being one of the giveaway signs. The Verne is now a medium security prison.

Continuing the 'can you spot…' theme, the more observant of travellers between Southwell (Dorset's most southerly village) and the Bill will notice the terraced slopes of the last remaining area of Portland's ancient strip farming system. These open fields have all but disappeared from everywhere else in

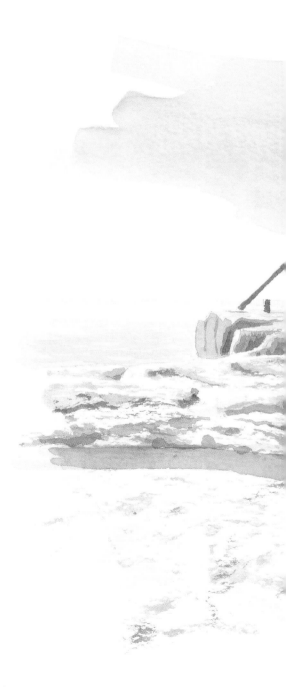

England, being obliterated by enclosure, building, and modern farming. However, until quarry expansion in the 1840s and more recent housing developments, much of the central part of Portland was still an agrarian landscape of eight great common fields that had survived for more than a thousand years.

Although that method of farming has now ceased, the system for administering the surviving 160 hectares of common land, the Court Leet – one of the last of its kind in Britain still functioning – continues to operate as it did in Saxon times when Portland first became a Royal Manor. Among the inalienable rights of the commoners are the grazing of animals, the removal of stone and the right to compensation for encroachments on the common land. The latter manifests itself today as the extensive

old crane, the Bill

59

village of beach huts on common land near to the lighthouse. The hut owners pay their compensation to the commoners, effectively a ground rent, at the Crown Court in Fortuneswell; further evidence, as if it were needed, that there is more to Portland than meets the observant eye.

Of all these island journeys, unsurprisingly this is the one that gives the least sense of a crossing. Although the road from Weymouth is along a natural causeway with the wide expanse of Portland Harbour seen to the left, Chesil Bank obscures the view of the sea in Lyme Bay to the right, giving the impression that you are passing along a stretch of coastline rather than away from it.

Stone bridge, Halleluja Bay

Once you arrive at Chiswell however and begin to climb the escarpment through Fortuneswell to reach the highest point on the island there is the definite perception of having arrived at an identifiably separate entity. Every aspect by which one assesses the character of a place is markedly different from its near neighbour Weymouth, and just about anywhere else you are likely to pass through on the way.

Portland is roughly the same shape as South America. However, there is a slight difference in scale. The island is a mere four and a half miles long and about a mile and three quarters at its widest, with a population of 14,000.

A casual visitor might think that there is little here to inspire. The island is host to two prisons, the stark landscape is scarred and virtually tree-less, and the mostly pale grey stone buildings are, on the whole, modest. There is little you would call chocolate box picturesque or pretty. It all adds up to what seems to be on the face of it an austere kind of a place, but it has a gentle bleakness that I find indefinably compelling. In fact, I have to confess that I love Portland and it has inspired me to produce – in my opinion – some of my best paintings.

Whenever I have visited the island my first destination has always been the Bill at its southern tip. This has been an unpremeditated act that has only occurred to me since I started to mull over my various visits before writing this account. It is only after I have had sufficient time there that I move off to spend the rest of my visit gradually working my way back to Chiswell. I always seem to find myself looking around as if searching for something, but never quite knowing what it is. Although the work I have produced here has been satisfying, I invariably leave with a sense of having missed something. My visits are as enigmatic as the place itself.

Portland Bill seems to be the magnet that draws the island's visitors. I am always amazed at the number of cars that accumulate in the car park next to the lighthouse no matter what the time of day, week or year. It must be because this is where the sea is most accessible.

My recent visit on a bright and clear October day coincided with a low spring tide, exposing to the seaward side of the lighthouse ledges that are normally inaccessible. I took the opportunity to walk around the lighthouse at the water's edge where I was able to get views of the tower rarely available. Portland stone, like all limestone, breaks naturally into large rectangular blocks, and even when worked by Mother Nature has an architectural quality. From here the lighthouse, already a building on a monumental scale, looked as if it had been set upon a colossal stepped plinth and I felt positively Lilliputian.

Once again Portland had worked its magic and I went back to my studio with so much good material I didn't know where to start.

Burgh Island

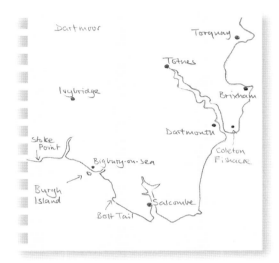

That wedge of south Devon between Dartmoor, Torquay and Plymouth seems an unlikely place to find pioneering pieces of modern architecture. Yet in the between-the-wars days before the wealthy built their grand designs in Tuscany, Provence or Andalusia south Devon, known as the English Riviera, was one of the places to build your new retreat.

In 1925–6 Colerton Fishacre was built on a secluded slope overlooking Pudcombe Cove, just east of the Dart, for Rupert and Lady Dorothy D'Oyly Carte (of Savoy Theatre G&S Opera fame). From the outside it is gentle, grey/brown and stone, probably the last flowering of recognisable Arts and Crafts, a grand cottage with a rustic nod towards Lutyens. Inside it is more forward looking; plain walls with lots of bleached oak and light fittings which are early angular simple art deco, modern but restrained. It's now National Trust, so you can see it for yourself.

Up the Dart above Totnes, where Leonard and Dorothy Elmhirst created their progressive Dartington College is High Cross House, something completely different from 1930–2. White (with a splash of blue) and cuboid, with long strips of windows and a roof terrace, it appears to be uncompromising International Style on the outside with Bauhaus influences inside. But this one is not quite as forward looking as you might think. Ultimately it's a sham. Underneath those sharp white walls is good old-fashioned brick. Why on earth would you need to render brick? To make it look like concrete, why else?

To be an out and out modernist and do the job properly you really needed to throw caution to the wind and use concrete.

If you want to see white painted concrete on the scale of an ocean liner you only need to go 200 metres offshore from Bigbury-on-Sea. Not to a moored ocean liner, but to the Queen Mary of hotels aground on a rock called Burgh Island.

The Burgh Island Hotel started life as a Moderne 1929 country house for the Midlands metal products millionaire, theatre impresario and film studio owner Archibald Nettlefold. It was to be somewhere he could hold wild parties for his famous friends. In 1932 he enlarged it and turned into a hotel, with long white balconies, big windows, a palm court and an angular Odeon tower; the full works.

The Art Deco interior is a living working museum to the style, encompassing its whole spectrum, simple Colerton Fishacre-like lights, a wavy black glass dado, a bronze relief panel of stylised deer running through a forest, a suntrap semi display cabinet...

If you want to see this interior you can't just wander in and order a cream tea. To get through the locked front door you have to make a commitment. Stay for a night or two in one of their suites and completely give yourself over to the period (its isolation keeps out the intrusions of the present). Don your best evening wear and have a dinner to remember with live jazz accompaniment. Or perhaps come for a smart lunch.

> Agatha Christie stayed in the Beach House, where she wrote *And Then There Were None* and *Evil Under The Sun*, both inspired by the island and its hotel.

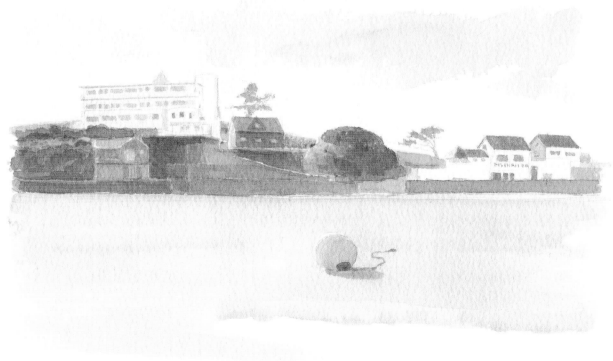

Burgh at low tide

The latter is the least you'll get away with, but at only three times the entrance fee to the V&A's 2003 Art Deco exhibition you will see its equal, be pampered for an hour or so and at the same time have an amazing meal. I would say that's a bargain.

On the other hand, you could tell the owners that you are working on a book about islands and that to do them and the chapter justice you would need to be shown round and hear their story of its acquisition and restoration. Then they'll invite you in and ply you with the best crab sandwiches on the south coast.

Deborah and Tony are passionate about the building and the period. They bought the hotel, complete with island, only a few weeks after being married here, not that Deborah was aware at the time of that being the plan.

It is a heavy commitment; buildings of this type are notoriously problematic, but Tony, being a structural engineer, knew that this was a good one.

For instance, its not-quite-flat roof does not sit behind a low parapet pushing the walls out as it expands when the sun shines and creating a leaky rooftop pool when it rains, but lies across the walls with a neat cornice at the overhang and channelling the rainwater into a gully. But it does have steel window frames, not ideal for a salt-spray exposed island. A rolling programme of maintenance is bringing it back to its sparkling white and verdigris best.

Some stunning original pieces of furniture came with the building and the owners have been collecting and restoring good examples of the period to add to the authentic interiors as well as commissioning new artwork to enhance the 1930s atmosphere. You have to admire their dedication to getting things right in every detail. And it is just right; a real treasure.

These are fabulous surroundings to work in, but for them it is a place of work too. Even the most dedicated sometimes need to escape. Tony and Deborah's home is the Beach House, just metres away, projecting on stilts over a sandy shore, modest and timber from the outside, a shrine to Philippe Starck inside.

Tucked into Bigbury Bay, Burgh's eight and a half hectares are only visible from Bolt Tail to Stoke Point. Bigbury is itself off the beaten track somewhat, and it is not until you reach the edge of the village and begin the descent to the shore that Burgh is first seen. You cannot miss the hotel; there it is, bold as brass (or should that be chrome?) monopolising the view. It sits on a rise above a small collection of close-to-the-shore buildings, the Beach House to the left being one, and the Pilchard Inn to the right another. Behind, the island is a shallow dome of grassland and heather. Although they own the island, and the hotel and its grounds are for guests only, there is a public right of way to the top of the hill.

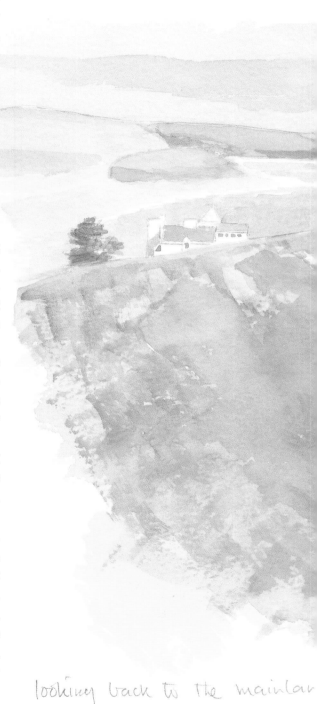

looking back to the mainlan

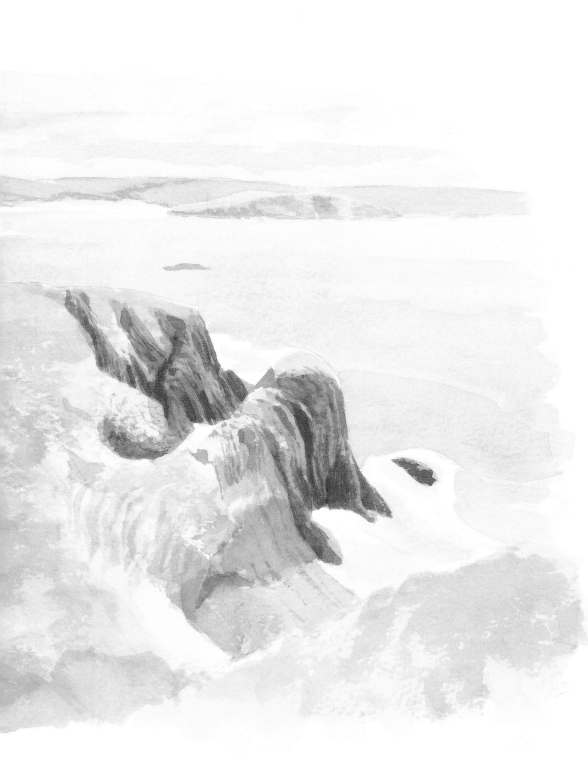

At low tide you can walk over across an exposed bar of sand; at high tide there is the sea tractor, a strange vehicle that is a motorised first floor veranda on tractor wheels.

The Pilchard Inn has the date 1336 on the outside. Inside it is small and dark, not trying to be anything else. Here, too, authenticity is paramount. The food is from the hotel kitchen; those wonderful crab sandwiches at lunch, or on weekend evenings fish soup, butternut pumpkin, aubergine and goats' cheese lasagne followed by chocolate, hazelnut crème brulée.

To walk up an appetite for that, you can stroll to the top of the hill where there are the remains of an old chapel that was once the shelter for the huer, the local fishermen's pilchard lookout, who would raise the hue and cry when a shoal was spotted.

Near the top, just when I thought that for once man had produced something more than Mother Nature had conjured up here, the footpath passes close to the edge of a dramatic cleft gouged out of the east side of the island, with a sheer drop of nearly 50 metres to the sea. Standing on the edge and looking back across the gap to the mainland, with the top of the hotel still visible down the hill, produced yet another wow moment in a day of wow moments.

St Michael's Mount

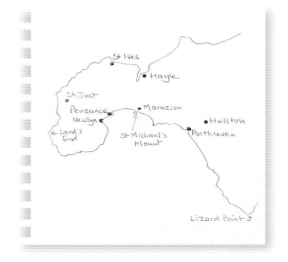

Yet another confession: I have no doubt given you the impression that I have been systematically working my way clockwise round the coast from island to island, but I haven't. Can you ever forgive me?

My intention with this visit was to take in St Michael's Mount and the Isles of Scilly in one trip. I achieved that, but the flights were more convenient if I went to Scilly first, so I did. I'm sorry about that, it's just the way things worked out.

As a consequence, when I set foot on the St Michael's Mount quayside at ten minutes to midday on a September Friday it was my third island in less than two hours. I started the day on St Mary's, flew on the 10.15 to Land's End, drove to Marazion, parked and, as the causeway was covered by the tide, caught a boat over. Not exactly a record, but maybe a contender for a gentle watery rival to the Three Peaks Challenge.

The island has a fairytale look about it; a cluster of buildings attractively grouped between the sturdy harbour jetties, and towering over them a steep rocky crag swathed in woodland, with the picturesque granite church/priory/fortress/house complex perched on top. It is a magnificent vision once seen never forgotten which requires a sharp intake of breath moment at the first sighting.

A brief explanation of the island's history may help to understand what you are looking at.

In earlier times, when sailors navigated by keeping land in sight, the Mount was an essential and easily recognised landmark from the sea, used by the Greeks (the island is probably that known as Ictis in Classical times) from as far back as 350 BC to rendezvous with Cornish tin traders, tin being an important constituent in a number of alloys, including bronze. They would have beached in the shallow waters close to the Mount, taken their tin on board and refloated on the rising tide.

The harbour at St Michael's Mount, Cornwall

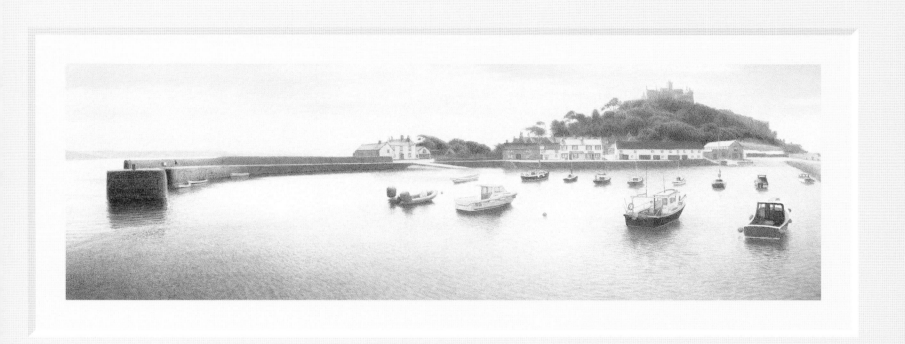

The remains of tree stumps exposed at low tide suggest that in those days the Mount may not have been an island, but was probably linked to the mainland by a marshy forest.

During a storm in 495 AD St Michael is said to have appeared in a vision to local fishermen and for centuries thereafter it was a site of pilgrimage. Despite being the sort of isolated location favoured by Celtic hermits there is no evidence of any significant building on the Mount until after it was granted to the Benedictine Abbey of Mont St Michel in France by Edward the Confessor.

In 1135 the Abbot of Mont St Michel built a church and established a community of a prior and twelve monks. The church was rebuilt in the fourteenth century following an earthquake. After declaring war on France Henry V separated the two communities and in 1424 Henry VI granted the Mount to the newly founded Syon Abbey at Twickenham. The harbour and causeway date from that time.

At the Dissolution it became Crown property and was turned into a defensive fortress. After the Civil War, Colonel John St Aubyn was appointed Captain of the Mount, purchasing it twelve years later. His descendents have lived here ever since, although it was not their main residence until a large new wing was added between 1873 and 1877.

In 1954 the family gave the Mount with a large endowment to the National Trust, but they still lease back part of the castle, grounds and the garden.

I was aware that by coming here to paint it I would be just one more of a great many who had made this journey over the centuries. Because of that I admit to being a little apprehensive. Could something original still be done, I wondered?

The weather at least was in my favour; warm, clear and sunny. I suspected that I might be painting something architectural, so the crisp contrast between light and shade would help delineate the hard surfaces.

The boats from Marazion deposit you at the end of the harbour jetty from where the castle looks even more magnificent and the village appears well protected and picturesque in its setting between crag and harbour. Close inspection of the houses overlooking the quay however revealed wooden guides in front of the lower door frames, allowing boards to be slid in place in front of the doors to protect the houses from flooding; on such a balmy day an unimaginable necessity.

The village is small, but should not be ignored. In fact, as many people make the journey over just to enjoy the village as pay to see the castle, which is understandable. On the day of my visit with not too many people about it seemed just about as perfect as anywhere could be; attractive, sea views, no traffic. Wonderful.

Between St Michael's Mount and Clifton Hampden in Oxfordshire is an alignment of ten St Michael's churches, four of which (at St Michael's Mount, Brentor, Burrowbridge and Glastonbury Tor) are built on natural mounds.

Some words of warning for potential visitors may be in order: The National Trust Handbook states that the climb to the castle is steep and uneven, that many surfaces are cobbled and unsuitable for prams, pushchairs and wheelchairs and that sensible shoes are advisable. I would suggest taking an oxygen tank and some Kendal Mint Cake.

Allow plenty of time for your visit; it's not something you can do to fill an hour or so, especially if you walk the causeway with granny and small children in tow. There are nine ferryboats, but at busy times (in August as many as 6,000 people visit the island every day) you may have to wait, but it's the best way to go and inexpensive too.

Above all, once you've recovered from the climb there's so much to see and linger over.

My abiding impression of the castle was not of the tour of the buildings, fascinating though they are (and hung with a good collection of pictures of the Mount showing the village as well as the complex of buildings at the top in various stages of development), but of the external views of them and of Mounts Bay from the terraces on the roof of the Victorian extension.

However, there had been something about my visit not typically National Trust and at first I couldn't quite put my finger on it, until I started to consider a few apparent anomalies. The guidebook being sold in the ticket office is not a National Trust publication, neither is the room-by-room tour brochure. There is also a café and a shop in the village which are not National Trust.

To try to get to the bottom of this puzzle I spoke to Lord St Levan's (the present John St Aubyn) agent, who is also, as it turns out, the National Trust's agent for the Mount.

To cut a long story short, when the property was endowed to the Trust they took on responsibility for the building, but the visitor trade remained with the family's Estate. It's an unusual arrangement, but I understand that it is one that works well.

Most of the people working on the island are Estate employees, even those who issue you with your National Trust ticket to view the castle, where the guides are Estate people too. Only about twenty people live permanently in the village and these are all Estate workers and their families. The Lindisfarne situation applies here too, for instance everyone is trained in first aid. Sometimes in winter bad weather prevents supplies from being delivered and so these have to be stored in Marazion until conditions improve, which just goes to show that nowhere is perfect.

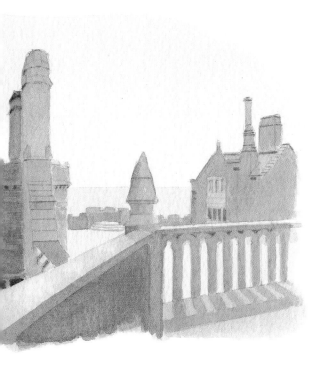

South Terrace

Isles of Scilly

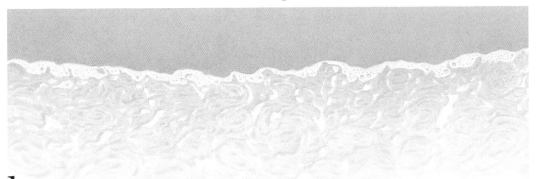

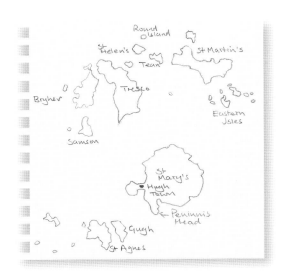

I've read a treatise that claims for islands to work you must approach them on their own terms, by sea. I take the point.

A sea passage prolongs the anticipation that accompanies an island journey and creates a proper sense of impending arrival as the land slowly appears from over the horizon. First there's a pale silhouette, then features of the landscape are revealed, a confusion of greys slowly evolve into the individual buildings of a port, the sun reflects off the windscreen of a car passing over a headland. Finally comes the calm of arrival as the engines are cut back and you pass the navigation lights at the harbour entrance.

It's the essential way to go the first time, but I feel it's not always necessary to repeat the experience on a second visit.

Arrival by air gives a more encompassing view, enabling you at a glance to see your destination as a living map, to evaluate the land use, estimate the ratio of urban to rural and to pick out the wild areas.

Having travelled the three hours from Penzance on *Scillonian III* before and not fancying twenty-five minutes in a noisy 32 seat helicopter from Penzance (I don't care if it is amphibious, you won't get me in an aircraft where the wing stops working if the engine fails), I opted to fly fixed-wing from Land's End in an eight seat Islander. The service is called Skybus. Skyminibus would be more accurate, Skyunusuallylongestatecar just about spot on.

A flight from Land's End puts the field back in airfield. If it's clear enough the islands are already visible on the horizon twenty-eight miles away. You are almost there before you go and the flight over (15 minutes at 1,000 feet and 130 knots) is spine-tingling in its anticipation and execution. If you want to take off on grass, read the cockpit instruments in flight, share a joke with the pilot, see his view

through the windscreen and be within range of his aftershave, this is the only way to go.

At our destination a minibus waited to deliver us to our various lodgings. Before we set off, the driver, a local man understandably proud of his islands, pointed out some notable views and gave us a short history lesson. Further on came another pause to show us a garden where a colourful but poisonous plant from South America was growing and later we enjoyed yet another stop to see the modest bungalow that was Harold Wilson's holiday home.

So what's out here?

A cluster of low-lying small granite islands of shallow acid soil punctuated by bare rock outcrops, supporting a sparse ecology of fewer native flora and fauna than the mainland, swept by strong salt-laden winds, occasionally blasted by wind-blown sand and subject to unusually high levels of ultra violet light.

It doesn't sound very promising does it? Thankfully, that's only half the story.

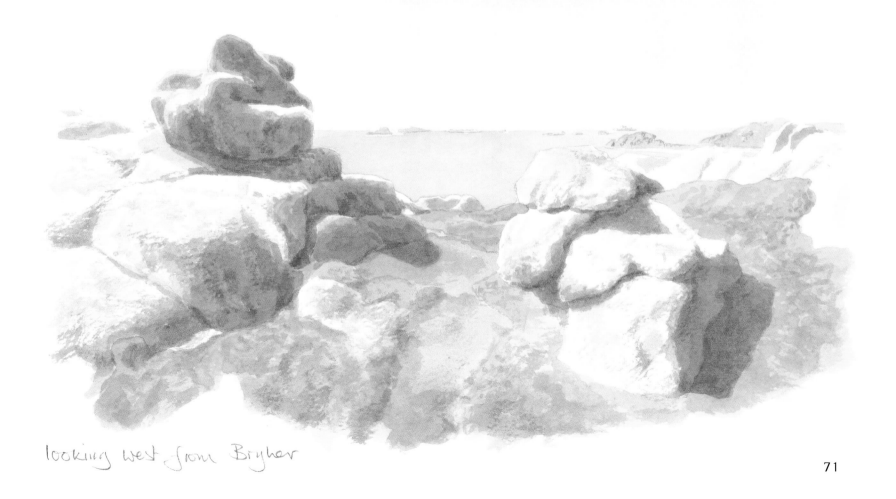

looking west from Bryher

Warmed by the Gulf Stream and virtually frost-free, there is a very small seasonal temperature range, low rainfall, high humidity, a good sunshine record and clear air free of industrial pollution. Home to many naturalised semi-tropical plants introduced from the Mediterranean and the Southern Hemisphere, the islands are a designated Area of Outstanding Natural Beauty. Their coasts are designated a Heritage Coast and the waters a Marine Park. There are 23 Sites of Special Scientific Interest accounting for 54% of the land. That's more like it.

In prospect these islands possess a serene grandeur, rugged yet delicate, sparse and rich, and when viewed in detail, exotic even.

It's tempting to imagine that at some time in the past England was once like Scilly; calm and quiet, small scale, local, neighbourly, cooperative, uncommercialised, working at the pace of man and not machine, a time when there was time… for everything, including being in tune with nature and enjoying simple pleasures.

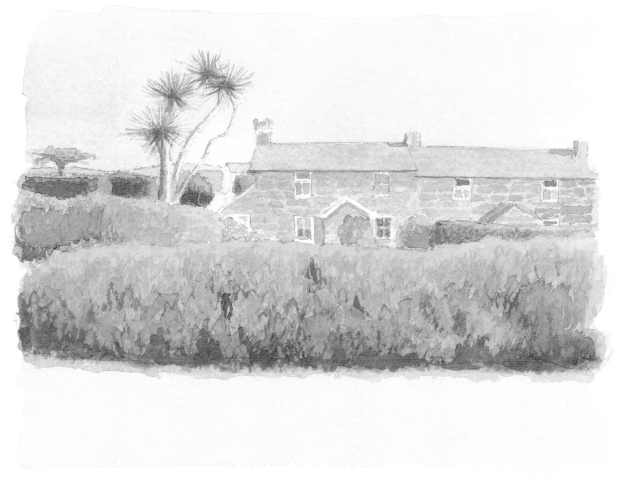

Tresco cottages

> Scilly is administered by a 21-seat council, a unitary authority the size of a Parish with the responsibilities of a District and County, including welfare, police and planning. It is also the smallest Education Authority in the UK with one comprehensive school of about 120 pupils.

That's the human side of these islands. As far as Mother Nature is concerned, they're not in a different time, rather they're just somewhere else, still recognisably England in places, but also somewhere warmer. Here the belladonna lily is grown as a field crop and agapanthus grows wild everywhere as a garden escapee. Here another South African native, the hottentot fig, drapes itself over garden walls and aeonium from the Canary Islands grow out of them. Here pittosporum from New Zealand and olearia from the Chatham Islands in the Pacific are grown as hedges and windbreaks. Here you'll find euonymus from Japan, tamarisk from the Mediterranean and Monterey pines from California, and no self respecting garden is complete without a one to two metre high example of the cactus-like succulent aloe.

The hub of these islands is Hugh Town on St Mary's, an English village from the days when an English village had shops, a Post Office, a garage and an inn or two. Here the familiar is unfamiliar; palm trees wave in the breeze outside the Lloyds TSB Bank and people walk safely in the road without having to dodge the traffic, because there's hardly any.

St Mary's is the largest (2.5×1.75miles) and main island. There are four other inhabited islands, known as the off-islands; St Martin's, Tresco, Bryher and St Agnes. The total population is a little over 2,000. There are a further 49 named but uninhabited islands, some no more than a rock supporting a patch of vegetation, and about a further 150 unnamed rocks.

If you are staying in a hotel or B&B on St Mary's it's likely that while you are having breakfast someone from the St Mary's Boatmen's Association (a cooperative of ten passenger boat owners) will drop by and tell you which islands they will be going to that day. This usually doesn't alter much, but sometimes the tides can contrive to make landing at one of them difficult if you don't want to get your feet wet. They also run trips for seabird or seal watching, to view the spectacular Bishop Rock lighthouse (Britain's tallest) and 'around the island' tours. Making your mind up about which island to go to will be the most difficult decision you have to make that day.

The morning boats all depart at 10.15 and by 10.00 everyone on the island appears to be making their way down to the quay. As it says in their leaflet, to visit Scilly without taking a boat trip is like visiting Egypt and missing the Pyramids.

With the exception of St Agnes, the main islands are separated by a shallow lagoon. Looking out across it from St Mary's it's not easy to get to grips with their size and distance; there are few clues to give an understanding of scale, to help interpret the scene. Once the boats start to make their way across, however,

everything begins to make some sort of sense and in a matter of about twenty minutes you have somewhere new to explore.

These little trips are cunningly planned so that you are dropped off at a quay at one end of your chosen island and later in the day collected from a different quay at the other end. If you want, you can do little more than do little, but at some time during the day you will have to make your way across the island, passing on the way all sorts of wicked temptations – a clotted cream tea here, a fresh crab roll or a lazy glass of beer there; it's hell, I tell you!

The islands all have their own distinctive character, but one thing they have in common is peace and quiet. Their allure lies in their very nature. They are what they are naturally and the islanders have no need to create artificial attractions. Activities are based on enjoying what is there. Just taking a lazy stroll and allowing your senses to attune to a unique environment is as good a way of enjoying them as any.

The most popular off-island is Tresco. It is so popular that an extra boat is laid on at 10 am and there is a frequent direct helicopter service from Penzance. The attraction here is the famous Abbey Garden, an eccentric creation of Augustus Smith. He was a landed gentleman from Hertfordshire, once described as a young man in need of an occupation, who in 1834 took a lease of Scilly from the Duchy of Cornwall, which still owns the islands (and his family still lease Tresco).

Augustus Smith built a house next to the negligible remains of the original twelfth century Benedictine priory and set about creating a garden of sub-tropical plants and trees, some of which were brought from Kew as cuttings, saplings and shoots and some as specimens and seedlings from travellers and ships' captains. Unlike Kew, where huge glasshouses are necessary to protect such plants from the worst of mainland weather, here they flourish in the open air and you can look down avenues of tall date palms and imagine you are in the Mediterranean, Australia or South Africa.

A visit to Tresco should not be confined to the Abbey Garden alone however. Much of the rest of the island is beautiful too, although the northern part is a barren rocky moorland. A coast-to-coast walk across the centre of the island is worth making just to peer into the front gardens of the attractive granite cottages, to see exotic plants in a more domestic setting and mixed with some that we are more familiar with on the mainland. I guarantee you'll be saying to yourselves: 'I wonder if one of those will survive somewhere in our garden'. The profusion of unusually tame song thrushes and chaffinches will remind you that you are still in England.

> The name Tresco is Cornish for 'farm of elder trees', indicating its less exotic arboreal origins.

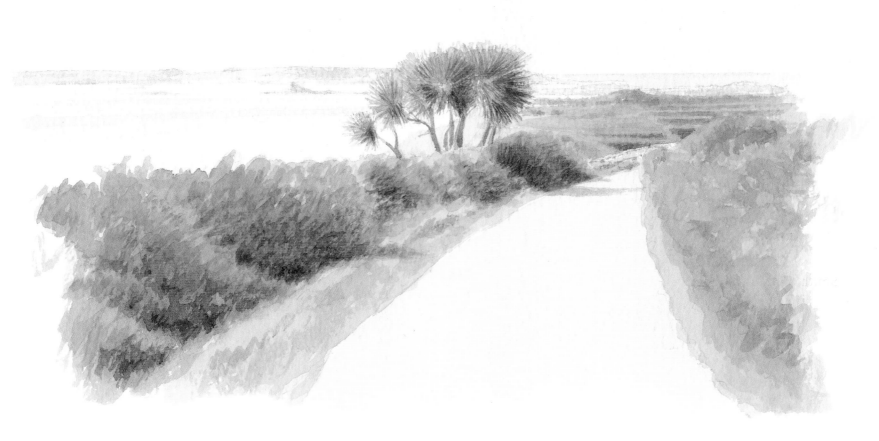

lane on St Martin's

Wherever you go on any of these islands you will find something at which to be amazed. I'll admit to being completely captivated by the plant-life; I could not get over looking down a typically English country lane and seeing a palm tree, it's so incongruous, but with the possible effects of global warming just imagine how our countryside could be transformed. The silence is noticeable too – you can actually hear yourself unwinding. It makes you realise how much noise pollution we have become used to on the mainland.

Take a walk along a St Martin's lane in September and as well as seeing palm trees you can nibble blackberries all day, knowing they haven't been constantly blasted with vehicle exhaust fumes or showered with industrial fallout.

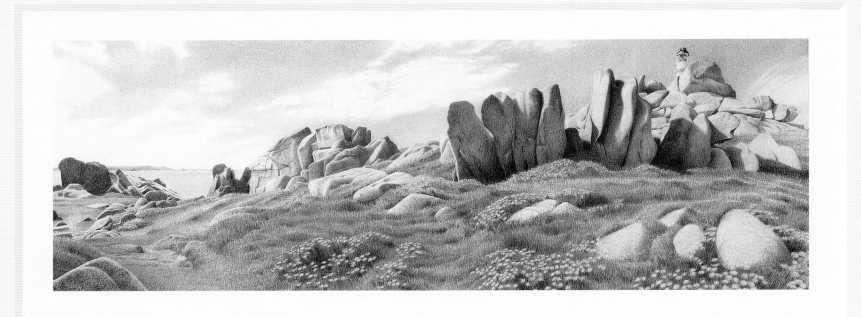

Another beguiling aspect is the views. Wherever you are there always seem to be views of the other islands. This is particularly true of St Martin's, where they are stunning in whichever direction you look. From anywhere on the west side of the island Tresco looks absolutely wonderful (and vice-versa) with Tean, Round Island and St Helen's with their accompanying flotilla of rocks just to the north. From the south side there's a great view of St Mary's and the uninhabited Eastern Isles (which look particularly inviting – a boat trip next visit). Look out in a westerly direction from Bryher, however, and you are confronted with a sudden change in scale; there's nothing out there until you hit Newfoundland.

The mild winters enable the earliest of the mainland's flowers to bloom here several weeks earlier. As a consequence there has been a flourishing cut-flower industry since the middle of the nineteenth century. Though not so important to the economy now as tourism, the long narrow south-facing flower enclosures, sheltered by their high windbreaks of escallonia and pittosporum, are still a feature of the islands' landscape. They are particularly noticeable on St Martin's, where they slope down to the glorious white sand beaches along the island's southern shore.

On the afternoon of my arrival I had wandered out to Peninnis Head on St Mary's to renew my acquaintance with the extraordinary formations of granite that dominate the headland there; massive architectural blocks, rounded by weathering, naturally grey but, as the sea-sprayed rocks are all over these islands, encrusted with the grey-green lichen sea ivory. As on my previous visit, these rocks provided the inspiration for some satisfying work, enabling the rest of my stay to be enjoyed in a more leisurely way.

For once I had felt like a tourist. What luxury and what a place to have the time to savour the islands' delights.

However long a stay here it's never enough and leaving was difficult. A light moment, an observation (one that reinforced the feeling of straightforward homeliness that these islands exude) made as I prepared to board the return flight, diverted my attention and cushioned the blow. Departure was from Gate 2. It is a real gate, a wooden garden gate outside on the grass, and while I waited in the departure lounge the flight attendant sat outside on a wooden bench in the sunshine reading a magazine.

These islands draw you in. Once you've been you're hooked and once becomes the first.

Peninnis Head, St Mary's, Isles of Scilly

Islands in the
Bristol Channel

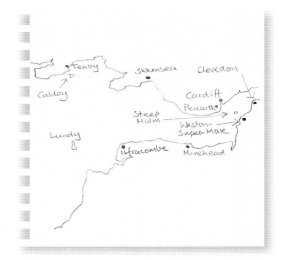

If Portland is an island, then Lundy is in the Bristol Channel. The man I spoke to at Imray, who publishes navigation charts, suspects the Channel's boundary to be a line from Hartland Point in Devon to St Govan's Head in Pembrokeshire, putting Lundy the wrong side of it, but he didn't want to be quoted as authoritative. If anyone is aware of a book that defines such things, I'd like to know about it.

Lundy, Bristol Channel, Devon is the island's address given by its owners, The National Trust, and the organisation that finances, administers and maintains it, The Landmark Trust. And if that's good enough for them...

Perhaps a few words about The Landmark Trust would be appropriate here.

A charity formed in 1965, The Trust rescues buildings (about 200 so far) and their surroundings from neglect. As long as the buildings are good of their kind, they will consider saving anything, from the humble and functional to the sublime and bizarre. They then promote the enjoyment of these buildings by letting them out to us as holiday homes, thus generating an income for their future upkeep.

Consequently, you or I can stay in a Suffolk Martello Tower, a summer house near Falkirk that looks like a giant pineapple, a Tayside corner shop with flat over by Charles Rennie Mackintosh in his prime or a gun battery perched on rocks off Alderney that goes by the wonderfully Trumptonesque name of Fort Clonque.

The Trust's Handbook is a fascinating catalogue of the quaint, the historic and the just plain odd. Taking the buildings alphabetically, the Lundy entry does not fall between Lower Porthmeor and Luttrell's Tower, as one might expect, but is found at the back in a 14 page section of its own, detailing almost every building on the island, 23 of them in fact, including the original 1820 lighthouse and the castle build by Henry III in 1244.

Lundy was bought by The National Trust in 1969, shortly before it was due to be sold at auction. They paid £150,000, given to them for the purpose by Jack Hayward, a British property developer living in the Bahamas, who wanted to donate the island to the nation in gratitude for everything Britain had done for him. The Landmark Trust undertook to restore and run Lundy and they were granted a 60-year lease at a pepper-corn rent before launching a public appeal to raise the £75,000 needed for the work, which took more than 20 years to complete.

Their care and attention to detail has created a harmonious environ-ment, which amply demonstrates what can be achieved if we look after our buildings and their environs, undertake repairs or alterations sympathetically, use local materials and generally just keep the place tidy.

If The Landmark Trust is not able to tempt you immediately with the prospect of a week in the Old School (small, blue painted corrugated iron lined with match boarding, sleeps two, shower only), or Admiralty Lookout (square, granite, functional but satisfying, sleeps four, solid fuel stove, no bath/shower, gas lighting, no electricity) try sampling the island first with a day trip from Ilfracombe aboard the *M.S. Oldenburg*.

The Old School

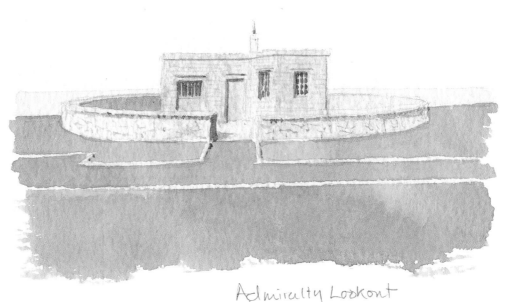

Admiralty Lookout

79

The *Oldenburg* is the island's lifeline, carrying supplies as well as visitors. She is not the most modern ship afloat, but is graceful nevertheless and vaguely reminiscent of the late, lamented *Britannia*, although greatly scaled down. The trip is more a short cruise (about two hours) than a ferry crossing, and for the journey the island sits enticingly astride the horizon ahead.

The day trip gives about four hours ashore, depending on the tides, and involves a steep walk up the footpath from the landing stage to the cliff top, but there above is the welcoming Marisco Tavern, where you can refresh your energy resources for the more gentle walking to come.

Lundy is a natural fortress of hard, grey granite, three miles long and half a mile wide. It offers a gently undulating plateau 120 metres above the sea, with cliffs rugged and almost sheer on its Atlantic side and more rounded and grass covered being merely steep along its east coast, which is what you see as you approach.

The surrounding waters are England's only Marine Nature Reserve and off the east coast the first official No Take Zone has been established to create a refuge for fish and shellfish and to help increase the wealth of marine life in general. The island once supported large populations of puffins and Manx shearwaters, but these have recently declined to critical levels. It is hoped the No Take Zone will also help the seabirds to recover, as will a Seabird Recovery Project set up by the RSPB in cooperation with the National and Landmark Trusts. Its main work is to rid the island of its rat population.

While enjoying a meal with some friends one summer's evening, one of them announced 'I see they're running that trip to Steep Holm again.'

'Trip to Steep Holm?' 'It's that paddle steamer isn't it? I'll send you the details.' It turned out not to be that paddle steamer (the *Waverley*) but another old pleasure cruiser owned by the same people, the *Balmoral* (a former Isle of Wight ferry).

Until that moment Steep Holm, all 900 by 400 metres of it, had not figured in my island itinerary. As there is no regular ferry service, there seemed little point including it in a book about islands to which we all have access. But maybe a once a year trip counts. It might not be frequent, but it could be considered regular. Suddenly a day trip to the island closest to my home seemed like a nice idea.

How wrong could I be?

We set off from the magnificently restored Clevedon Pier at 8.15 on a mid August morning that was cool, grey and overcast, breaking a heatwave that seemed to have lasted all summer long.

At this stage I was not sure of the day's plans, but as we were not due back for

Lundy South Lighthouse

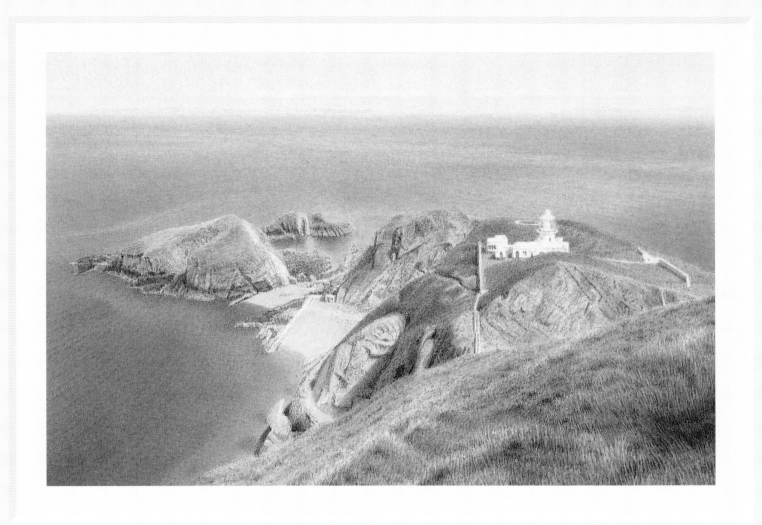

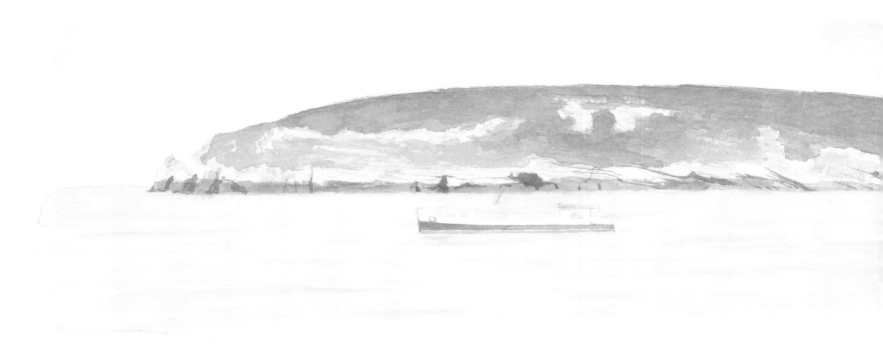

Bristol Queen at
Steep Holm

twelve hours, and Steep Holm was only an hour and a quarter away, a good few hours ashore looked in prospect. Not so. First we had to go to Minehead, two and a quarter hours away, to collect more passengers. At least the Bristol Channel was calm, and as we passed Hinkley Point nuclear power station a cheerful patch of emerald sunlight drifted across the Quantocks. If only it had been the shadow of a single cloud.

Did we then go to Steep Holm? No. We crossed to the other side of the Bristol Channel to pick up yet more passengers at Penarth.

We eventually arrived at Steep Holm at 1.15 pm.

By now, although the day had brightened considerably, a northwesterly wind had sprung up, and for forty minutes we watched as the boat that was to take us ashore (the *Bristol Queen*, formerly *Pride of the Bay* and once used for pleasure trips from St Helier, just in case you're interested in obscure information) tried unsuccessfully to come alongside.

Eventually the captain came on the tannoy to announce that Steep Holm was off. Instead, to get some shelter from the wind, we would cruise along the South Wales coast. My heart sank. By now I just wanted to go home...

Caldey (three quarters by one and a half miles) lies about a mile off the Pembrokeshire coast south of Tenby and has been a monastic island since the sixth century. There is a modern monastery, built between 1910 and 1912 for an Anglican community of Benedictines, which has been occupied since 1929 by Cistercians. They share the island with the substantial remains of a mediaeval monastery, an automated Trinity House lighthouse, former coastguard cottages, a post office which is also the Caldey museum and a tea garden.

Caldey is a popular destination on sunny summer days with up to a thousand visitors on a busy day. A small fleet of eight boats, two belonging to the monastery, ferry people over from Tenby. The boats start operating at Easter, and a few days after on a calm sunny day I was at the quayside kiosk where you book the trips. To my dismay, and despite assurances from the Tourist Information Office, a sign on the side read 'no sailings today, first sailing tomorrow 10.30'.

Someone appeared to be busying himself inside, so I waited until he emerged to ask why there was no sailing. He muttered something about the weather being unsuitable and disappeared. The next day's sailings were cancelled too.

The Shipping Forecast for sea area Lundy was northwest backing southwest 3 or 4. Showers. Good. If you can't sail a flat calm sea in a southwesterly 3 or 4 on a warm sunny day, then when can you? I suspect he thought it was hardly worth turning his engine over for just three passengers.

Such is the nature of travelling to islands: you don't always get there. After the second cancellation there seemed to be little point in hanging around so I went home, having spent the cost of the boat trip on a nice bottle of wine in the excellent Italian restaurant overlooking the harbour.

As with the ill-fated Steep Holm trip, I cannot give you an account of a visit to the island, but I can at least give you an insight into life at the monastery. My editor put me in touch with Patrick, a former work colleague of his who had been a novice monk on Caldey in the mid 1960s. I also spoke to the monastery's present Commercial Manager. Yes, you read that right: life there is not as primitive as you might think.

The Order of Cistercians of the Strict Observance, sometimes called Trappists, follow more strictly than the Benedictines the rules of life laid down 1500 years ago by St Benedict; rules that stress communal living and physical labour. They make vows of poverty, chastity and obedience. There were 36 in the community during Patrick's time there; today there are just 16.

Their's is a contemplative life, attending prayers and services seven times a day, the first at 3.30 am and the last at 7.30 pm with bedtime soon after. In between there is meditation and study along with periods of work.

> The first Abbot of Caldey was Pyro in the sixth century, recorded in the Welsh name for the island, Ynys Byr.

They are a silent order. Monks are only allowed to speak to the Abbot, and in the case of the novices to the Novice Master. Any other communication is in the form of signs and facial expressions.

They are also vegetarians. The unworldly Patrick seemed not to have been aware of this until the day he arrived there! As well as a 5 am breakfast there are two other meals a day, which include an allowance for each monk of a pound of bread, and all the vegetables they can eat. They now have fish on Fridays. The monks eat communally in a large vaulted refectory sitting at long scrubbed tables.

As a novice Patrick told how he wore a basic white robe – a button-up long sleeved and ankle-length tunic of unbleached wool, a white scapula – a hooded strip of the same material 45 centimetres wide and ankle-length back and front which sits on the shoulders, denim knee breeches, which served as underpants and were changed at bath time every week, and an all-enveloping white cloak, the formal choir garment. Monks that have taken the vows and committed themselves to staying there for life wear a cowl, the all-covering monastic robe.

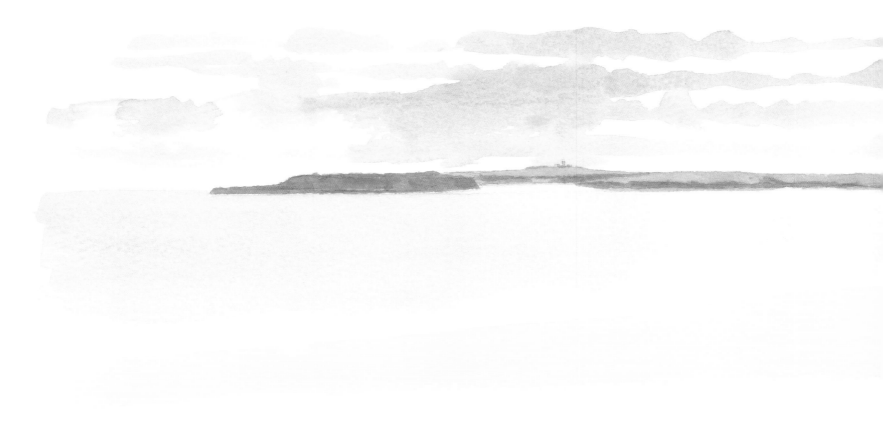

> Lundy, Steep Holm and Caldey have names that are Norse in origin.
> *Lundi* – Puffin, *ey* – Island.
> *Stiepe* – Old English for a steep place (to distinguish it from its neighbour. Flat Holm), *Holm* – an island in an estuary.
> *Keld* – Spring, *ey* – Island.

The monastery farms most of the island. They used to grow barley and keep a herd of Jersey cows which produced milk for making butter, clotted cream, yoghurt and ice cream, but today the land is given over to grazing for a herd of beef cattle and the only crop is grass cut for silage. The beef goes to local hotels and restaurants and to one local butcher. The monks maintain a kitchen garden for their own consumption and grow potted herbs and tomatoes to sell to the tourists.

The community also sells chocolate and shortbread made in their bread ovens, but the main income, that sustains their isolation, is from a range of perfume and toiletry products. These were initially made from gorse and lavender picked on the island, but increasing demand and dwindling labour means that today the essence is bought in. The monks use it to make their own label cologne, aftershave, bath essence, hand lotion, soap and other scented products.

They maintain two shops on the island, another in Tenby, and also sell by mail order and through their own website. No wonder they boast a Commercial Manager.

One enterprising monk has a digital camera and takes photographs of the island, which are also sold in their shops. As they rise so early, he does a good line in sunrises, so visitors may come across one labelled 'this morning's sunrise'.

In Patrick's day the monks did all the work, with the novices doing the backbreaking tasks, which even included shovelling 350 tonnes of coal by hand off the coal boat on its annual visit, but the dwindling monastery population means that today some of the work now has to be done by paid employees, many of whom make up the island's lay population of about 20.

I wondered if there was a number below which the community would become unsustainable, and if there was a contingency plan for such a situation. I questioned the Abbot, Father Daniel, and also asked how he saw the near future developing.

He explained that things became really serious in the 1980s when their number went down to just eight, and they had to make plans to sell the monastery and move elsewhere, so having 16 now is 'a tremendous turnaround'. He could not be certain about the future, but at the moment, although there are five members he described as 'pretty old', they also have a novice and three junior professed monks, whom he hopes will 'bind themselves for life within the next few years' and two more candidates who will be joining them over the course of the next year.

Island life clearly has its charms. So for the time being things are looking positive and Caldey will continue to be a monastic island.

Caldey from Tenby

Anglesey

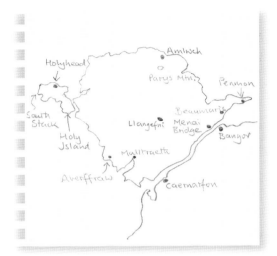

Many people make the journey across the Menai Strait to Anglesey, as is clear from the amount of traffic on the new A55 dual carriageway across the island, but I wonder if they merely see it slip by without actually taking notice. I suspect that the subtle intricacies of Anglesey's main theme is too gentle a tune to stir the emotions, following as it does the rousing fanfare of the drive through Snowdonia, or along the coast road from Llandudno.

The first to bridge the watery pause separating these disparate parts was Thomas Telford. It took him seven years (1819–26) to complete the task, one he began at an age when lesser mortals are contemplating a life revolving around slippers and open fires. Although he did not invent the suspension bridge, his chunky but elegant Menai Bridge (387 metres long with a central span of 177 metres) demonstrated for the first time that the principle worked when applied on the grand scale.

Within a quarter of a century and just one mile Robert Stephenson, son of George *The Rocket* Stephenson, had built Britannia Bridge to carry the railway from London Euston across the same stretch of water. For this task the box-girder bridge was invented; two rectangular iron tubes 458 metres long through which the trains ran. After a fire in 1970 the bridge was rebuilt as a tube-less double-decker with the A55 on top.

Two revolutionary forms of engineering applied within sight of each other to link a few square miles (261 more or less) of almost flat farmland with a mountainous region of a sparsely populated corner of Britain. Why?

The answer is Holyhead, or to be more precise, Dublin.

Mail between England and Ireland has been passing through Holyhead since the packet service began in 1573. After the Union of Britain and Ireland in 1801

there was a need to improve communications between the capitals. That is when the great Thomas Telford was brought in. His new road from Shrewsbury to Holyhead, the present A5, reduced the 286 miles journey time between London and Holyhead to a mere 27 hours. The railway reduced it to just nine and a half, and the average rail journey time now is four and a half.

Holyhead to Dublin is still an important and popular route across the Irish Sea, to the extent that Irish Ferries operate the world's largest car ferry, *Ulysses,* here. That's why so many people continue to come to Anglesey; not to be here exactly, but because it is an essential link on the way to or from somewhere else.

You do not, however, get to see the real Anglesey while you are bowling along the A55 towards Holyhead, and you should not judge the island from what you see of that town while searching for the ferry terminal. (It's on the right next to the railway station, between the aluminium works and the town centre.)

I'll say something about it now to get it out of the way.

You may have heard of a company called Farrow and Ball that makes traditional paints. As far as I am aware they have absolutely nothing to do with Holyhead, but they do make a colour that may have been inspired by the town; drab.

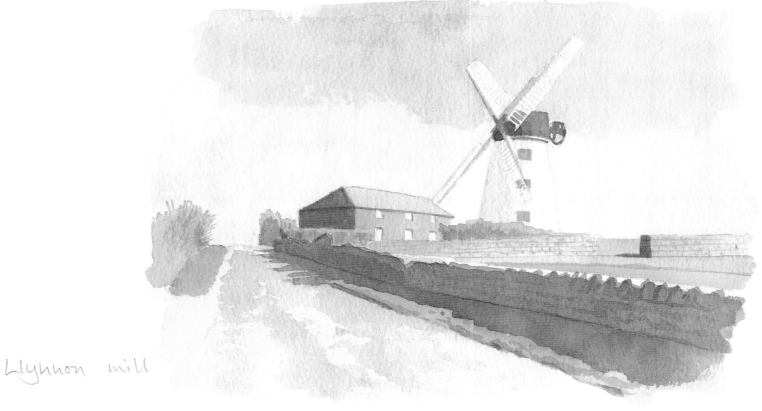

Llynnon mill

To be fair, Holyhead has plenty of history if you care to search for it (there are Roman remains, and don't miss the Maritime Museum), but on the whole all that is well disguised, and for the price of the *Rough Guide to Ireland* you can board the fast ferry and be in Dublin in less than two hours.

Actually, Holyhead is on another island off Anglesey, our second Holy Island (Ynys Cybi), so I suppose we should really call it Holy Head.

To see the real Anglesey forget the A55 and don't try following a map. Find a minor road (there are 734 miles of them to choose from) and just follow your nose, taking the least major road at each junction you come to. You may get hopelessly lost (OK then, take a map, but make sure it's OS Landranger 114 and not a road atlas), but if it's a nice sunny day you won't care in the slightest and you will discover that these country lanes are the real essence of the island. You get into its pastoral heart and see it as it really is.

Small 16 hectare farms covered the island at one time, and wherever you look the view will invariably include a number of Victorian farmhouses. Look more closely and you will also notice that the remains of windmills are almost as plentiful. In the nineteenth century there were 50 working windmills on Anglesey and as many watermills (there is now just one of each still working).

The island was once the breadbasket of Wales and was known as Mon, Mam Cymru – Anglesey, Mother of Wales. Today the land appears to be almost entirely given over to pasture. I asked my hosts, themselves farmers, why this change had occurred, but there was no clear or obvious answer to explain it. Maybe mechanisation did not suit these small farms with their small fields (still separated by hedged turf banks) and it became more economic to bring grain in from other areas. More recently farms have been amalgamating. The one I stayed on is farmed in partnership with a large estate, which a generation ago had 250 tenants. Today there are only 45.

With the exception of Llangefni, the place's administrative centre, the communities of this island's green and gentle heart are small and often amount to little more than a handful of houses. Anglesey's built up areas, the few towns and major villages, are on, or very close to, the 125 miles of coastline, and are linked by a round the island road. So too are a nuclear power station, an oil terminal and an RAF base, as well as the aluminium works. Oh dear, that all sounds a bit grim, but trust me, these are very minor blots on the landscape and they are big employers, essential for the island's economy. There are 67,000 people to support.

Before I made this trip, a friend who is a knowledgeable and active ornithologist brandished a copy of *Shorelands Summer Diary* and told me that I must visit South

St Cwyfan's Church, Anglesey

Stack, a favourite haunt of the superb wildlife artist Charles Tunnicliffe (1901–1979). He moved to Anglesey in 1947 and was both an artist and a conservationist. If you think you are unfamiliar with his work you will know it if you have seen the 1932 illustrated edition of Henry Williamson's *Tarka the Otter*, the government's Dig for Victory literature from the Second World War, or the Wild Birds of Britain picture cards given away in packets of Brooke Bond Tea sometime around 1962, if my memory serves me correctly.

Shorelands Summer Diary, which includes seabird illustrations studied at South Stack, is his own book and is an account of his first summer at his Anglesey home, Shorelands, on the Cefni estuary at Malltraeth.

So, on my first morning, in less than ideal weather conditions, I went to see South Stack. It is now an RSPB reserve where Holyhead Mountain (at a mere 219 metres; not a mountain at all) plunges spectacularly into the sea in near vertical

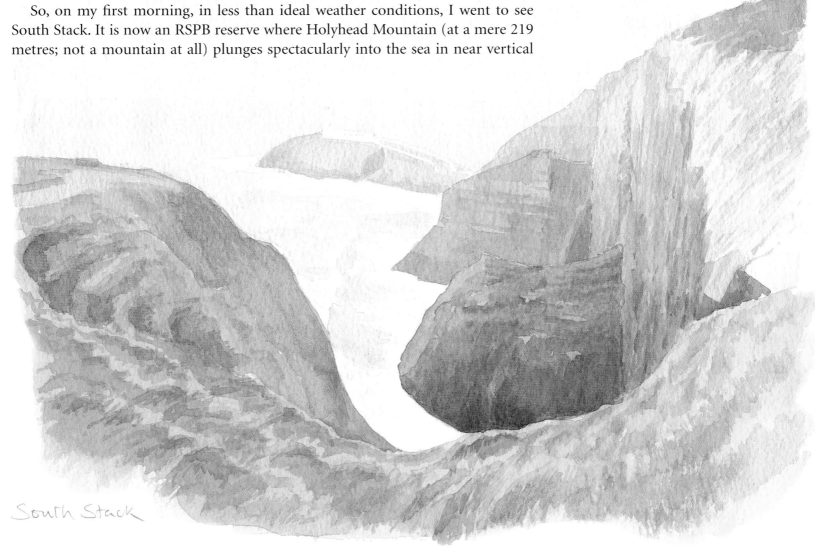

South Stack

> Copper mined on Anglesey dominated the world markets in the late 1700s. A must for visitors is the vast open-cast copper mine which has removed the top of Parys Mountain, an impressive, otherworldly chasm with piles of orange, purple, red, yellow and blue spoil, unusual plant life and a lake of sulphuric acid.

120 metre cliffs. On South Stack itself, a rock off the northwest tip of Holy Island, down 400 steps and over a small suspension bridge, stands the 28 metre high tower of South Stack Lighthouse, which helps to add a sense of scale to the scene as you peer down into the sea below from the dizzying heights of the cliff top.

This did not strike me as the safest place to be in the strong gusting wind and I was reluctant to get too wet so early in the day, so I went from there to Oriel Ynys Mon, Anglesey's public museum and gallery just outside Llangefni. Here they have on display the contents of Tunnicliffe's studio, as well as a large and varied collection of his work. The gallery (for which the Welsh word is oriel) was established principally to house the collection, bought by the Borough Council using mainly royalties paid to them by Shell in return for the use of the offshore oil terminal at Amlwch.

While at Oriel I did some research about a location recommended by my hosts, so when I had become completely Tunnicliffed I went in search of what they called 'the church in the sea'. It sounds intriguing, doesn't it?

The church, St Cwyfan's, is close to the village of Aberffraw, which itself is intriguing. Today Aberffraw looks quite ordinary at close quarters, although the setting is good. It is approached from the south across a system of huge dunes, which stretch inland for a mile and a half between two low parallel ridges. Aberffraw sits commandingly along the edge of one of the ridges and is reached across an old stone bridge.

The village's unremarkable appearance is surprising, because from the seventh century it was the seat of power in the mediaeval Kingdom of Gwynedd, in the twelfth and thirteenth centuries the predominant force in Wales, and the site of one of the three main courts in Britain. It is mentioned in the Mabinogion and there was even a Prince of Aberffraw. This all came to an end in 1282 with the conquest of Wales by Edward I of England, which is why, in Wales, you should be careful about using the word Edwardian; it has a different meaning here.

Modern Aberffraw gives no hint of this once glorious past and the actual site of the court is still uncertain.

The road through the village winds its way around a couple of farms before coming to an end at an isolated beach in a small bay. I parked, walked the last few metres, and as the whole of the bay came into view there it was, not quite as I had imagined it might be, but nevertheless a church almost surrounded by the sea.

Now, if you come from England you might be inclined to refer to the small single-aisled building that appeared before me as a chapel, but that is another word you should be careful about using here. In Wales chapel refers specifically to a Nonconformist church.

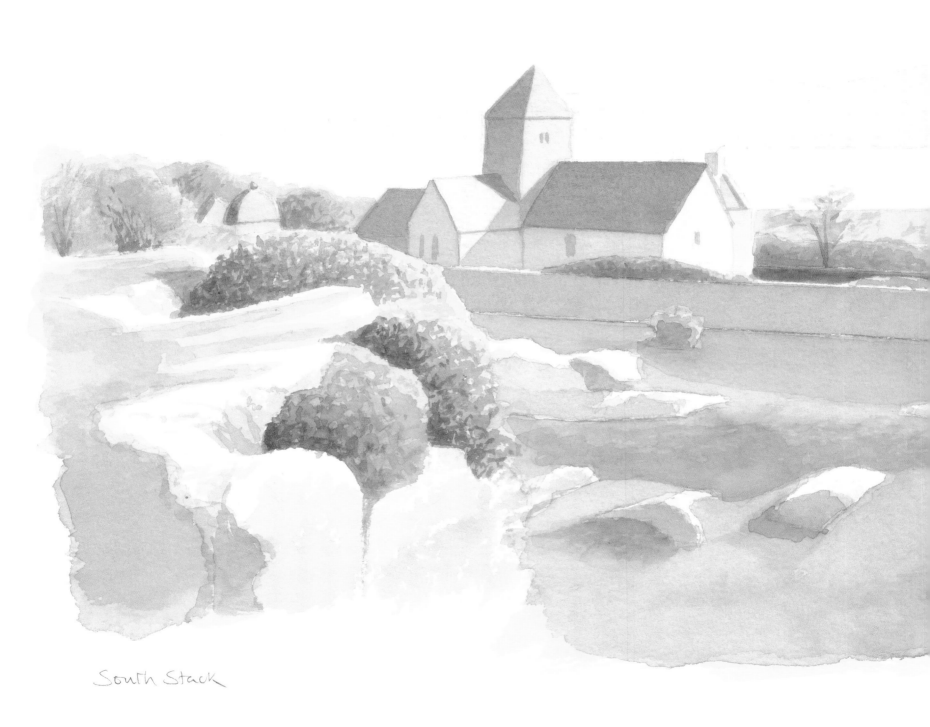

South Stack

St. Cwyfan's, in its form very similar to many others on Anglesey, was built in the twelfth century on a clay cliff overlooking the sea. Over the centuries the sea has been eating into the bay, pushing back the cliff line and gradually surrounding the church. Because of this a second aisle had to be demolished in the early nineteenth century. At the end of that century a stone sea wall was built round the 'island' to prevent any more erosion. For much of the time the church can be reached across the remains of a causeway, which is only covered by the highest of tides, unless the sea is particularly rough. Services are only held there three times a year, in the calm months of June, July and August.

I was hoping to turn this unusual site into a painting, but on this occasion at least, there was something lacking. I clambered 60 metres up the headland overlooking the bay to try to get a different viewpoint, but it was so windy that sketching would have been not just difficult, but dangerous too. I decided that sea level was the best place to be and that I should return another time when the sea might be higher and the weather improved.

Sure enough, later that evening, a heavy shower approached from across the sea behind the church and a sudden shaft of sunlight lit up the sea around it; perfect timing.

The next day was 'getting lost down the lanes day', and this day too ended with me clambering where I shouldn't to get a good view of some unusual ecclesiastical architecture. At Penmon, on Anglesey's eastern tip, with the mountains of Snowdonia as a backdrop, is a twelfth century Romanesque priory, which survived destruction at the Dissolution, becoming a rather grand parish church. There is also a splendid Elizabethan dovecot, and a country lane meanders gently through the complex, making for a 'nearly fell out of my seat' moment for unsuspecting motorists.

This had been my second painting/writing visit to Anglesey in a little more than two years and I have to say, it's beginning to grow on me, very much so. If someone said that I would have to spend the rest of my life here I would not be disappointed.

Isle of Man

Before package holidays to Spain took off in the 1960s the Isle of Man was northwest England's getaway destination.

In the 1820s the advent of the paddle steamer brought the island within range of those who could afford the £1 passage to enjoy the curative effects of bathing in Douglas Bay. In 1829 the island's own shipping company was established, providing a more reliable service for the growing population and encouraging more visitors. The Isle of Man Steam Packet Company began with the cut-price fare of five shillings and still operates today (although charging a bit more than that).

All through the nineteenth century the number of steamers and hotel rooms grew to cope with increasing visitors as Douglas became more fashionable. An estimated 3,000 visitors a year in the 1820s grew to a peak in 1913 of 600,000. To put these figures into some perspective, they amounted to less than one visitor per year per head of population in 1830 and twelve per head in 1913.

In the late 1940s the figures rose again to their 1913 high, but a slump soon followed, with a steady decline as people began to travel south in search of the sun.

Concerned by the fall, the Manx government commissioned a report in 1955 into what they called then the Visiting Industry, which recommended the encouragement of early and late season visitors and the promotion of the island's traditions and monuments – in other words, the unique Manx culture, including the introduction of Manx language street signs.

I asked the Department of Tourism and Leisure what the present visitor numbers were and the information they gave me made interesting reading. The total they described as 'tourist visitors' came to a little under 327,000 (54% sailing, 46% flying), a reasonably healthy figure (but still with a high percentage, 39.4%, from northwest England). However, of these 65% were there on business, visiting

friends and relatives, or as day trippers, the actual number staying in paid accommodation, which allows a direct comparison to be made with the earlier figures, came to a modest 114,000 or one and a half visitors for each head of population.

By coincidence, the day I started work on this chapter on my return from the island, the *Radio Times* carried a double-page advertisement for the island aimed at, as they worded it, the food fan, scenery searchers, activity addicts and heritage hunters. The only mention of Douglas was in the return address on the entry form for a draw to win a three-day island break. My immediate response to that possibility would, I guess, be a good measure of the island's appeal. So soon after being there to work, would I consider going back purely for pleasure? As a matter of fact, I would.

For this visit I did something I had never before considered when travelling around the British Isles. I booked a special-offer package, a four night stay in an out-of-Douglas hotel at a rate which, compared with the usual hotel and ferry charges, meant that I crossed with the car for nothing. I visited during the period the 1955 report described as 'the late season' and the hotel was, to my surprise, very busy with visitors taking in the scenery and the heritage sites, so the report had had some long-term success.

Although Douglas has its attractions, and the legacy of its heyday is that the town still retains something of a Victorian flavour, it is not the place to be for too long if you want to get a real flavour of the island. Walk down the main shopping street today and you could be almost anywhere in Britain, with the usual chain stores that make one town centre much like another, and not a great deal else.

This may come as a surprise if you are aware that the island has the same relationship with Britain as the Channel Islands. A low rate of tax (income tax for example is less than half that of the UK) and the offshore banking industry (they don't like to be called a tax haven) mean that it could fairly be compared with Jersey, which has, more or less, the same population. The streets of downtown Douglas, however, unlike those of St Helier, are not lined with shops selling perfume, expensive jewellery, smart clothes and other things you can fritter away your untaxed income on. House prices on the island are similar to those in the West Country, about two thirds of those on Jersey.

So what's the problem? With five times the land area, a much more varied and dramatic landscape, quiet rural areas and little traffic, I know where I would rather be if the situation was forced upon me. Sorry Jersey, but there's no competition, it would have to be Man.

> Man is a Crown Dependency, not part of Britain or the UK, but an independent self-governing sovereign country with the world's oldest continuously held parliament, the Tynwald. The Queen, as Lord of Mann, is Head of State, dealing with them through the Privy Council and appointing a Lieutenant Governor as her personal representative on the island.

Maybe it's the weather.

I think I struck it lucky there. We had showers, heavy ones, with the wind from the north, but that also meant there were some dramatic skies, particularly at dawn and dusk, and long cloudless periods. Visibility was good in the cool, clear northerly airflow.

In these conditions the island's position in the centre of the Irish Sea, almost equidistant from England and Ireland and a little nearer to Scotland than Wales, becomes apparent as the hills of the Lake District can be seen on the eastern horizon, those of Dumfries and Galloway to the north, the Mountains of Mourne to the west and, if particularly clear, but not during my visit alas, Snowdonia to the south.

As far as my potential painting subject was concerned I travelled, as always, with an open mind, but with the thought that as the island was so much larger than any I had so far visited (32 miles long, 13.5 miles wide), it would be good to travel inland to find something away from the coast. For no other reason than that, it would make a change.

All the island's towns are on the coast and during my stay I eventually visited them all, either in search of refreshment or to satisfy my curiosity and to be able to say 'been there'.

Away from the coast an undulating plateau of farmland rises inland to a range of hills that come to a 400 metre high ridge forming the island's backbone, with one peak, Snaefell, reaching 621 metres. Once you are among the hills it's possible to forget that you are anywhere near the sea.

My travels began on the lower hills in the south, gradually making my way north onto the higher ground and in the general direction of Snaefell. This was intended to be a scouting exercise, to familiarise myself with the landscape and, hopefully, spotting along the way locations that might prove productive on a return visit later in my stay, when I would spend more time searching on foot for *that* view.

By midday on my first morning I had covered plenty of ground, seen some very nice views, watched the cloud swirling around Snaefell's summit in an otherwise clear sky, but nothing had really grabbed my attention. I had spent a whole morning without experiencing a 'wow' moment. Panic was not the right word, but I began to wonder if I'd lost my touch. I was sure that to concentrate my search here was the right thing to be doing and that the island's essential character was going to be found hereabouts somewhere. But to go three hours in good scenic country without a bite was a disturbingly long lean spell.

Snaefell, with sheep

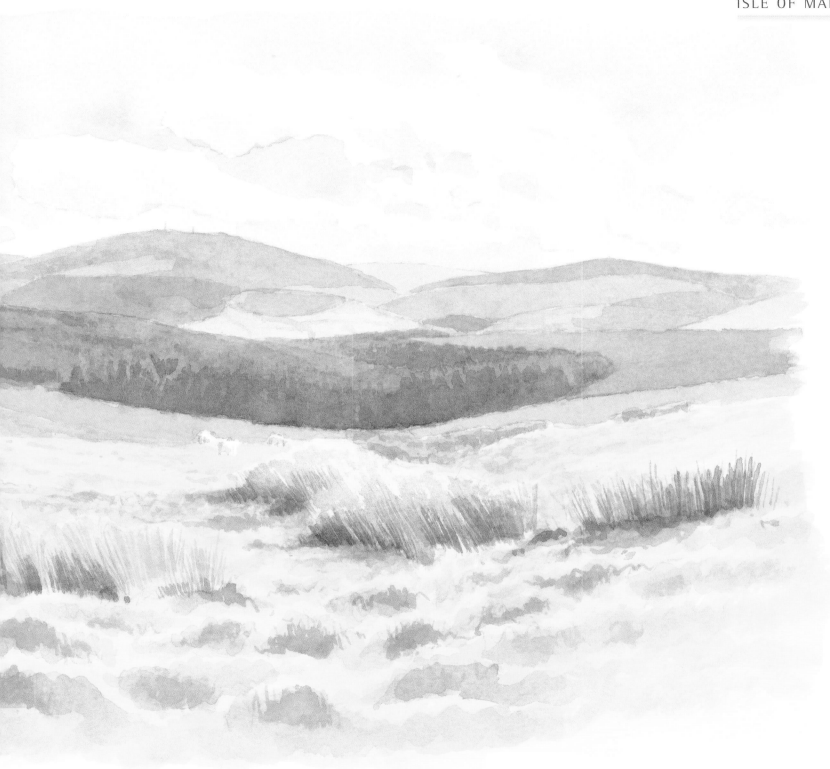

The Ordnance Survey came to the rescue. After pausing to study the map more closely I noticed a narrow single-track lane meandering through the hills that I had earlier skirted round on the main roads. Marked with chevrons to indicate steep gradients, it appeared to take a high route through open country with an uninterrupted view of Snaefell's western slopes.

After a twisting climb through conifer plantations the road levelled out and there was a magnificent view east across natural grassland and more conifers to moor and mountain. Getting me here had taken a certain amount of reason and experience, but knowing that this could be *it* is purely intuitive, and this felt like *it*.

tram at Laxey

Castletown harbour

After my moment of doubt less than an hour behind me, I was now in the position of still having two and a half days ahead, which I could now enjoy at a more relaxed pace.

Now that we still have most of the afternoon free and it's a lovely day, if a little fresh, why don't you jump in the car and I'll take you for a spin down the east coast from Ramsey to Castletown?

Running alongside the road between Ramsey and Douglas is a railway line, but keep a look out for what runs along it. You won't see any trains, you may see nothing at all, but you might spot one of the original Victorian single-carriage electric trams.

Just after Ramsey there's a headland off to the east, Maughold Head. In the church is a sandstone cross bearing the earliest known example of the triskelon, the island's three-legged symbol. In the churchyard a small open building houses an amazing collection of Celtic and Viking carved stone crosses. Some elsewhere on the island bear the signature of Gaut Björnsson, the Viking craftsman who carved them in the tenth century and these could well be the earliest example of an artist signing his work.

We then pass through Laxey, the place where that much-photographed waterwheel is; the largest in the world apparently. You have to look carefully for it as it's up a lane off the main road just at the point where the tramlines cross the road. The waterwheel is an impressive sight, but I think even better is to watch one of the beautiful old trams trundling along with the houses dotted about the

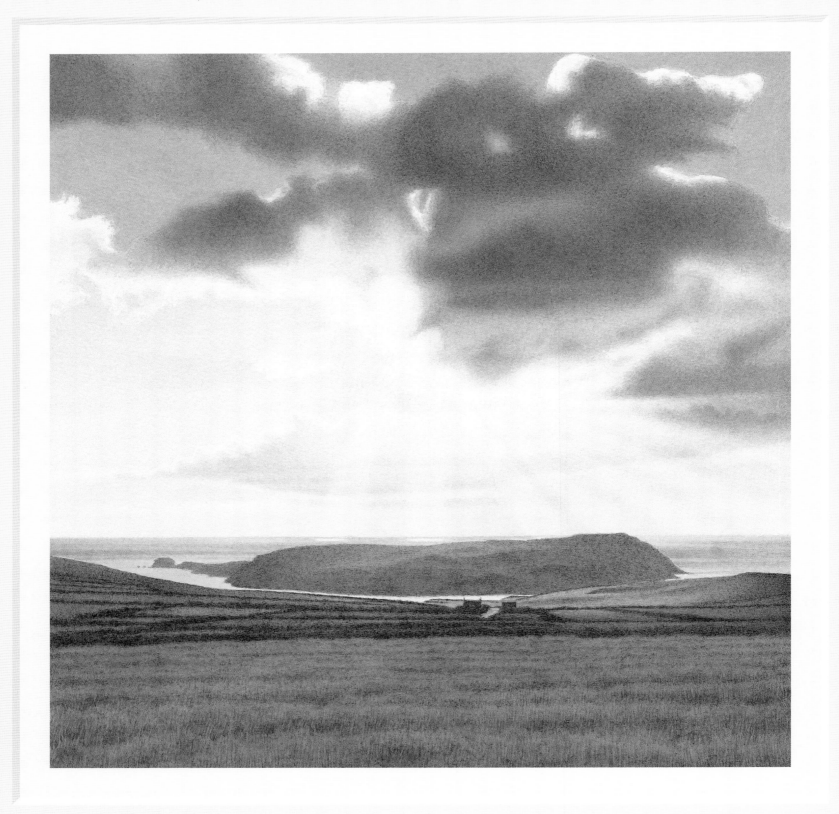

hillside behind, a scene as un-British as any you will see on these islands. The trams cross the road at an ungated crossing where you have to give way to them. They just give a high pitched toot and keep coming.

We'll save Douglas for another day. All I really want to see there is the museum, where they have a fabulous collection of the work of Manxman Archibald Knox, who designed much of the Celtic-revival silver and pewterware we associate with Liberty's at the turn of the twentieth century. Compare his decoration with the intricate interwoven designs on the stone crosses and you can see the influence of the island on his work.

The road south from Douglas passes through a spot called Fairy Bridge, where you have to say a greeting to the fairies for safe passage. Look carefully and you'll see that some people have even attached notes to them to the trees. We then pass over the narrow-gauge steam railway from Port Erin, which has been in operation since 1874 and as we approach Castletown we pass on our left the airport. Its name will be familiar to those who listen to the shipping forecast, as it's also the home of the Isle of Man Met Office – Ronaldsway.

Castletown is very attractive. I think I could cope with living here. The town was the capital of Man before Douglas became so important. The narrow streets twist round awkward corners to reveal cobbled squares and views of the sea. As the name suggests there is a castle, fourteenth century and not a ruin. The best view of the town is probably from the back of a seagull, but for second best, we'll take a walk along the harbour jetty and look back.

We still have at least another hour before the sun goes down, so I think we should drive down to see the Calf of Man. At Man's Land's End is The Sound, a narrow stretch of water separating Man from The Calf, a 250 hectare island of heather and gorse.

Before taking the road down to the shore I think we should pause at the top of the hill and admire the view of the island with the late evening sunshine, because that is one of the most stunning views I have seen for a very long time. The sun behind the cloud casting its rays down onto the sea makes it so atmospheric, and the cottage part way down the hill adds a sense of scale. I'm having another one of those *it* moments again, this could be a rival to the view of Snaefell for the Man painting.

What a stunning end to a great day. After such an unpromising start, it has been one of the best days I have had ever. Wonderful. Thank you Man.

So, what shall we do tomorrow? Take a wander round Peel and buy some lovely Manx kippers to take home perhaps...

Evening at The Calf of Man

101

Islands in the
Firth of Clyde

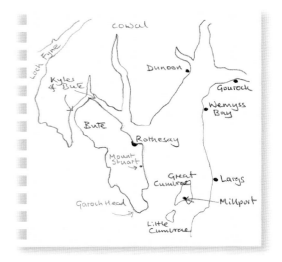

'**J**ust a ten minute ferry ride from the central industrial belt of Scotland the Isle of Cumbrae basks, oblivious of the world beyond, its only town Millport; the only seaside town that gives out free woolly socks when you buy your flip-flops.'

So began BBC Radio 4's *Millport*, Lynn Ferguson's bittersweet sitcom about life on a tiny Scottish island, revolving around Irene, a thirty-something barmaid played by the author herself, and her dream of escaping to, as she saw it, a better life on the mainland (Paisley in fact, as it turned out).

The cast of characters – Irene's older sister whose ambition was to have a story published in *The People's Friend* magazine, a Scots-Italian café owner convinced the Mafia were after him, a talking dog, and a bus driver who got through all his conversations with only his many variations of 'eh!' and 'aye!' – all painted a picture of a small isolated community who were, quite frankly, barking mad.

I was hooked from the first episode, and as the Isle of Cumbrae and Millport actually exist I just had to go there to see for myself what it was *really* like.

From the moment the bus from the ferry ('Return to Millport, please.' 'Eh?' 'You do come back?' 'Aye.') entered Millport I realised that Lynn Ferguson had been kind and painted a sympathetic picture. Her fictitious image being nowhere near as weird as the reality.

A board at the side of the road proclaimed 'You are now entering bandit country', the sign over a newsagent's read 'Nashville Gazette Office', a nearby bar was the 'Tombstone Saloon', the Indian restaurant 'Sitting Bull's Curry House', and so it went on from shop to shop.

Aaahhh! Get me out of here!

I soon discovered that I had, in fact, just missed Millport's Country and Western Festival. It was such a relief to know that, and to have missed it, even

West coast of Bute, with Arran

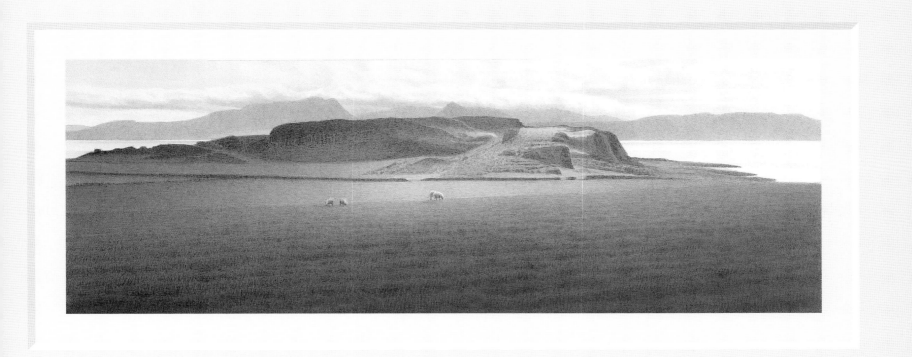

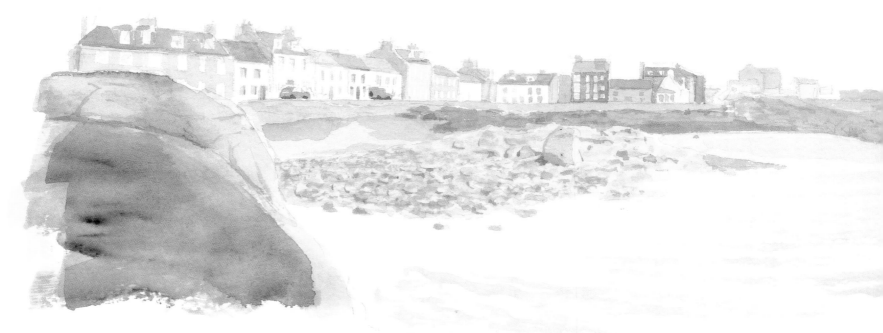

Millport

though they set a new world record for the largest line dance (nearly 300 apparently and raising £4000 for Cancer Relief in the process).

There are in fact two Isles of Cumbrae. The Isle of Cumbrae, all five square miles of it, is also known as Great, Greater, Larger or Big Cumbrae, and half a mile to the south lies the much smaller Little, Lesser or Wee Cumbrae. I confined my visit to the accessible main island and, of course, to Millport.

Cumbrae lies off the Ayrshire seaside town of Largs, with Millport unseen from the mainland tucked into a deep and wide south-facing bay, enabling visitors and residents alike to be oblivious of the world beyond. That, I believe, is why people come here.

As I alighted from the bus and began to wander along the long promenade, what struck me most, Wild West shop signs apart, was the lack of any modern development. The town seems remarkably free of twentieth century buildings considering that the central industrial belt is so close (Glasgow is less than 30 miles away). You would think that its combination of easy access yet away-from-it-all feel would have encouraged many flats and holiday homes to be built, but there are none. It remains a complete small Victorian town, and is all the better for that.

I think I should be calling it a village (1400 people live here), but with its many shops, cafés and urban-style houses stretched out along the bay (nearly all its buildings are in a line along the seafront) it has the look of a small town.

I was here at the beginning of September, a time when we have become accustomed to something of an Indian summer, but the weather was cool, cloudy and blustery. The few people around wore fleeces and hats and were cowering more than sauntering. It was difficult to imagine it packed with visitors on a sun cream and ice cream summer day. I guess this was Millport's cowboy summer.

There is little point in going to the expense of bringing your car over from Largs. Most people come as foot passengers and take the bus. If they want to explore the rest of the island they hire a bicycle. So that is what I did. With three hire shops having a thousand bikes between them I was spoilt for choice. There is a level road 10.5 miles long running round the island, so a two-hour hire gives plenty of time to enjoy it all.

Inland the island is a gentle hill divided into fields with small patches of woodland and areas of heather moor, a couple of small reservoirs and a golf course. Sheep and cattle graze, while from its 127 metre summit there are panoramic views of the Ayrshire coast to the east (including, it has to be said, the one blot on the local landscape, the nearby Hunterston nuclear power station), the hills of the Cowal peninsula to the north, and the neighbouring islands of Bute and Arran to the west.

But inevitably, the island's main attraction is Millport's gentle Victorian time-warp. Visit The Sweet Shop and buy some of their homemade tablet (a rich, harder-than-fudge concoction of sugar, butter and condensed milk) and take a leisurely stroll to the sublime smallest cathedral in Europe and the narrowest house in Britain at 120 centimetres (ridiculous). And I can report that there's not a talking dog to be found (sanity).

In the mid-nineteenth century the advent of the paddle steamer enabled tens of thousands of people from Glasgow to enjoy an excursion down the Clyde and a holiday at one of the new resorts which sprang up within their range. Places like Millport, and Rothesay on Bute, my next destination, grew like topsy to cater for this new form of travel. Over time, out of these and the many steamer services to the more far-flung islands, the ferry company Caledonian MacBrayne emerged. To get to any of the islands off the west coast of Scotland with your car you cannot avoid Caledonian MacBrayne, or CalMac as it is more commonly referred to in Scotland.

CalMac, based along the Clyde at Gourock, is a limited company with one share, which is owned collectively by the Scottish Ministers sitting in Holyrood. They provide the year-round lifeline to the west coast islands, and to enable this to happen they are given an annual deficit grant by the state along with an obligation to break even. On their 26 routes they carry about five million passengers and one million cars annually.

> Thirty six miles south of Cumbrae and Bute is the tiny Clyde island of Ailsa Craig. A volcanic plug two miles in circumference, 339 metres high and shaped like a muffin, it is a privately owned bird sanctuary and was once the main source of granite for curling stones.

EU competition law has deemed that they now have to tender for their own routes, as one package. A Rothesay resident told me that no one stood a chance of outbidding them as they owned the final ten metres of the Rothesay pier and it would cost a rival so much to lease it from them the service would not be viable.

This seemed a strange situation to me. Surely if CalMac is in effect owned by the state and the Scottish people own the pier, then they could allow anyone to use it. To get to the bottom of this I spoke to the man CalMac have taken on to deal with the tendering process. Initially his contract was for six months, but it has proved such a long-winded process he's now been there two years.

So, from the horse's mouth, here is a brief explanation of the situation. Whatever happens, under the new regime there will be an asset company established to own the vessels and piers, and these will be leased to the successful bidder, CalMac or anyone else, who will run the services as an operating company. Every six years the process of bidding to be the operator will be repeated. Whoever the successful bidder is, the vessels will still sail as Caledonian MacBrayne.

Bring on the talking dog.

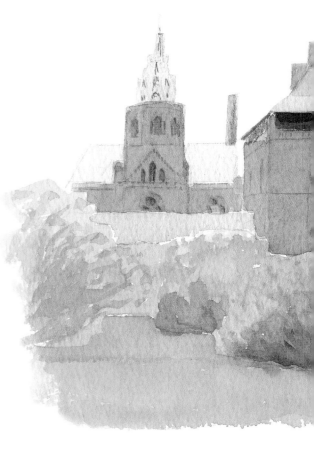

The 35 minute crossing from Wemyss Bay to Rothesay, Bute's only town, is CalMac's busiest route. Bute in many ways is like Cumbrae; mainly low, gentle farmland and with one town drawing the visitors. It is, however, considerably larger (roughly 15 × 4 miles) and The Royal Burgh of Rothesay, unlike Millport, already had a notable history as its impressive name and moated thirteenth century castle suggest, long before the invading hoards came paddle steaming down the Clyde from Glasgow.

In the recently restored cast iron Winter Garden, next to the ferry pier, is the new Discovery Centre, an interactive heritage exhibition where you can sit on a comfy seat and watch old early colour film of the last great days of the steamer age. The pandemonium as one steamer arrived after another, each disgorging its hundreds of passengers on to an already crowded quayside laden with carts piled high with visitors' trunks is remarkable. Not a suitcase, rucksack or car in sight. How things have changed!

Although most of Bute is farmland, the northern half is generally higher and less cultivated than the south and is tucked into a wide inlet of the Cowel peninsula making it almost indistinguishable from the mainland. Only the picturesque 400 metre wide waters of the Kyles of Bute separate it from the surrounding hills. The southern half, although more gentle (the geological fault dividing highland from lowland Scotland also divides Bute) still has its wild and rocky moments.

This north-south divide is always remarked on in guidebooks, but to me was of less interest than its east-west divide, about which I have found nothing written.

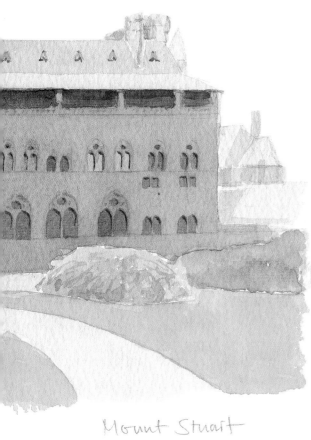

Mount Stuart

The east coast, although not one continuous ribbon of development is, nevertheless, almost that, particularly north from Rothesay Bay. South of Rothesay the houses are further apart, being more grand and secluded. They were built by the wealthy Glasgow industrialists who first established Bute as a holiday destination, but still a continuous line of buildings, ending with Mount Stuart, the grandest of the grand (about which more later). These east coast buildings look out on the Firth of Clyde and the mainland.

The west coast has hardly any development at all. The landscape is very rural and nearly all the buildings are agricultural. Along the coast are some wide sandy bays which, as this side of the island faces southwest, can enjoy more than half a day's sunshine when it chooses to come out. Nearly this entire coast looks out on the most stupendous view of Arran. There's no competition as far as I'm concerned; this is the side of the island to be on.

Although I was here to paint Bute, I just could not get over that view of Arran, and decided that I would need to find somewhere that showed some typical Bute landscape as a foreground with Arran as a backdrop.

I eventually found myself near Bute's southern tip, Garroch Head. Flat pasture ran down to the shore where an outcrop of basalt formed a fortress-like ridge, looking all the more impressive in shadow with the sea glistening behind it. As I made my study a small patch of sunlight moved across my view, illuminating the silhouette of the ridge and picking out the details; a brief moment of relief in an otherwise still and unchanging scene.

I ended my stay on Bute with a tour of Mount Stuart, the extraordinary home of the Marquesses of Bute. Houses of this size (I seem to remember 117 being mentioned as the possible number of rooms, but there was some uncertainty there) usually ramble, with wings added here and there over time. This house, begun in 1880 after a fire destroyed the previous one, is one vast block, clearly visible from across the Clyde at Largs. It is red sandstone, gothic and extravagant, and remained unfinished after 21 years of construction when the third Marquess, whose vision it was, died.

He was believed to be the richest man in Britain and no corners were cut. This was his mediaeval romantic fantasy with all the stops pulled out, full of detail and historical references; a house of illusion and allusion. Looking up from the main entrance it looks like a grand Venetian palazzo, but round the other side, which looks out across the gardens to the Clyde, it's a vast Flemish Guildhall. If you are a classicist or minimalist you'll probably hate it. I think I'm an Edwardian who usually prefers to see some restraint exercised, but I loved its exuberance. It had been worth making the trip across for this alone.

Arran

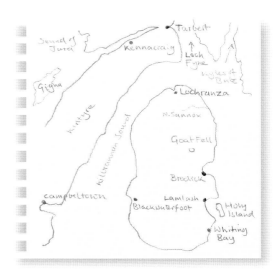

You could argue that Arran (kidney bean shaped, roughly 20 miles north to south and ten east to west) should be included with the Clyde islands, but as the water to the west, separating it from the Kintyre peninsula, is Kilbrannan Sound then I would suggest that it is *by* the Firth of Clyde rather than in it.

I'm also inclined to say that it doesn't matter. All that matters is that it is there.

Whether seen in the west 15 miles from mainland Ayrshire, a long blue silhouette sitting on the horizon, or ten miles to the south from the small ferry that crosses Loch Fyne from Portavadie to Tarbert, or four miles to the east from Kintyre, Arran always looks enticing and beguiling. It is big, mountainous and, because the veil of distance masks its richness and detail, mysterious.

How fortunate then that it is so visible and so accessible. The CalMac ferry takes just 55 minutes to cross from Ardrossan, making it a popular island to visit, but I would even look forward to a whole day aboard a ferry with such a ravishing destination at the end of it.

I have searched for a word that adequately describes Arran in a hope that it might help me to understand why I have apparently fallen in love with it. I found this definition in my Chambers dictionary: '...with qualities that give pleasure or delight to the senses...or which awaken admiration in the mind'. Awaken admiration in the mind; what a wonderful phrase. If we take admiration to mean to wonder at, then I think we are close. I would not have thought of using this word alone as it seems so overused and inadequate, but with that definition, Arran is simply beautiful.

Once you have seen that blue silhouette you do not need to read anything about Arran to make you want to go there. You need to know nothing else because nothing else matters. Its physical appearance is sufficient inducement, the perfect

Lochranza Castle, Arran

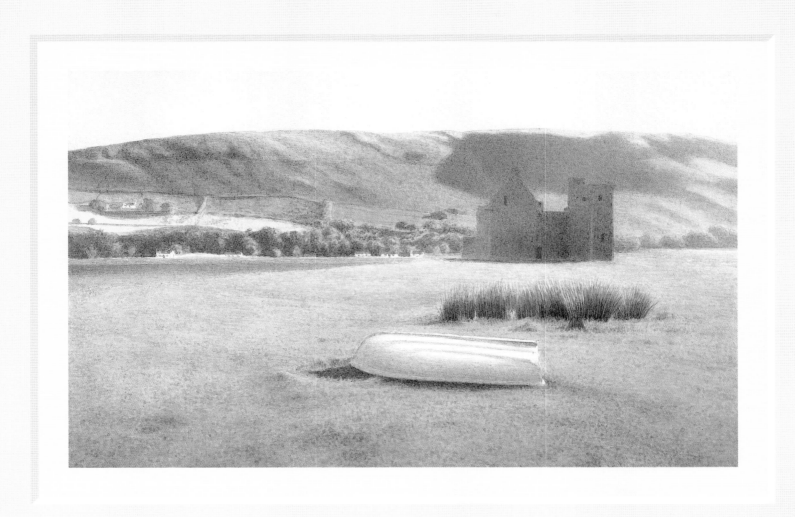

advert. It just reaches out across the water, slips an arm around your waist and whispers in your ear 'here I am, what are you waiting for?'

If I could be described as 'smitten of Wiltshire' then, in one of those strange isn't-it-a-small-world occurrences, so too was the Wiltshire born lady who ran the guest house I stayed at in the village of Lochranza. Her family first came here when looking for somewhere to take a long away-from-it-all break. After seeing the island featured on a TV holiday programme, they rented a house for a month at Blackwaterfoot, the only village on Arran's west coast. They loved it. While in Lochranza one day their attention was drawn by a flock of sheep coming down a lane; it was then that they also noticed a 'for sale' sign going up at a house at the end of the lane. They went and had a look, liked it, bought it and have been here ever since.

I had no particular reason for staying in Lochranza other than it is in the mountainous north of the island where I expected the more dramatic scenery to be, along with the fact that my original choice of accommodation also housed an art gallery and I thought I might find some kindred spirits there. They were, however, closed that week, but fortuitously recommended one of their neighbours.

Lochranza, as I discovered the next morning (having arrived at dusk) is, in my opinion, the most beautiful setting of any settlement on this beautiful island. The shallow sea loch, Loch Ranza, is a small 500 metre wide inlet on the north coast framed on either side by wooded hills that rise to 300 metres and with a straggle of white houses facing each other on either shore.

As I tucked into my Loch Fyne smoked haddock breakfast I was able to watch the early morning sun slowly draw the details of the opposite hill and shore from out of the obscurity of shadow. By the time I was out there in the calm warm air the whole glen was basking. An elderly man leant on his garden gate soaking up the peace. 'Lovely morning,' I said. 'Aye, it is that,' he replied. 'Is it always like this here?' I enquired. His wry smile indicated we both knew otherwise (average annual rainfall is 125 cms on the west side and 175 cms on the east, with 250 cms in the mountains).

A grass covered spit of sand projected into the loch from the near shore where we stood. At the end of the spit, in the centre of the loch, is the picturesque ruin of Lochranza Castle. The tide was low and inland from here the loch had almost completely emptied. Sheep grazed the shoreline marsh, a heron stalked the shallows on the seaward side of the castle and the only sound was of a small group of oystercatchers flitting noisily from one feeding spot to the next. Inland further, deer grazed along the edges of a fairway on Lochranza golf course.

Since the last ice age Arran has 'bounced back', the melting of the ice causing it to rise more than seven metres. The land that was once a beach is now, for much of its route, the coast road, with the old cliffs a hundred metres inland.

Before I came here I had been smitten by Arran's appearance from afar. At this moment I was seduced. I turned round and looked at the old man and his old cottage and thought lucky you, what more could one want?

South from Lochranza for three miles the otherwise coastal route of the 60 miles long road that circles the island takes an inland course, to the south of the hills that frame the loch. Just as it is about to rejoin the coast the road bridges the fast flowing North Sannox Burn that flows down North Glen Sannox. There is a car park here, and a footpath that follows the course of the burn up into the heart of the mountains that give the island its striking distant appearance.

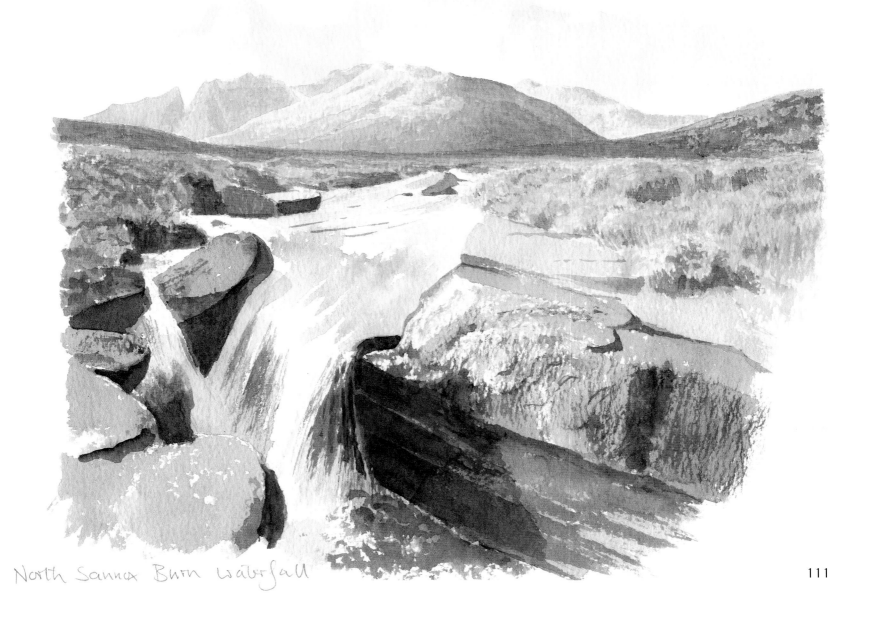

North Sanna Burn waterfall

Acting on a recommendation from my hosts and the fact that the fine and warm sunny start to the day was promised to continue, I parked and set off along the path, not knowing what I would find, but not expecting to experience a better moment than I already had, no matter how much I saw or how long I stayed.

One thing I very soon discovered was that after about 200 metres the hard surface of the footpath ends at the first stile, and after that wellies are more appropriate attire than walking boots. Fortunately, I already had mine on, not through anticipation of the soft ground, but because I could see that in places the burn flowed across wide, flat slabs of granite and I had an idea that mid stream on one of these slabs might be the ideal spot from which to sketch. The things I do for my art.

I trudged onward (probably no more than a mile) and upward (a mere 170 metres according to the contour lines on the map) for an hour, occasionally sinking almost to the top of my gum boots. The view of the mountains was obscured first by the trees of a conifer plantation and later by the heather covered ridge Creag Ghlas. Now and then I stopped to catch my breath, gaze at the sky hoping to catch my first sight of a golden eagle and, I have to admit, wonder if it was worth the effort.

Lamlash harbour – Holy Island

Eventually I, and the burn, rounded Creag Ghlas and I found myself looking up to a crescent of peaks culminating in the 859 metres of Caisteal Abhail (only 15 meters short of the island's highest peak, Goat Fell). Not only had I found a fantastic view, but just in front of me the burn cascaded in a series of waterfalls. What more could I ask for? It was well worth the effort after all.

What a day I was having with my sketchbook out and a nice rest on a broad flat rock. Still no eagles though.

The northern half of Arran is mountain and moor and sparsely populated. The south is hilly but more gently rolling agricultural land, mostly pasture and conifer plantations. Almost everyone lives in small hamlets along the coast road, or close to it, and most are in the island's southern half. The three main villages are on the east coast. Brodick at the mid point of the coast is where the CalMac ferry docks and where most of the shops are. Further south there is Lamlash, which is the administrative centre of the island, with also the secondary school and the hospital. Down the coast a little more is the small resort Whiting Bay. The majority of the island's visitors tend to stay in this southeast corner, which surprises me, as the north is a landscape visitors are less likely to encounter on a daily basis. Perhaps they are not looking for somewhere rugged and different, just an escape.

It is probably fair to say that you are unlikely to visit Arran to get a suntan. You

are more likely to come here to be active. There's golf (seven courses), fishing, pony trekking, and you can even learn to paraglide, but if that all sounds too energetic, just taking a stroll is probably the best way of enjoying the scenery. Even in the south there are some magnificent sights at the end of a not too strenuous walk. For instance, the Glenashdale Falls are only a mile and a half through the woods from Whiting Bay, or the Machrie Moor standing stones are about a mile from the road north of Blackwaterfoot.

As I live in the same county as Stonehenge and I have Avebury just down the road, it's easy to get a bit blasé about stone circles, but at Machrie Moor there are the impressive remains of six circles, with a good view of the mountains to the north.

Although I did not have time to try it out for myself, I understand that even Goat Fell is a manageable walk from the grounds of Brodick Castle providing you are clothed appropriately. A week after my visit, though, the mountain was in the news when someone fell off it.

If all that sounds too tiring you can intersperse the moments of activity with visits to some of the island's food producers, where you can sample some of their tasty wares.

Migraine sufferers look away now. There are two cheese producers, a chocolate maker, a brewery and a distillery (although this has only been going since 1995 so you will have to wait a while to sample their single malt).

If that still seems too mainstream, you can even take a course with the Buddhist community on our third Holy Island in Lamlash Bay. Inner peace leads to world peace it says on their booking caravan on the quayside at Lamlash. You can go there just for a boat trip and a walk, but you must refrain from smoking on the island, and if you take a picnic don't put in any alcohol.

The essence of Arran, what makes it special for me, is the variety. One moment you can be in the hills, away from all signs of human activity; the next you can be driving along by the shore, glimpsing the sea through trees. Or you might find yourself in a pretty hamlet like Corrie, with whitewashed cottages on one side of the road and a small jetty with fishing boats hauled out of the water on the other.

Arran has something to seduce everyone.

At the end of my visit I returned to Lochranza. From there CalMac's small landing craft type ferry takes you over to Kintyre in half an hour and you can sit on deck and watch Arran slowly slip back into mysterious blue silhouette mode.

Back on the mainland I had a five mile drive to Kennacraig on Kintyre's west coast where I joined another CalMac ferry for the crossing to Islay.

> Lochranza Castle is said to have been the spot at which Robert the Bruce landed in 1306 on his return from Ireland and before his successful bid for the Scottish Crown.

Islay

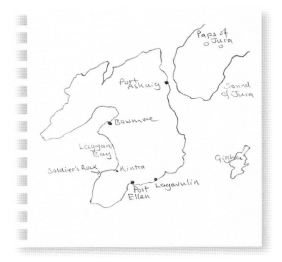

When I'm on the road, or even tramping across a peat bog, it is not always convenient to stop for lunch. Sometimes I am miles from anywhere all day. As I hadn't eaten since my Loch Fyne kipper breakfast at Lochranza and the ferry to Islay sailed at 6pm I decided to eat as soon as the ferry left Kennacraig.

There was not much that looked appetising. CalMac's idea of steak pie looks more like a dense beef stew with islands of puff pastry floating on it and their fish looks as if it has spent more time in a factory than in the sea. How many fishing harbours do CalMac ferries sail into every day? Haven't they noticed what goes on there?

I decided to play safe and have the lasagne; lots of good healthy ingredients with plenty of protein, fibre, antioxidants, complex carbohydrates . . . a balanced meal in itself. What more could you want? Well, according to CalMac; chips and peas.

As this was a two hours and twenty minutes crossing, those passengers who wanted to eat later in the journey had plenty of time to spend on deck watching the mainland slip by. Or so they thought. At about a quarter to seven came the announcement 'last orders for the cafeteria'.

One wonders who was being put first.

A suggestion to the shareholder: when it next comes to tendering for the routes, how about treating the catering as a separate item and awarding it to someone who can come up with appetising local dishes, giving a flavour of the islands and serving them for the convenience of the passengers?

I have to say, though, that the staff members are usually polite and helpful.

The sea was surprisingly calm considering the stiff breeze blew, or maybe it was just where I happened to be standing. I was the only passenger on deck to watch as we slowly slipped into a leaden dusk accompanied by a flight of Manx

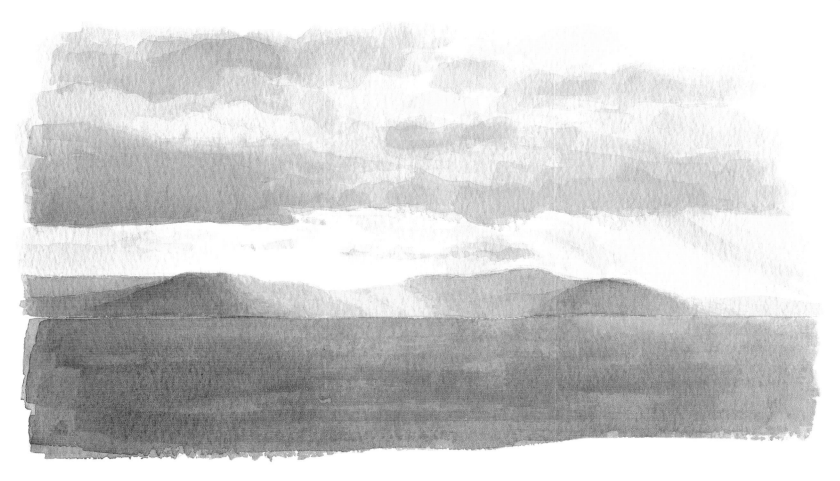

east Islay from the ferry

shearwaters. As we passed Gigha a small crowd joined me for a few minutes to watch a submarine surface close by.

I imagine it was only I and the crew on the bridge who later saw the short but spectacular light show as a small break in the clouds allowed shafts of the last sunlight to turn the hills of east Islay from the colour of stout to that of whisky. What an introduction, and how appropriate.

I'm a beer and wine man myself, but you cannot come to an island with seven distilleries on it and not go on one of the distillery tours. However, I don't like to waste precious out-of-doors time, even if I have no particular place in mind to be. So I thought it best to start my first day by going to the Lagavulin distillery to find out their tour times, so that I could consider that as an option if (when, more likely) the weather became indifferent. This whisky is the one I like most of those I have so far sampled.

On my way there a shower fell from a bright but fast moving sky.

'There's a tour starting in ten minutes.'

'Count me in.'

We were five (they like to keep the tours small and personal), the others being two young men from Switzerland, and two men who work together in Germany, one from New Jersey and the other from Hull. They all knew their whiskies intimately. In fact, I got the impression that this is how they spend every holiday.

Briefly, this is the process. Barley is steeped in water to allow it to germinate while it is continually turned to ensure uniform growth. When partially germinated the process is stopped by drying the grain over a peat-fired kiln. The resulting malt is then milled and the grist mixed with warm water, producing from the starch a sugary liquor to which yeast is added, thus fermenting the sugar into alcohol. This is then boiled in a pot-still, separating the spirit as vapour and condensing it back into alcohol. This last process is repeated in a second still to produce malt whisky, which is barrelled, then left to mature before bottling.

What I found extraordinary is how much is produced by so few.

At Lagavulin they get through 120 tonnes of barley a week, which yields 380 to 400 litres of whisky per tonne. They employ only 12 people.

It costs between £7 and £8 per litre to produce, but when you buy a bottle in the UK 68% of the cost is tax. It is estimated that £150,000,000 a year leaves the island to the exchequer.

They, and all the other distilleries, use a strain of barley called optic, which is grown specifically for the purpose. The tall blue industrial shed in Port Ellen next to where the ferry docks is Lagavulin's malthouse, which also prepares nearly all the barley used by the other Islay distilleries.

Lagavulin distillery

On the tour we sampled the liquor pre-distillation. It is basically a beer. We then tried whisky that had only been put into casks the day before, and distilled the day before that – 63.5% alcohol and sipped out of a cupped hand at 10.15 in the morning. What a way to go! At the end of the tour we sampled their standard 43% 16 year old malt and a new 12 year old cask-strength malt, 58%. We were then left for a while on our own, sitting in leather armchairs, with the bottles, to 'soak up the atmosphere'. We eventually emerged into a now sunny day three quarters of an hour after the tour officially ended.

I thought it wise to spend the rest of the day on foot.

In my room at my excellent B&B, Kintra Farm, was a framed photograph of a dramatic piece of coastline – headlands, tall cliffs, and in a bay a slim rectangular stack which had a diagonal white band of quartz through it. I asked where this was

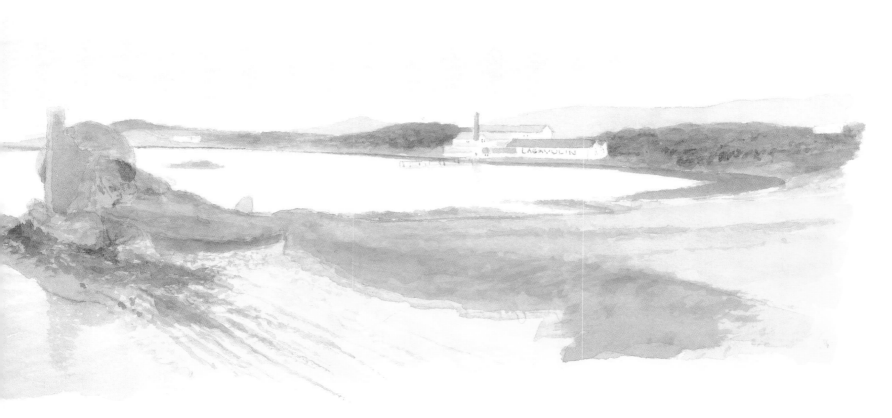

and was given directions from the farm. It was their land. The stack is called Soldier's Rock, as the quartz looks like the sash of a soldier's dress uniform.

The farmers, Hamish and Margaret Ann, have been working with a local group, Islay Community Access Project (funded by the National Lottery and Scottish Natural Heritage) to enable better access to this part of their land so more people can enjoy this stunning scenery.

As it had become warm and sunny while I was distilling, I allowed myself the rest of the day to enjoy the walk... and to clear my head.

By the time you read this, a leaflet and two interpretation panels will have been produced explaining the route, and a pedestrian gate installed where a fence and farm gate keep the cattle and some feral goats on the hill.

Once the route leaves the farm track and heads out towards the cliffs across a hillside, all evidence that anyone ever comes out here disappears; there is no well-worn route. What is there are the ruins of former crofting villages to remind us

that people once managed to scrape a living from this beautiful but difficult landscape. It was the potato famine of the 1830s that made it impossible for them to continue. They either moved nearby into the newly created fishing village of Port Ellen, or took the laird's offer of an assisted passage to a new life in Canada.

For the last ten years my painting trips have been almost exclusively round the coasts of the British Isles. As you can imagine, by now I have seen quite a lot of it and some of the sights I have witnessed have been breathtaking. When I reached the cliffs at Soldier's Rock I was overwhelmed. I tried to think of anything I had so far seen in Britain that came close to what stood before me, but nothing immediately sprang to mind.

At first I stood on the cliff edge, content to enjoy the view as I had first encountered it. When I moved to the edge of a narrow ravine, cut through the headland by the burn I had followed to get here, I discovered that the narrow headland on the other side of the ravine was in fact a huge natural arch, with the sea surrounding Soldier's Rock visible through it. This was even more amazing than I had first thought.

I was elated to have found this, yet saddened that so few people get to see what must be one of the wonders of the British coastline. To think that seeing this all hinged on me choosing to stay at Kintra Farm and Margaret Ann deciding to put me in that particular room.

I walked back to the farm on the seaward side of the hill under a clear blue sky, following sheep tracks through the thick heather and enjoying a wonderful clear view across the five mile wide Laggan Bay and the north and west of Islay. Beyond were the two prominent and distinctively shaped hills, the Paps of Jura (look up pap in the dictionary for an explanation) more than twenty miles away.

Apart from the chilly start on Cumbrae I had been fortunate with the weather so far, but I suppose it was inevitable that on this four islands journey I would at some time encounter rain, and so for the rest of my stay on Islay most, but not all, of my time out of doors was snatched in the drier periods between some prolonged and at times heavy rain.

So far my travels had been confined to just a few square miles surrounding Port Ellen, but as Islay is 235 square miles in area I still had plenty of island to see.

The southeastern third of Islay is trackless peat bog and hilly moor, but the rest is relatively flat and green, the most fertile farmland in the Hebrides. You will see sheep or cattle grazing most of the land, the main crop being grass for silage to feed the animals through the winter. Barley, which you might think would be grown here considering the demands of the distilleries, is only a small crop and

Natural arch and Soldier's Rock, Islay

119

whisky galore
(Port Ellen)

grown not for its grain but for straw, as bedding for the animals. Optic is bought in from wherever it can be most economically obtained. Lagavulin's current stock was shipped from Cornwall.

Bowmore is the nearest thing Islay has to a town. It is small, but caters for the whole island. There is a long and wide inclined main street with shops, cafés and hotels; at the lower end is the harbour and at the upper a round white church with a conical roof and a stout square stone tower topped with an octagonal cupola.

> The tidal range on the east coast of Islay is the smallest in Britain, with spring tides ranging between just 0.6 and 1.5 metres and neap tides showing no discernible movement at all.

There is also another of Islay's famous distilleries (these tend to be white too, and topped off with small pagodas).

Although it was raining the first time I passed though Bowmore, I decided that one distillery tour had been enough, so did not linger. When I passed through again later I wasn't entirely surprised to see the two young Swiss men I had toured Lagavulin with staggering along laden with Bowmore Distillery Shop carrier bags.

I stopped and had a chat and discovered that, as I had suspected, they had spent all their time here touring the distilleries, but was heartened to learn that they thought Lagavulin's the best tour.

I hadn't come out here just to tick islands off a list, but while standing on the quayside in Port Askaig (the lunchtime CalMac ferry comes here instead of Port Ellen) during some particularly heavy rain, and feeling totally uninspired, I noticed the Jura ferry was in. I thought instead of standing and getting soaked, for £2.40 return I could go to Jura (five minutes and just half a mile across the Sound of Islay) and stand around and get soaked over there for an hour, so I did.

Why do I do these things?

The water was fast flowing and choppy and we appeared to make most of the crossing sideways. I noticed this less-than-reassuring sign on the ferry: 'Space must be left to allow passengers to escape easily from vehicles.'

Not wanting to pre-empt anything I might do in the future, here's something about Jura. It's twenty eight miles long and mostly uninhabited and inaccessible. History, including the notorious clearances, has largely passed Jura by. Being one of the least fertile islands it has not been worth exploiting or colonising. Its population of 200 rely mainly on its 6000 red deer, 20% of which are killed each year, producing 50 tonnes of venison. The animals are the most efficient food converters of all the ruminants and require no feeding, no housing in winter, and no visits from the vet. Not only that, people actually come here and pay to kill them for sport. Jura hinds have provided most of the breeding stock for Europe's farmed deer.

There is also yet another distillery.

On my last evening on Islay, after the rain thankfully had stopped, I disturbed a large bird of prey while on the dunes near Kintra. I hadn't noticed it on the ground. It appeared to lift off in slow motion, its wings forming two graceful arches. I have seen plenty of buzzards, and on my first day here got within three metres of one. I am familiar too with red kites, which I can see within a short walk of my home, but I had never before seen anything this dark in its colouring or this big. I am sure this was my first golden eagle. It gave my trip quite a finale.

Iona

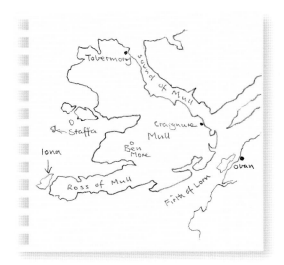

For many visitors Iona's attraction is its association with St Columba and everything that is here as a consequence of his arrival here in 563. It is a place of pilgrimage.

Very little is known about Columba, and how much you believe probably comes down to how much you want to believe. To begin with, Columba is not his name. That is a Latinised version. His Gaelic name was Colum Cille, which means Dove of the Church.

In his time Iona was part of a sea kingdom, Dalriada, a result of Irish invasions of the west coast of Britain. The island became I Chaluim Chille, the isle of Colum Cille. The name, slightly anglicised, was used by Shakespeare in *Macbeth*. When asked where Duncan's body is, Macduff replies, 'Carried to Colmekill, the sacred storehouse of his predecessors and guardian of their bones'.

This is a reference to the burial ground where the remains of 48 Scottish, eight Norwegian, four Irish and four Manx kings are said to lie (the last being Duncan in 1040), although none of the graves are indentifiable today. It is said they were buried here because they believed the soil to be so sacred it would expunge their sins.

Columba arrived on Iona under a cloud, having been involved in an argument over an illegally made copy of *St Jerome's Psalter*. He won the argument, but 3000 men lost their lives in the battle it provoked. To repent, he went into exile accompanied by 12 monks and it is said that he chose Iona because it was the first land they found from where Ireland was not visible.

The monastery Columba founded became a great seat of learning and for a time was the Christian centre of Europe. St Aidan, founder of Lindisfarne was from Iona, and the *Book of Kells*, the greatest tangible legacy of that time, was started here. The monastery was eventually abandoned in the tenth century, primarily the effect of numerous Viking raids.

Nothing from Columba's time remains above ground today. An Augustinian nunnery and a Benedictine monastery were established at the beginning of the thirteenth century and the monastery was substantially rebuilt and added to over succeeding centuries. Iona's isolation was not enough to prevent both from being ransacked at the Dissolution.

In 1899 the then owner, the eighth Duke of Argyll, transferred ownership of the buildings to the Iona Cathedral Trust, which was linked to the Church of Scotland. The Trust reroofed and reglazed the Abbey church between 1902 and 1910, enabling services to be held there once again.

In 1938 the Iona Community, an ecumenical Christian body, was established. After nearly 400 years, a working religious community had returned to Iona. Initially they brought together craftsmen and trainee ministers to restore the other monastic buildings on the site to bring them back into use, the physical renewal of the buildings being intended to achieve the spiritual renewal of the trainees. The rebuilding work was completed in 1965.

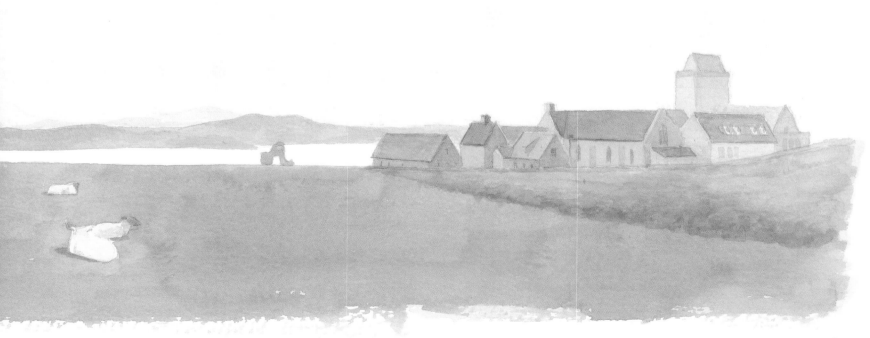

the Abbey, with Mull in the background

Iona lies less than a mile off the southwest tip of the Isle of Mull at the end of the long peninsula the Ross of Mull (the end of which, I was disappointed to discover, is not the Mull of Mull). On a southwest to northeast axis, it is three miles long and one wide and low lying, with its highest point being only 100 metres. It is a traditional crofting community with a population of about 130.

You have to make a special effort to get out there as it is not on the way to anywhere else. Tour boats will go during the summer months, often also visiting nearby Staffa to see Fingal's Cave, but to get there by regular service means using the frequent ferry across the Firth of Lorn from Oban to Craignure on Mull and then, after crossing Mull (34.5 miles), the short ferry crossing from Fionnphort.

You can take your car on the Oban ferry, giving you the freedom to enjoy Mull while you are over there, but you cannot take your car to Iona; only Iona residents can do that.

Although this is not a particularly straightforward journey, the little CalMac landing craft ferry across the Sound of Iona carries a quarter of a million passengers a year, making it their seventh busiest route.

Like Columba, I too arrived on Iona under a cloud, a blanket of cloud that stretched to the horizon in all directions, turning a potentially warm early May Saturday into a miserable chilly damp day, as dreary and grey as any winter's day can be.

I did, however, enjoy my drive across Mull from Craignure; along a mostly single track road, up and down and round small hills and along the shore of Loch Scridain, with some spectacular views of the mountains.

As the road descends the slight gradient into Fionnphort the first view of Iona is seen. This is not spectacular, and with the Sound of Iona being narrow and hidden from view, you could think it was still Mull ahead, but then the grey stone Abbey emerges from its grey stone background and there it is, and so close.

How incongruous this huge building looks when, finally, you get to stand on the Fionnphort slipway and view it in its setting, just to the right and north of the single row of cottages that make up most of Baile Mor, Iona's village.

I took the first ferry of the day.

From the Iona slip a lane leads inland a short distance up a gradient, with some small houses and a couple of shops on the left and a tiny post office, which is almost on the beach, on the right. Also on the right is the lane which passes in front of the main row of cottages.

Behind the first of the cottages stands the still ruined nunnery, and beyond that a track leads off to take you along the back gardens of the cottages and out towards the Abbey.

Upkeep of the Abbey proved to be such a financial burden to the Iona Cathedral Trust that it was handed over to Historic Scotland in 2000. Care of about half the island's land has been the responsibility of the National Trust for Scotland since 1979.

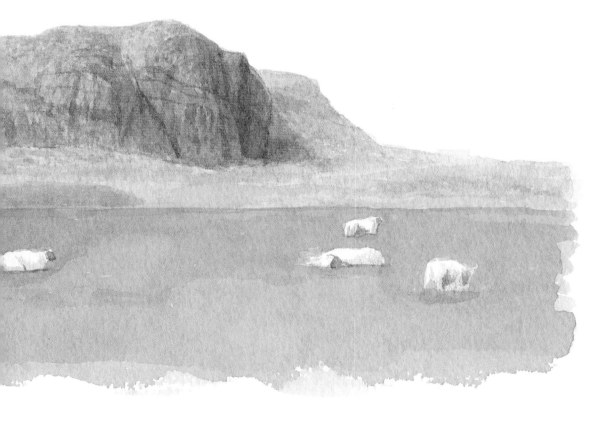

natural Iona

To the left among trees, with a rocky hillside rising steeply behind, are the school, the former manse, now Iona Heritage Centre, and the village church.

From here the ground rises a little, and once past the St Columba Hotel (which serves very good lunches) the view to the right opens out, with the Abbey in the foreground and a panorama of the west side of Mull and its mountains in the distance.

Seeing the Abbey complex at close quarters with the Sound of Iona and Mull behind and surrounded by sheep did not change my initial impression. These buildings look so out of place in this setting. Maybe it is because we are conditioned to seeing such buildings as picturesque ruins.

Beyond the Abbey the lane continues out towards the north of the island, with more fields of grazing sheep sloping gently away to the shore on the seaward side, and inland more grazing sheep and hills of bare grey rock – natural Iona.

It could all have been very peaceful, but as the day wore on and the ferry brought more and more visitors the lane between the slip and the Abbey became a busy thoroughfare.

Some may have been on a pilgrimage. I had the sense that on the whole most of the visitors had come here for a purpose beyond curiosity, but the numbers did nothing to add to the sense of it being a special place; curiously they dissipated it.

On the exposed open deck of the ferry back to Mull everyone was wrapped up against the elements in thick fleeces and woolly hats, except for one large distinguished looking man in an immaculate pin-stripe suit. He was the former Lord Chancellor, Derry, Lord Irvine of Lairg.

It had certainly been a day for incongruities, and I couldn't help thinking that my visiting Iona had been another of them.

Skye

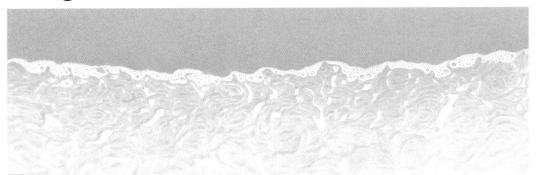

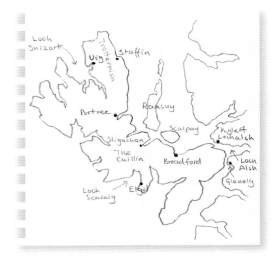

To some it's the misty isle, for me it's misty eyes. You would have to be the epitome of soullessness not to be moved by its grandeur and beauty.

Let us get a few facts out of the way first. They are useful to know, interesting even, but something of a diversion when contemplating the sublime.

Skye is a bunch of peninsulas tied into a knot. By road its most southerly and northerly points are 70 miles apart and the easterly and westerly 68 miles. The coastline is so indented that it is nearly a thousand miles long and nowhere is more than five miles from the sea.

That is the unromantic view. The romantic view is that the island is so astounding it would melt a cast iron heart buried in the Antarctic.

I still have a vivid memory of the late October day in 1991 when I first caught sight of Skye. I had set off from a grey Glasgow in an icy gloom and heavy rain. By Loch Lomond the rain had turned to sleet and after Crianlarich, snow that brought me down to second gear with the wipers on double speed. Fortunately this was a hire car and I trusted its youth. The novelty of a first sun-roof experience meant that I had it open with the heater on full blast – well, you've got to live a little. Bizarrely, from the radio the Mamas and the Papas sang *California Dreamin'*.

By Fort William the snow had stopped and as I passed the Five Sisters of Kintail (mountains, not a roadside tavern) the clouds had cleared. I arrived on the ferry slipway at Kyle of Lochalsh at sunset when the sky had turned turquoise and all that the setting sun illuminated was Skye's snow-streaked Cuillin mountains, glowing bright orange as if lit from inside by a volcanic bulb. This was Mother Nature's neon sign that flashed 'naked landscapes, continuous showings'. At this moment an American might have exclaimed 'Awesome!'. Magnificent was sufficient.

> Skye has an area of 700 square miles, populated by 15,000 people and 100,000 sheep, but these are outnumbered by the 500,000 visitors attracted there annually, making it Scotland's most visited island.

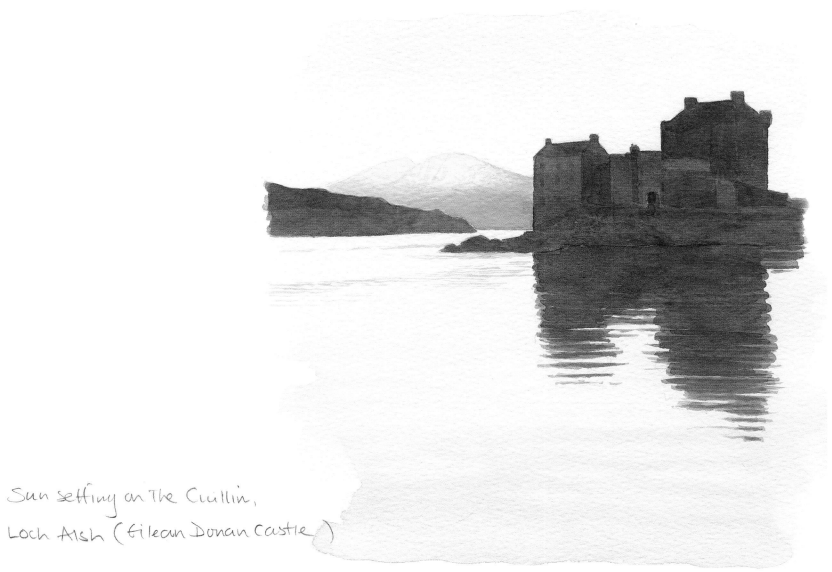

Sun setting on The Cuillin,
Loch Alsh (Eilean Donan Castle)

Sadly, the Caledonian MacBrayne ferry I caught for the half a mile crossing that magical evening no longer runs; there is *that* bridge instead. The first physical link between Skye and the rest of Scotland since the ice age, it was a condition of its construction that the ferry should not continue as competition.

Until people-power forced a change, it was a private toll bridge partly owned by an American bank, and the fact that the toll booth was not at the Skye end was seen as somehow symbolic by some of the islanders. Many signed a petition to say they didn't want the crossing, but they got it anyway.

Tolls were high, between seven and nine times those at the Forth, Tay or Erskine Bridges and locals say it was the only place in the world where you got mugged *and* got a receipt.

There's now an alternative ferry crossing from Glenelg on the other side of Loch Alsh from the bridge (turn off the A87 at Sheil Bridge – a road that prepares you well for driving on Skye). This is a revival of the old drovers' route and the departure point for Dr Johnson and James Boswell on their tour of the Hebrides in 1773. It only runs from April to October and isn't any cheaper than the bridge was, but at least it's there if you cannot bear to use the concrete monstrosity. You won't see herds of cattle swimming across anymore but you might be lucky enough to spot seals and otters on the five minute crossing.

If by now you have started to hum to yourself Robert Louis Stevenson's *The Skye Boat Song*, 'over the sea to Skye' refers not to either of these short journeys but to Bonnie Prince Charlie's and Flora Macdonald's stormy crossing of the Minch from Benbecula to Kilbride Bay north of Uig on the Trotternish peninsula.

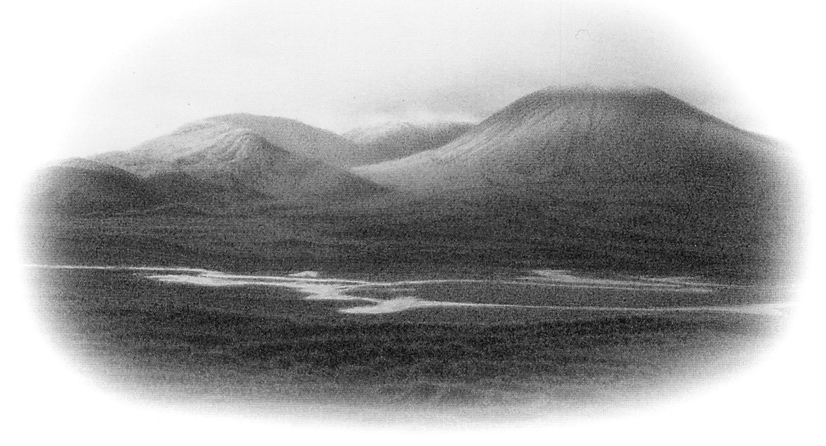

The Red Cuillin from the Elgol road near Broadford

For much of its route the main road north to Portree, the island's capital (and then on to Trotternish, my particular favourite part of Skye) follows the east coast, skirting round the shore of sea lochs and climbing over headlands where mountains reach down to the sea, a giant switchback ride which, seen from a distance, barely scratches the surface or disrupts the harmony of nature.

The drama of this journey north really begins after passing through Skye's second community, the useful but unremarkable Broadford.

After calming you with attractive views to the north of Skye's satellites Scalpay and Raasay the road sweeps ninety degrees left to head southwest along the south shore of Loch Ainort. Approaching the head of the loch you are hit by the most spectacular view of the near vertical north face of Marsco, 736 metres high and always in shadow. You enter a vast dark amphitheatre of rock with its glittering cascades of water, scarcely able to concentrate on the road ahead.

I would recommend a first time visitor to find somewhere to stop and get out so your jaw can drop all the way down to your feet; you will never forget this moment. There is nothing to humanise the landscape on this island; no exploitation by centuries of farming, no major quarrying scars, no great feats of Victorian railway engineering, no modern motorway embankments or cuttings, just its chilling majesty. This is Skye at its most gloriously overpowering.

There are not many roads that bring you this close to the savage side of the island's scenery and this is a good introduction to how wild Skye can be.

I recounted my feelings about this spot to a friend who, like many, is unable to get through life without an occasional 'fix' of the Cuillin. His reply was 'by the time I've reached there I'm just thinking about Sligachan' (pronounced Sliggan).

Onward over the next mountain headland and along the south shore of Loch Sligachan is the Sligachan Hotel, from where the view south of these stunning mountains has opened out into a grand panorama. From here it becomes clear that the Cuillin are in fact two distinct ranges; to the left the rounded cones of pink granite that are the Red Cuillin and to the right, separated from them by Glen Sligachan, the older, jagged dark grey crystalline peaks of the Black Cuillin.

To reach the latter is a three-mile trek across boggy moorland. It's a deceptive distance, but a necessary beginning nevertheless for those who use this as a starting point for a walking or climbing expedition.

I have to admit that I have not attempted it so far. The peaks look far too forbidding. As my friend put it, 'it's not the sort of place you mess around with'. He promises to take me one day. It is something I want to do, but I am concerned about the little phrases like 'it's a bit of a scramble up the last bit' that frequent his

accounts. He's talking about something that is sheer and loose and 900 metres up. For me this translates into 'this is difficult and not for the faint hearted'.

Once up there you are onto a narrow, rocky, seven mile long ridge that links 20 peaks, 11 of them Munros. It's the potential view from the top that makes me want to do it.

Our discussion of the mountains also touched on the tricky subject of their name, do we call them the Cuillin or Cuillins? I looked into this, and checked with the family who actually owned them. They use Cuillins, but I felt that was not a valid reason for doing the same – after all where would we be if newsreaders had to pronounce place names as the locals do? As with many landmarks visible from the sea around Scotland the name is Norse in origin, so sticking an s on the end is merely anglicising it, and as I tend to the argument that changing tricky non-English place names because they are hard to spell or pronounce falls somewhere between laziness and arrogance, I choose to go with Cuillin.

Off the main road at Broadford is a 14 mile long B road that ends by the slipway at the village of Elgol from where there is, in my opinion, an even more amazing view of the Cuillin seen to the north across the sea loch Scavaig.

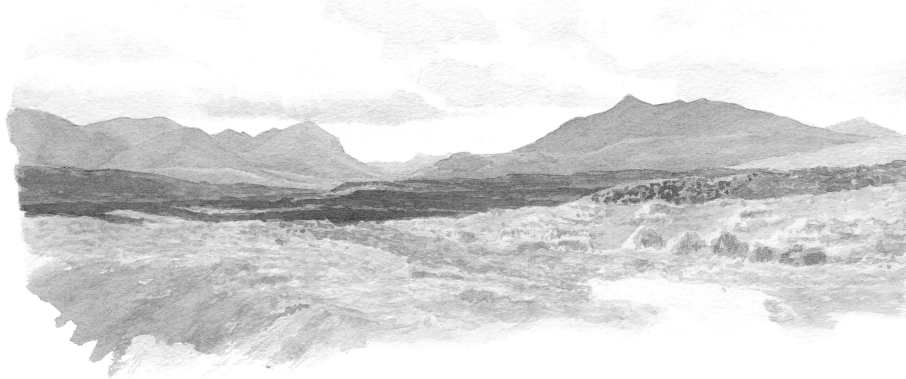

The Cuillin from the Portree road near Sligachan

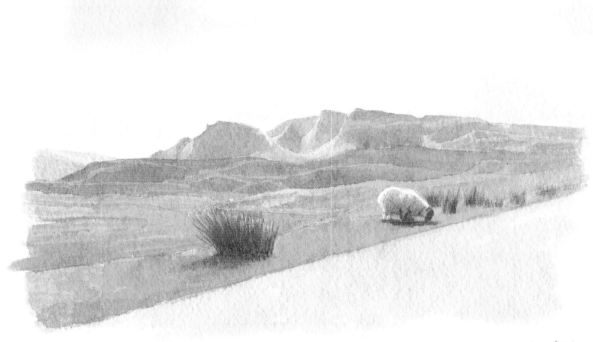

The Trotternish ridge at Staffin

From here it is possible to join a boat trip across the loch enabling you to reach Loch Coruisk, a deep and dark glacial trench isolated and encircled by the peaks of the Black Cuillin. I am saving that for another visit.

After seeing the view from Elgol you will wonder how anywhere in Britain will ever impress you again. But it will, and it's on this island.

From Sligachan the journey into Portree is a gentle interlude. It is Skye's only town and the hub of the island's road network as well as being the centre of commerce. Portree has everything a small market town on the mainland can offer and is well prepared for the tourist hoards who flood onto Skye in the high summer months on their 'if it's Tuesday it must be Skye' whistle stop coach tours that congregate in Somerled Square for a 'comfort stop'.

Here is a good place to buy tweed, woollens and anything tartan. There are some attractive corners and vistas and the views around the harbour are particularly good. However, Portree is not life as most islanders experience it and, for that matter, neither are the Cuillin the typical Skye landscape.

> Not until the Scots king Alexander III defeated the Viking king Haakon at the Battle of Largs in 1263 did Skye come under Scottish control.

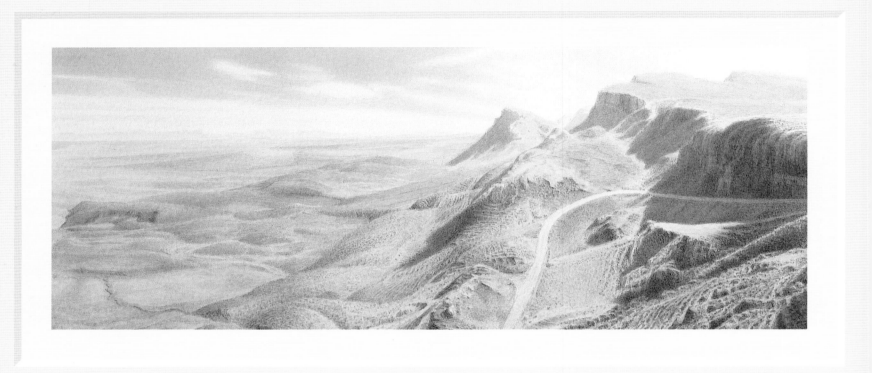

Whenever I think of Skye I see rugged hills dotted with brave stone houses, isolated crofts surrounded by fenced off patches of pasture grazed by shaggy sheep and cattle. I see small collections of modern bungalows huddled together for protection against the wind and rain, single track roads with passing places. There is a buzzard approaching a fence post as if it is going to rip it out of the ground. There are views of the island across sea lochs or out to sea to dark offshore skerries and other islands. This is an open untamed landscape of rough grassland, peat, rock and water. It is the land north and west of Portree and out of sight of the Cuillin.

To the north of Portree lies the Trotternish peninsula where the hills that form its backbone reach up more than 600 metres. The west coast route alongside Loch Snizort is the most direct to Uig, where the road to the Western Isles continues via a CalMac ferry and the hills to your right are a rounded plateau of old lava flows.

The east coast journey takes you alongside the same hills, but on this side the hard overlying layer has collapsed onto the softer rocks below, breaking off in a spectacular series of landslips (or possibly just one) creating an eighteen mile long undulating wall of rock that towers over the jumbled mass of screes, rocks and pinnacles below to form some of the most impressive scenery on Skye.

At Staffin a minor road climbs to the ridge in a series of hairpin bends to take you into the heart of this wonderland, the Quiraing. At the top is a parking place from where some not-too-difficult walking along a network of footpaths will take you through the strangest landscape you are likely to find anywhere in Britain.

Such is the attraction for me of these Scottish islands that I increasingly find myself eyeing the property for sale. On Skye I noticed that, for somewhere so off the beaten track, the prices are quite high. At one solicitor' office I asked for an explanation and was told that it was the retiring English effect. 'Eighty to ninety per cent of the property we sell is to English people. Many of them are cash buyers, not young people but mostly the retired, those taking early retirement or buying in advance of retirement. It's putting most property out of the range of local people. There are now sales by English to English; some of the families are third or fourth generation on the island.'

The population is slowly becoming older. 'Many young people leave the island to further their education on the mainland and do not return, so the local population is no longer regenerating itself.' I said I thought it a sad situation and one difficult to reverse; maybe they should consider the Guernsey model and have two housing markets, one for locals and the other open. 'Well, that's the way of the world, you can't turn them back at the bridge can you?'

Now there's a thought, all you have to do is overprice the crossing. But they've already thought of that one.

The Quiraing, looking southeast

Harris

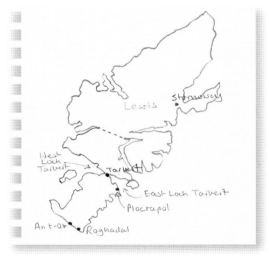

There was a time, before I was old enough to go to school, when I believed the moon was made of cheese. Even then, though, I was sceptical. Later I learned that it was covered in a thick layer of moondust, but this turned out to be inaccurate information too. I can reliably inform you now that it is, in fact, made of papier-mâché. I know this to be true because I have met the man who made it. He was a lecturer at the art college I went to. Well, he didn't make all of it, just the surface. Well, not all of it, just the area that is flown over by Dr Floyd's moon bus in Stanley Kubrick's film *2001: A Space Odyssey*.

You may be surprised to learn that the only part of the film to be shot on location was the flight over the surface of Jupiter, which comes at the end of the dazzling light-show sequence portraying the journey through the planet's atmosphere.

This wasn't actually filmed on Jupiter, obviously (although, if you are reading this in a second-hand bookshop on Mars in the twenty-second century it might not seem such a far-fetched notion), it was filmed over... you've guessed it, Harris.

You do not need a vivid imagination to appreciate the other-worldliness of this place, and listening to the film's soundtrack (Gyorgy Ligeti's *Atmospheres*) as you drive along the single track east coast road between Roghadal (Rodel) and Tarbert would only serve to cloud your judgement and drown out the more subtle sounds of Mother Nature's atmospheres.

It's a place uncompromising in its starkness, primeval even, but beautiful all the same.

Harris is an island of contrasts.

The west coast is a series of wide bays, where a deep blue and turquoise sea laps over beaches of sparkling white sand, backed by magnificent towering dunes and an extensive machair; green, fertile, lush and gentle. There is nowhere in the Hebrides more exotic or alluring than this.

In the north is a raw, boulder-strewn terrain of ice-carved mountains, the highest land in the Western Isles, lonely and majestic.

Harris is in fact only one third of an island, the other, northern, two thirds being Lewis. Until the reorganisation of local government in the mid-1970s created the Western Isles Council to govern the whole of the Outer Hebrides, there was the bizarre situation of Lewis being in the county of Ross and Cromarty and Harris in Inverness-shire.

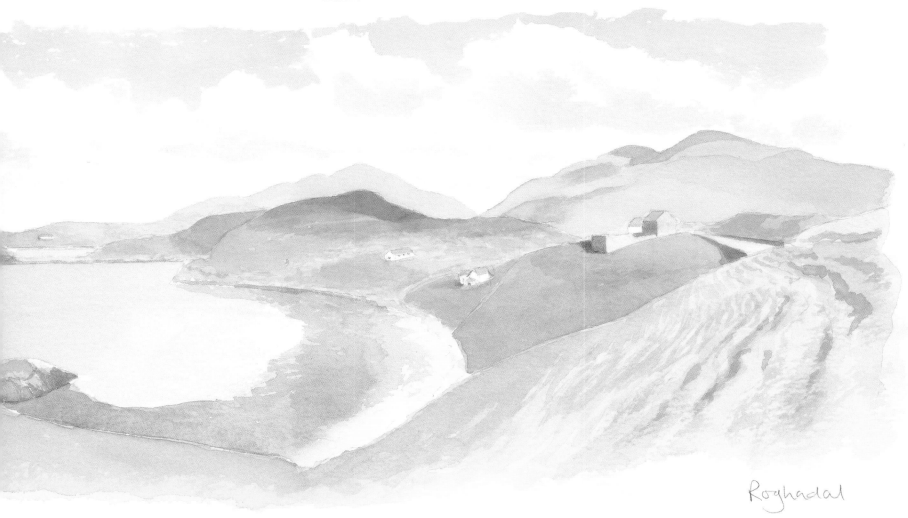

Roghadal

The CalMac ferry from Uig on Skye takes an hour and forty minutes to cross the Little Minch to Tarbert on Harris. Tarbert is Harris's hub. It is the largest settlement with a population of about 500 and stands astride an isthmus with East Loch Tarbert looking out across the Little Minch on one side and West Loch Tarbert with the Atlantic and Greenland beyond on the other. Without this narrow neck of land south Harris would itself be an island.

I stayed on the west coast and enjoyed some very warm May sunshine. To go anywhere involved a drive around those magnificent sandy bays and across the dunes, and it always took longer than anticipated, as I had to keep stopping to marvel at the scenery. Add the odd palm tree here and there and you could be anywhere tropical, but it is *here* in Britain. What are you waiting for? Put the book down and get out here.

I began my exploration with a drive north along the single track east-coast road across that Jupiter landscape. It is known here as 'the Golden Road' because of the cost of its construction. Without any machinery, just hard physical manual labour, it took nine years to make nine miles.

The area is known as The Bays, an undulating landscape with high ground, the spine of South Harris, to the west and the Little Minch to the east with a distant view of Skye. It is an untamed and untameable land, crossed by the single track road that has hardly a straight and horizontal stretch that is more than a car's length. It constantly twists, with short steep rises that suddenly fall away, disappearing below the bonnet, leaving you not knowing until the last moment whether it will take you left or right, or if the way ahead is blocked by sheep.

The sheep seem to care little about traffic and doze at the side of the road, sometimes in the middle of it, and wander out in front of you.

The journey took most of the day and hardly any vehicles passed by in either direction. It is not a difficult drive even at the low speed needed to negotiate the constant changes in direction, although the road is very narrow in places. But great concentration is required to prevent oneself from going off-road as the scenery is so distracting. It seems only a few hundred metres since I last stopped to marvel at the view before I'm out again gazing in awe at something else totally stunning.

The land is grey granite mounds and slabs scoured and scratched by glaciation, separated by reddish-brown peaty ground, moist and boggy in places, heather covered, with areas of lime green moss.

What the sheep find to eat I cannot imagine.

The Bays, east coast of Harris

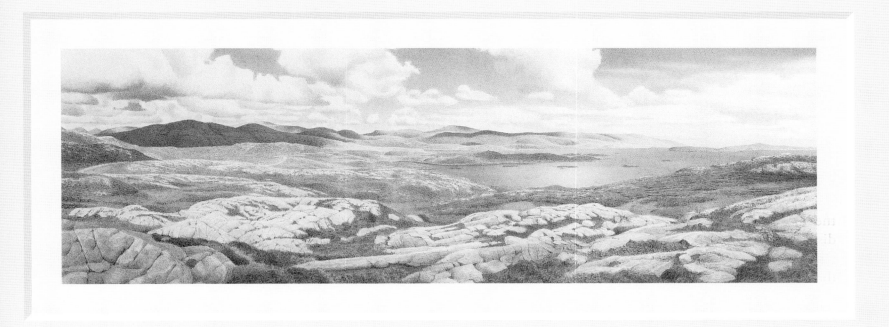

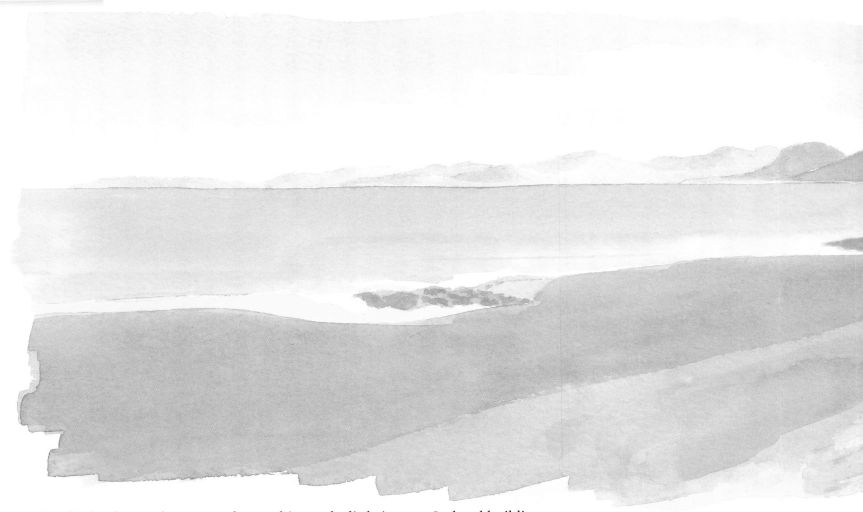

In this landscape the scattered townships make little impact. Isolated buildings are spotted only after a period of careful scrutiny, serving to add a sense of scale and wonder. It is a subtle landscape with a rounded evenness, an all-encompassing beauty that is as much defined by its colour as its form.

If you have ever handled genuine Harris Tweed and studied closely the often rich combination of colours that make up its harmonious design, then you will understand the landscape of this side of Harris. Once you have been here and witnessed it for yourself then the tweed will take on a new meaning, will be seen as a natural development from this land and a permanent reminder of the rich collection of colours that combine to create its beauty.

When these island journeys began in the Firth of Forth I bought a Harris Tweed jacket in Edinburgh, and while I was here was keen to see how the cloth is woven.

west coast

Many weavers, including the one who wove the tweed for my jacket, are outworkers for one of the tweed mills, which are now all on Lewis. The wool is made up into a warp at the mill and is delivered to the weaver's home along with the yarn to be used as the weft, the design instructions and a pattern sample. The finished cloth is woven on a hand loom. This is the essence of what makes Harris Tweed special; the weaving of the cloth on a hand loom at the weaver's home. If this does not happen, and happen here in the Western Isles, then it cannot be called Harris Tweed.

At Plocrapol, a tiny township on the Golden Road, Katie Campbell works next to her house in a shed that is perched on the edge of sea-washed rocks that form an inlet of East Loch Tarbert. Katie works for herself independent of the mills and welcomes visitors to her workshop, where she will demonstrate how this unique process works.

She makes up her own warp, a mesmerising process involving the bringing together of different coloured threads of wool yarn from large bobbins and winding them onto a vertical frame of wooden pegs, the size of one side of her shed, to make hanks ready for use on the loom. If that sounds complicated, watching her weaving is mind-boggling. I'm convinced it's magic.

Katie usually makes up small quantities of different tweeds, so she always has bolts of cloth in a good variety of designs and colours for sale. There are also tweed shawls, scarves and hats for sale.

She also makes a knitting yarn, and somehow finds time to knit the most delicate, very reasonably priced chunky sweaters. I picked up one that was Harris granite colours and, you wouldn't believe it; it fitted perfectly. How could I resist? It was obviously meant to be.

While I was there Katie's friend Suzanne arrived. Suzanne is Swiss. She came to Harris on a coach trip to see tweed being made and felt so sad at having to leave that she moved here. She is now having a house built in Tarbert. I understand how she feels. It has had that effect on me too.

I was asked if I would like to join them for tea, and so we went over to Katie's house and sat round the kitchen table and continued our conversation.

Tea in Scotland means more than just a cup of tea and a biscuit. Even so, Katie's hospitality was overwhelming. Smoked salmon salad, home made cakes and scones with clotted cream and jam . . . yet an hour before, I was a total stranger.

I asked what people do here for a living. Between them they could think of ten people who made tweed, there is some fishing and fish farming, there is no agriculture as most of us from the mainland would know it, but there are sheep everywhere. There is some haulage, the CalMac terminals at Tarbert and An t-Ob

(Leverburgh as it was known for a while), a few shops, a hotel or two and a handful of craftspeople. Then there are the things you find in all communities; the buses, the schools, some local government workers, some builders and a garage. That's about it.

They said that houses and building plots are snapped up the moment they come on the market.

At the croft where I stayed they reckoned that property was in such short supply you could sell a hen house.

Donald John built his croft house on the site of his father's, which he demolished. The croft is about eight hectares, but came with a one tenth share of communal grazing land, the hillside behind it, which is 1100 hectares. He has 120 sheep now, but in the past farmed three crofts together, with around 500 sheep.

The west side of South Harris is mostly crofts. There are a number of townships along the west coast road, with the individual houses spread out on their own plots of croft land. In some townships the communal grazing land might include the machair between the road and the dunes.

Donald John is looking for a quieter life now. Not only do they do B&B, as a number of crofts do, but next door they have built a small cottage to rent out by the week for those who want to go self-catering.

Hospitality is warm and friendly and guests are made to feel at home. There was one request to have consideration for their way of life. On the back of my room door was a notice: 'Guests are respectfully requested to refrain from viewing TV on Sunday'.

When I returned from Katie's and told him what a marvellous day I'd had and commented on the weather – warm and sunny with no wind – he smiled and said 'It's not usually this good in July'.

The next evening the sky was blackened by a hailstorm that stripped some of the roughcast rendering off the house and formed a drift of hailstones against the back door.

The owners of the small but exclusive hotel along the road, which used to be the Manse, have published a cookery book of their recipes (*Scarista Style*). In that I read 'home grown vegetables blow away as often as they take root in our breezy garden'.

Lucky me. The warm sunny weather continued for the length of my stay.

On my final day I experienced another one of those moments that spoke volumes about how special this place is, of the genuine warmth and friendly nature of its people.

> "Tarbert is a name that occurs at five other locations across western Scotland. Norse in origin, it is the name for a narrow strip of land across which boats can be carried or dragged from the head of one loch to another."

I was travelling along the single track road that skirts the southern slopes of the mountains of North Harris. I hadn't seen a soul for miles, then, in the middle of nowhere I could see ahead a small cedar-clad building. It was a primary school and in the playground were its seven or eight pupils sitting at a bench having their lunch. As I passed they jumped to their feet, ran to the fence and waved.

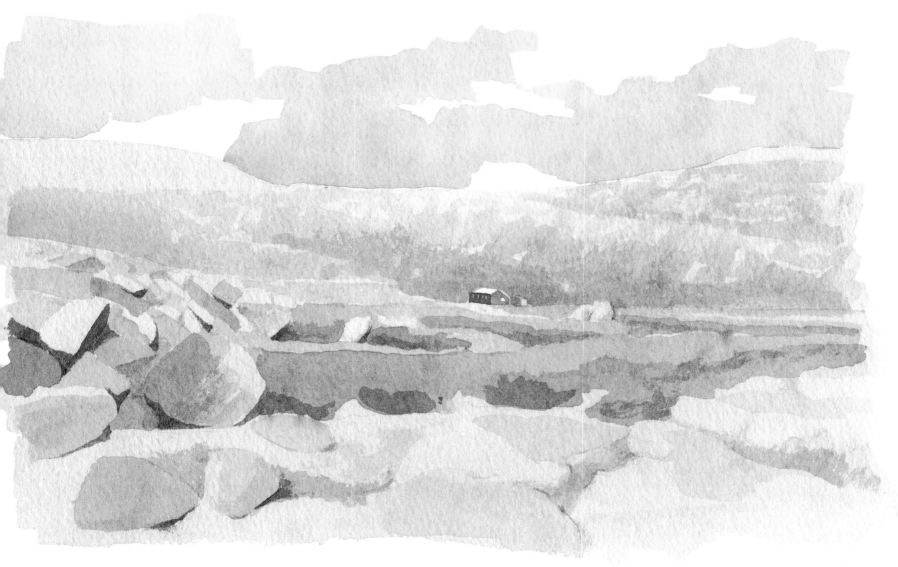

school

Orkney

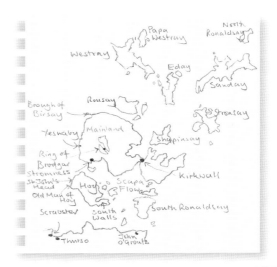

If you go to Scrabster by car, having first travelled up from England and driven across Caithness from Inverness to Thurso, it feels like you have arrived at the last place on earth. And it looks like it, too. But unless you are going to fly this is the place from which you catch the shortest ferry crossing from the mainland to Mainland. That is, from Scotland to the main island of the Orkney archipelago.

Think of it as the place you are going there to leave and it doesn't seem so bad. Just don't get there too early, you wouldn't want to linger.

On the way up I passed the first Birds Custard lorry I can recall seeing and began to wonder how many milk tankers it would need to make all that up into the right consistency, and then how many tons of loganberry pie it would complement. These sort of journeys get you like that.

From Scrabster the ferry to Stromness sails more or less due north to the west of Hoy... usually. It was a very nice sunny day, clear, but with a strong wind from... actually I cannot remember which direction the wind was from, but wherever it was, it was the wrong direction (somewhere vaguely north–ish I think) making the sea too rough for the normal route.

As a consequence, instead of sailing the shortest clockwise route round Hoy to Stromness we had to go anticlockwise. This took longer (two and three quarter hours instead of two), and we had already set sail 35 minutes late, presumably because the ship had first taken the long way round to get to Scrabster from Stromness.

This is not another opportunity for me to grumble about CalMac, because CalMac do not operate to the northern isles. You can say what you like about them, and in my experience the people who rely on them often do, but I have never known them to be late.

This ferry was one of the last to be operated by P&O Scottish Ferries. By the time I go to Shetland a new company, NorthLink, will be the operator. I hope I'll be able to say 'thank goodness'.

Actually, I was rather pleased to be going this way round, as long as we came back the correct way, as it gave me the opportunity to see more of the islands than I had anticipated. Although I had this down as just a day for getting there, I could now treat it as my first working day in the island group.

Hoy is not the largest of this group (that is Mainland), but it is the second largest in area. It is the highest by a long way (Hoy is Old Norse for high island) and is the only Orkney island that looks like an outcrop of the mainland. What it lacks in area it makes up for in volume, although with the highest point at 479 metres, you could only say it was hilly, but out here with only waves for comparison, it looks impressive enough.

At St John's Head on the northwest side, which the ferry usually passes close to, are some of the tallest perpendicular cliffs in Britain, more than 300 metres high.

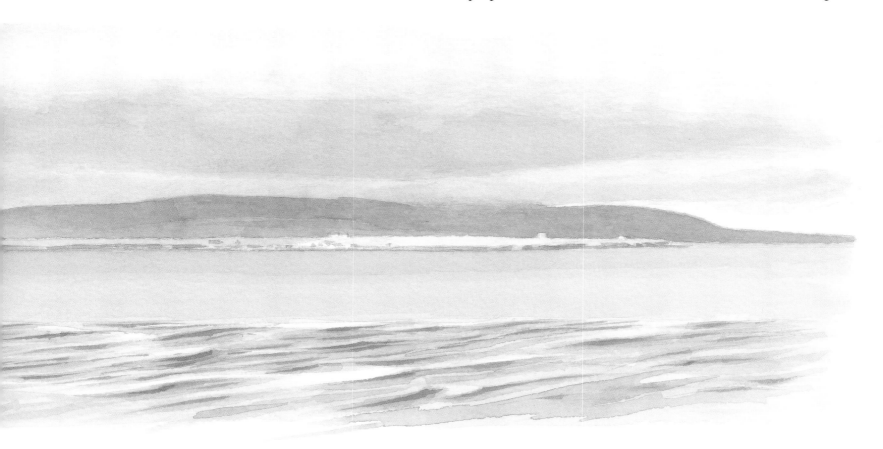

South Walls and Hoy — from the ferry

Hoy is also the most sparsely populated Orkney island. With 80 per cent of its land being high boggy moor, most of the people live along the road that runs down its low east coast and on South Walls off its southern tip, almost an island, joined to Hoy by an isthmus. Hoy should be seen as Mother Nature's grand entrance gate to the estate of small farms lying beyond. It's an impressive arrangement of stone, but not like anything else you will find out here.

Orkney is 70 islands, 18 of them inhabited, scattered across almost 1600 square miles of sea, with a total land area of 375 square miles, more than half being Mainland alone. On a map the individual islands do not appear neat and solid like Arran or Cumbrae, or even Hoy, rather they are gangly and amorphous; collections of sandy bays gathered together around narrow peninsulas to encompass gentle low hills, neat and fertile farms and small villages.

As the ferry rounded South Walls the small coastal settlements stood out clearly in the sunshine against the dark hills behind, now in shadow beneath a spreading blanket of cloud. We then crossed a calm, sheltered Scapa Flow on our approach to Stromness, and a scene more typical of Orkney opened up to the north and east.

Stromness is more than just the ferry terminal. It is a thriving port in a sheltered bay; an attractive old town, not ancient, and never a rival to the capital Kirkwall, but small and fascinating, with a narrow mile-long cobbled main street snaking along the shore. It is a cosmopolitan town quite unlike anywhere else of its size on the mainland.

Until I came here my vision of Orkney was found in a painting hanging in the house of some friends. This is a bright oil painting, almost Impressionist, like a Monet or a Pissarro from the 1870s. It depicts a coastal scene of dramatic cliffs with a frothy sea and the sun on cotton wool clouds, very blue and white. It is an impressive piece of work, one of those, 'I wish I'd done that' pictures, something I would love to have hanging in my own house to look at and admire.

My first reaction to it was to ask 'who did that and where are those marvellous cliffs?' It turned out to be by an uncle of my friend (whose family are Orcadians), Ian MacInnes who taught art at Stromness Academy and eventually became its headmaster (now there's enlightenment). The location is the cliffs at Yesnaby on the west coast of Mainland, a place with which he had something of an obsession, returning again and again to paint.

The painting had on me the effect I hope my paintings have. It made me want to go there to see it for myself, and so, at last, the opportunity had eventually arrived.

Yesnaby, Mainland, Orkney

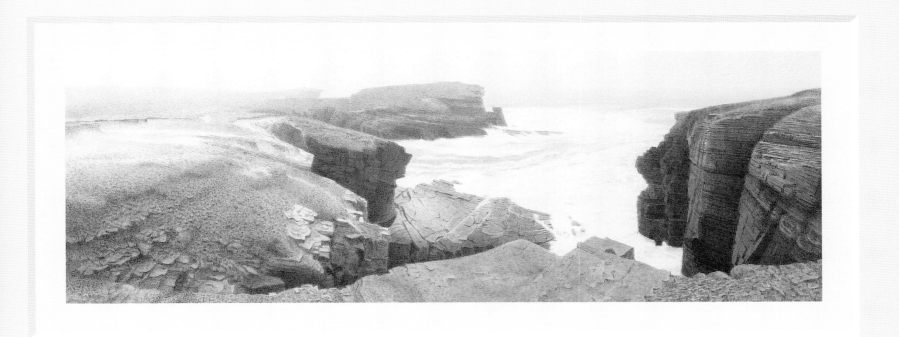

Yesnaby is at the end of a minor road off a minor road, the only easily accessible point along a six mile stretch of dramatic coastline. The arrival is not promising, with the derelict remains of a former military camp greeting visitors, but beyond these the cliffs are astonishing.

Sadly, I had not arrived with the weather that accompanied my crossing, but in near horizontal rain that was increasing by the minute. If I'd been working somewhere inland I would probably have been concerned about this, but on the coast I have found the weather does not really matter that much; the drama of the sea works in all conditions, and here there was also the drama of the cliffs.

I wanted to get near the edge to look into the gully below, to see the waves crashing across the ledges at the base. Although the cliffs seemed stable enough (they are a hard fine-textured sandstone that fractures into sharp angular slabs) I didn't feel safe in the gusting wind and had to be content to stand back. I had read that the cliff tops here support a unique plant life that thrives on salt spray. I am not surprised.

Mainland is littered with ancient sites. It is an archaeological paradise, the Egypt of the north. Brochs, cairns, tumuli, standing stones are evidence that, far from being remote and on the edge, Orkney has for millennia been the centre of life in the north, continuously occupied for more than six thousand years, longer than much of mainland Scotland.

Not far north of Yesnaby is the most famous of these sites, the almost complete Neolithic village at Skara Brae. The houses, with walls still standing to eaves level, are connected to each other by narrow passages and are complete with their built-in stone furniture. That's probably not how everyone imagines stone-age life. The site was abandoned around 3000 BC when it was buried in sand during a storm, and rediscovered when, in 1850, another storm removed the cover of dunes.

Where the B road from Yesnaby back towards Kirkwall passes along a narrow neck of land between two lochs there is another site that I had learned about by unconventional means.

Four times a year the Charles Rennie Mackintosh Society newsletter drops through my letterbox. In the spirit of passing on useless information, you should be told that he was the first dead architect to have a fan club. Anyway, in the Spring 1994 edition was a small article by the membership secretary to say that a friend of a friend of a friend, who collects postcards of standing stones, had recently found one that had been sent from Orkney by the great man himself. The card was illustrated in the article and was a photograph of the stones at Stennes (Stennis on the card). At the time I thought, if I ever get to Orkney I'd like to see those.

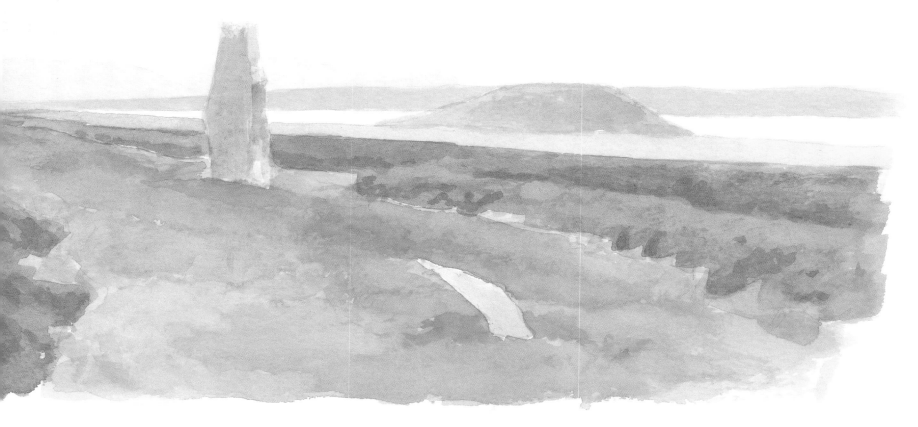

Ring of Brodgar

Now that I was here, I discovered that less than a mile along the road is an even more impressive stone circle, the Ring of Brodgar. I have always been puzzled by the position of the circles at Avebury and Stonehenge, which seem to bear little relationship to the topography of their setting, but somehow these stones, on raised ground with the lochs on either side, and a with distant view of Hoy, looked as if they belonged here. More than half the stones are missing, and the surrounding ditch is not as deep and wide as it once was, but it remains an impressive and mysterious site all the same.

Kirkwall (not as homely as Stromness, beware of roads that look like pavements, St Magnus Cathedral is magnificent) also stands on a neck of land with water on either side and it's from here you catch the ferries to the outer islands.

Orkney Ferries' fleet of seven run services to 13 of the islands and even do mini cruises. They generally leave between seven and eight in the morning and between three-thirty and five in the afternoon, some days with a lunchtime sailing too. Journey times are between an hour and a little over an hour and a half.

If you come here for a stay, don't just confine yourself to Mainland. I would recommend a visit to at least one of the outer islands to meet their friendly and welcoming residents and to get a flavour of their peaceful isolation.

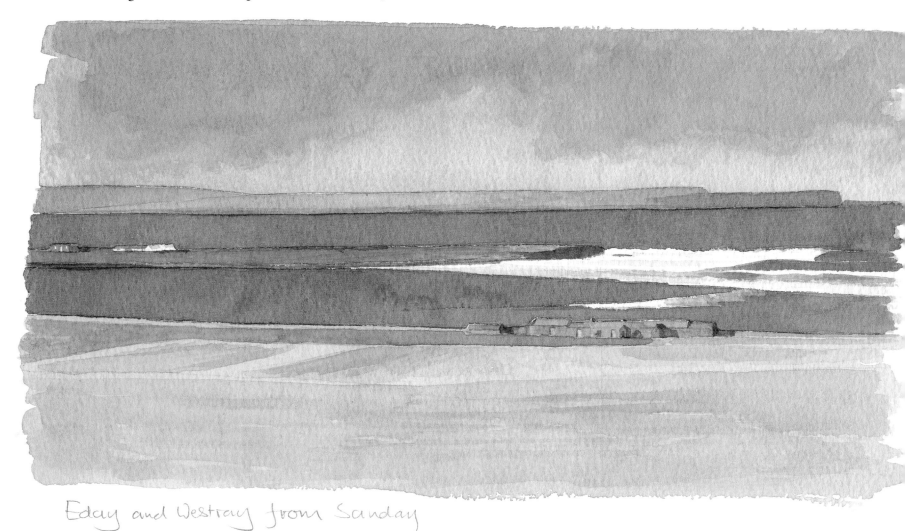

Eday and Westray from Sanday

If you take your car, you line up in lanes at the quayside, a lane for each island, each one indicated by a nameplate on a metre high steel post slotted into the ground at the front of each lane. It's a great idea, but if you are several cars back, it's dark, and lashing with rain, as it was when I first experienced this, how are you supposed to know which queue to join?

With a car you will be able to zip round any of the islands in no time at all, but most of the time you will only leave it parked somewhere as I guarantee you will be spending most of your time on foot. You could, if you are willing to chance the weather, go as a foot passenger and take or hire a bike, as most of the islands are little more than gently undulating.

If you do not have any particular island in mind to go to, I can recommend Sanday, which is good for beachcombing and communing with seals, or you can visit Papa Westray (travelling via Westray) where there is a pair of semi-detached houses that are, at 5000 years old, the oldest houses in Britain.

There is Hoy, of course, where on North Bay (in the south of the island) is Melsetter House, probably the best piece of architecture out here, an existing eighteenth century house greatly altered by W R Lethaby in 1898. Lethaby (who was one of the founders of the Art Workers Guild, of which I am a Brother) along with M H Baillie Scott (who lived for a time on the Isle of Man and collaborated with Archibald Knox) deserve as much praise as Mackintosh, but rarely get it. Melsetter House is privately owned, but can be visited by appointment.

Sticking a pin in a map is probably as good a way of choosing where to go as any, but you are three times more likely to hit water than land.

The journey out is a mini cruise in itself, but you will need to be on deck to enjoy the scenery as the windows in the ferries' seating lounge are placed more for letting light in than seeing out.

I am a sucker for stacks. Indeed, on these travels I had come across two new ones I'd not been aware of – May's The Angel and Islay's Soldier's Rock. Consequently, I had been looking forward to seeing the ultimate; the towering 137 metres high Old Man of Hoy which I'd been disappointed not to see on the journey out. Fortunately we took the 'correct' route back to Scrabster, sailing at dusk in yet more rain, but as we rounded St John's Head there was still just enough light to see it loom out of the gloom.

Shetland

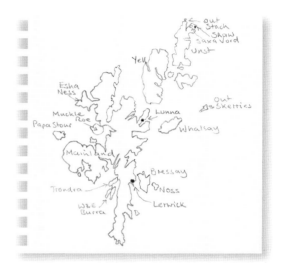

On the jigsaw puzzle map of the British Isles, Shetland looks like the last few scattered pieces still waiting to be put into place in the top right corner.

You'll find Shetland a little to the northeast of Rob McElwee's left ear. The BBC weather map is one of the few places you can guarantee to see it in its proper position (as well as, of course, in this book). Everyone else wants to put it in a box and moor it off Wick. Road atlas publishers don't even bother to show it on the same scale as the mainland. Their attitude seems to be that so few people live there who's going to complain?

It is not surprising then that when I tell people how long the ferry journey is – 14 hours – they are amazed. 'Is it really that far?' Yes folks, it is, but hooray for NorthLink Ferries!

At last, a ferry company that wants to make getting there a pleasure; not just a journey from A to B (in this case from Aberdeen to Bressay Sound) but an enjoyable experience. This service offers good facilities, comfortable and varied surroundings and, joy of joys, good food if you want eating aboard to be as special an event as the trip you are embarking on.

I know what you're thinking; what do you do for 14 hours? The answer is that half the time you sleep. The ferry leaves Aberdeen at five in the afternoon and arrives at Lerwick at seven the next morning. Some time into that period you go to your comfortable en-suite cabin (your boarding card is also your cabin key – very Star Trek), get your head down and let the North Atlantic rollers gently rock you to the land of nod (or in this case, with Vikings in mind, Noggin the Nod).

When you get there, you drive your car off and park it. Then you go back aboard and have a leisurely breakfast. They've thought of everything.

What I hadn't thought of, until the last minute, was accommodation. I had picked up a Shetland brochure on the way back from Iona, but then did nothing with it until a week before travelling.

I wanted to be out in a rural location, the real Shetland, but the out-of-Lerwick guest house pages looked an uninspiring lot, nearly all typical, modern, rendered block bungalows. Then suddenly my eyes alighted on 'North Mainland – Lunna House, Lunna, Vidlin. Warm and comfortable 17th century laird's mansion, former Shetland Bus Norwegian resistance base. Spectacular views and tasty home cooking'.

That's the place for me! But they're bound to be full by now. 'You're lucky, we can fit you in.'

Historical Note: In April 1940 Germany launched an unprovoked attack on a neutral and ill-prepared Norway. By June, King Haakon and his government decided that resistance within Norway was no longer possible and removed to Britain. Shetland was the nearest friendly landfall, and so began an organised traffic (at night and in winter, using Norwegian fishing boats that would not be too

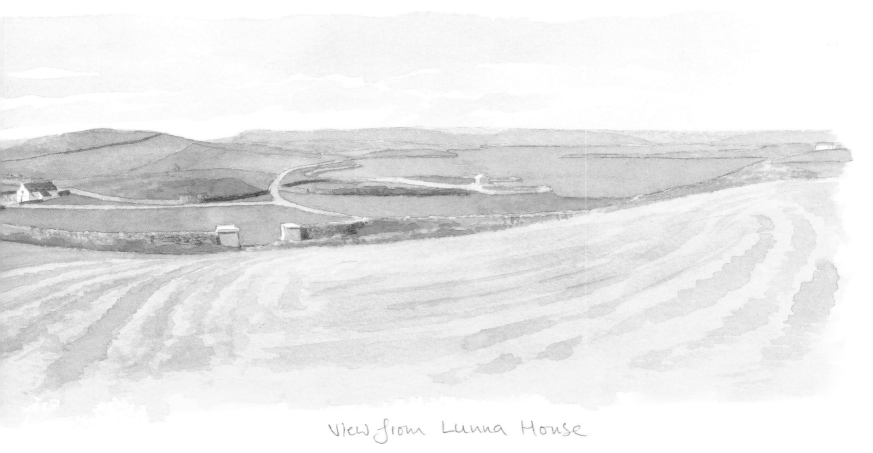

View from Lunna House

conspicuous) carrying undercover agents, weapons and supplies to Norway for sabotage actions, and bringing back refugees and recruits. Because of its isolated position, Lunna House was chosen as the initial base for these secret operations. Every Norwegian knew this was going on and was fortified by the knowledge. To escape imminent danger was 'to take the Shetland Bus'.

Norwegian links with Shetland have been strong since the Vikings and the islands were still part of Norway until as recently as 1471. A campaign group in Norway claims that, although the islands became Scottish as security on the dowry when Margaret of Norway married James III, they were legally only pawned, and could be reclaimed if Norway paid Scotland 58,000 florins.

The legacy of those links is that many Shetland place names are Old Norse in origin: Fladdabister, Hamnavoe, Hermaness, Hascosay, even Lerwick. Anything ending in -a, -ay or -ey is an island, -wick or -voe describe bays of different shapes, –ness is a headland, and -sta, -ster, or -bister indicate the locations of Norse farmsteads.

Norse is evident still in the local dialect and in the words and phrases that have remained in the language since the introduction of the lowland Scots variation of English. I have heard this mix called Lerwegian.

I noticed on my Shetland travels that new strongly coloured Norwegian-style timber houses are springing up across the islands. I wondered if this was the result of a policy at Shetland Islands Council to Scandinavian-ise the islands. My enquiries led me to Bobby, half of the building firm Elphinstone & Howarth, who are responsible for the houses that I was particularly taken with.

I asked him why timber houses, when there are hardly any trees in Shetland; wouldn't stone be more appropriate?

He said that the powers-that-be in Edinburgh would prefer it if he built traditional stone croft houses, but nine out of ten houses he is asked to build are of timber. Norway has a strong pull on Shetland, the people are proud of their Norse heritage and the country is a popular holiday destination for the islanders. They come back wanting to build something that looks like the houses they have seen over there. If there is a desire to make Shetland more like Scandinavia it is coming from the islanders themselves.

When these houses first started to appear they were shipped across the North Sea in kit form. Since then Bobby has been adapting and modifying his own designs and construction methods to suit local planning regulations and the particular demands of the Shetland climate. He aims to produce unique houses that are as energy efficient as possible and bring an attractive, colourful, Norwegian look to the landscape.

> Shetland is at the same latitude as southern Greenland, Helsinki, St Petersburg and Anchorage. Lerwick is 600 miles from London but only 400 from the Arctic Circle.

Basalt cliffs at Esha Ness

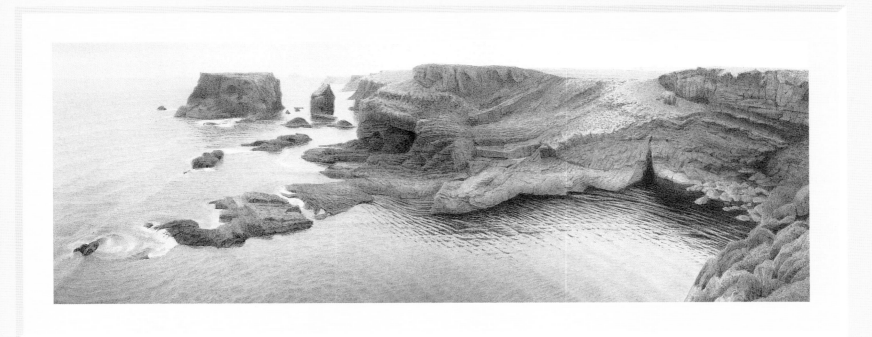

If these eventually replace the plain, rendered block boxes then I'm all for it.

The Shetland landscape has been scoured by glaciation and swept by violent weather. It is hilly but rounded, with the coastline a maze of deep inlets (nowhere is more than three miles from the sea) and headlands that are frayed at the edges where they have been battered by the waves.

My Shetland painting is of the rugged cliffs on one the most exposed headlands of northwest Mainland – Esha Ness.

The higher hills are covered in peat and heather moorland. The lower lying areas are herb-rich grasslands and meadows, with maritime grassland on the fringes. Trees are rare. Farms are small (there is still traditional crofting) and the multicoloured varieties of Shetland sheep are to be seen everywhere and, yes, there are Shetland ponies too. Fish farms and mussel rafts are a common sight in the voes. It is at times a dark, sombre brown and grey land, then at others a ravishing vivid green and reflected electric blue.

There are more than 100 islands covering 567 square miles, 70 miles from north to south, 35 from east to west and 110 miles north of mainland Scotland. Fifteen are inhabited. Mainland, looking itself like a collection of close islands, is by far the largest, followed by Yell to the north and Unst further north still. Then come Fetlar, Muckle Roe, Bressay, Whalsay, Papa Stour, Noss and the outlying Out Skerries, Fair Isle and Foula that are of any size. West and East Burra and Trondra are linked to each other and to Mainland by road bridges.

One thing I wanted to do while I was here was to take my (Scandinavian) car as far north as it is possible to go in the British Isles, to bring these travels to a fitting end by driving until I was as far away as I could get, until the road ran out. This involved catching two ferries, one from Mainland to Yell, then after an 18 mile drive across Yell, the ferry to Unst.

The inter-island ferries operated by Shetland Islands Council are frequent and not expensive, unless you have to do this on a daily basis. The ones I caught had few vehicles on them, but I was still obliged to phone at least half an hour in advance to let them know I was coming.

The trail eventually took me to Skaw, in Unst's northeast corner, hot on the heels of some heavy rain. As the single-track road descended a steep incline for the last quarter of a mile, water flooded off the hillside and across the road, creating a new burn as it cascaded down the hill on the other side. At the end of the road the tarmac stopped and became two puddle-filled wheel ruts through grass continuing the other side of a wooden bridge over a burn.

The single storey croft house with its collection of outbuildings, one an

upturned boat, that looked out on this modest landmark is Britain's most northerly inhabited house.

As I had come this far I thought I would make a six mile detour and take the track up the nearby hill, Saxa Vord, in the hope of seeing from there Britain's most northerly building, the Muckle Flugga lighthouse. The rock beyond it, Out Stack, is the most northerly of the British Isles. As I had sketched what some claim to be the most southerly building on Britain's islands, the communal toilet on Les Minquiers south of Jersey (a dubious claim in my opinion, as Jersey is not part of Britain) I thought it would be appropriate to add the most northerly to my collection.

It was probably not the best time for attempting this, as heavy rain had fallen for much of the day and, although it had now stopped, low cloud still hung round

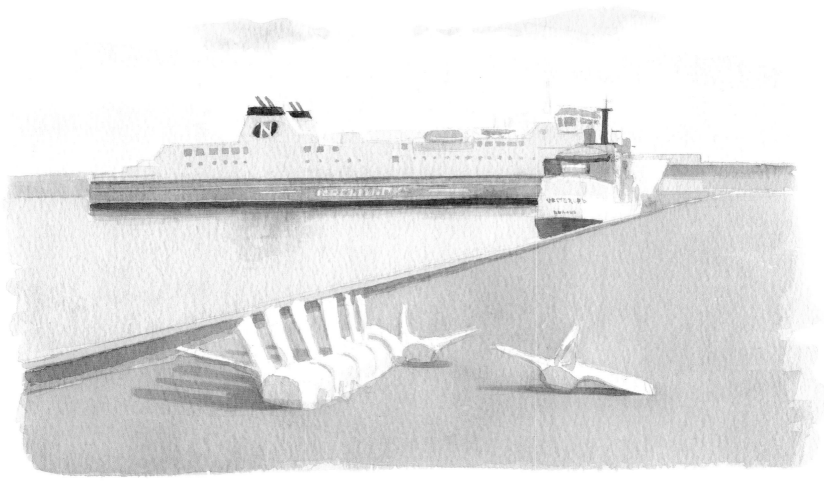

Lerwick harbour

the hills. At the top as I feared visibility was no more than a hundred metres, not much use for viewing something nearly three miles away. The journey did bring one reward, however. A great skua, or bonxie as they are known locally, and the first I had ever seen, swooped low over me and flapped aggressively as I started the descent.

While I was here much of the country was experiencing some warm seasonal weather, 25 degrees celsius in England, but here it managed only 15, which is about as good as it gets; but hey, I like sweaters.

June was supposed to be the sunniest month up here, but if that is measured in hours, not just the number of days with more than a certain percentage of sunshine, then being this far north in mid June has one great advantage. It feels strange at first to a southerner, but the sun does not go down until 10.30pm and it stays light for another 45 minutes. After that it still doesn't get dark, just a long dusk and then sunshine again from about 3.30am.

Being so far from the mainland has made Shetland probably the most self-sufficient community of 23,000 people in Britain. As one used to the marked lack of local produce in many mainland food shops, I found the local shops across Shetland both a revelation and a delight. Looking at the produce on sale suggests there is a considerable cottage industry keeping them supplied, particularly with fresh bread, oatcakes, shortbread and the like.

Lerwick, though a town with a population of only 7500, functions as a small city. You can get anything, though there may not always be wide choice, and it manages with only one chain store, a small Boots. There are two out of the centre supermarkets, which can run out of fresh items if bad weather stops the ferries from running for several days. The town's setting is dramatic; the main shopping street, which runs parallel with the waterfront, is a narrow winding gorge of sandstone buildings. On one side narrow lanes climb long steep flights of flagstone steps to the upper town, and on the other is the busy harbour and its views across Bressay Sound to the island of Bressay.

In Lerwick one of the industries these islands are heavily reliant upon is prominent; fishing. The harbour is busy with fishing boats and at the northern end are the large sheds where the catches are processed. So important is fishing that there is a local newspaper devoted entirely to the industry and even in a Shetland knitwear shop you will be told that 'pelagic is doing well at the moment' (pelagic being mackerel and herring). Shetland is close to the fishing grounds, mackerel to the west and herring to the east, making it the perfect place to land the catches as the boats spend less time travelling from grounds to port.

the end of the road

Tourism is also important, with many people coming here to watch the seabirds in their vast nesting colonies on some of the most spectacular cliffs in Britain. How much longer this will continue is in doubt. On the day that I finished the Shetland painting in my studio, the only story on the front page of *The Independent* was of the catastrophic failure of many Shetland species to nest and rear chicks; 6800 pairs of great skuas produced fewer than 10 chicks while 24,000 pairs of Arctic terns and 16,700 pairs of kittiwakes suffered a complete failure.

The reason for this is thought to be a rising sea temperature, which has caused the plankton which sand eels feed on to move north to cooler waters, causing the sand eels to move north too, out of range of the Shetland seabirds which rely almost entirely on them for food.

At the end of my trips to Harris, Orkney and Shetland I have travelled back to the mainland with the thought that I was not returning to civilisation, but leaving it behind. This is particularly true of Shetland, which has been the highlight of my travels. These beautiful and self-reliant islands have had a profound effect, leaving me with thoughts of moving north. The idea of asking Bobby to build me a wooden house with a voe view is very appealing, but probably, ultimately, just a dream...or is it?

Index